The Male Journey in Japanese Prints

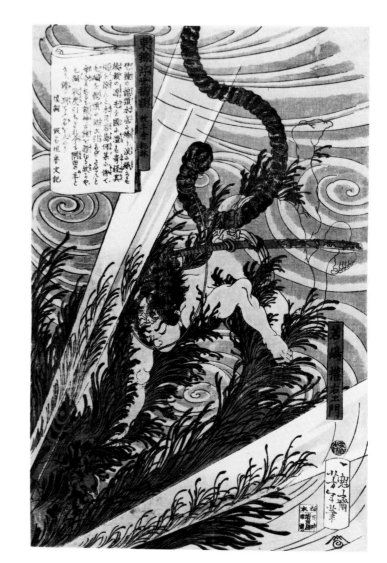

Frontispiece. Wakashima Gon'emon dives into a whirlpool to retrieve an ancient dragon-headed bell. 1867. From the series *Color Prints for Tales of the Floating World.* Tsukioka YOSHITOSHI.

Ōban format. Gon'emon risks his life in a heroic quest: to dive into uncharted depths, find a sacred treasure, and bring it back to the world.

The Male Journey in Japanese Prints

Roger S. Keyes

Published in association with The Fine Arts Museums of San Francisco

University of California Press · Berkeley Los Angeles London

Published in association with The Fine Arts Museums of San Francisco.

University of California Press
Berkeley and Los Angeles, California

University of California Press, Ltd.
London, England

Library of Congress Cataloging-in-Publication Data

Keyes, Roger S.
 The male journey in Japanese prints /
Roger S. Keyes.
 p. cm.
 "Published on the occasion of the exhibition Rage, Power, and Fulfillment: the Male Journey in Japanese Prints"—T.P. verso.
 ISBN 0-520-06512-3 (alk. paper). ISBN 0-520-06513-1 (pbk. : alk. paper)
 1. Ukiyoe—Exhibitions. 2. Color prints, Japanese—Edo period, 1600–1868—Exhibitions. 3. Wood-engraving, Japanese—Edo period, 1600–1868—Exhibitions. 4. Men in art—Exhibitions. I. Title.
NE1321.8.K487 1989
769'.423'0952074—dc19 88-22736
 CIP

Printed in Japan

9 8 7 6 5 4 3 2 1

This book was published on the occasion of the exhibition *Rage, Power, and Fulfillment: The Male Journey in Japanese Prints*, organized by The Fine Arts Museums of San Francisco. This exhibition and publication have been made possible by generous grants from The Toyota USA Foundation and the National Endowment for the Arts, a Federal agency.

To the men
of my father's generation
and my own,
all of us hurt,
barely aware of our anger and grief.
In our unknown pain
we are deciding
the fate of our world.

And
to our sons.

Contents

vii

Illustrations

Most of the prints in the volume were ably photographed by Joseph McDonald. They are in the collection of the Achenbach Foundation for Graphic Arts, the print and drawing department of The Fine Arts Museums of San Francisco (hereafter designated as AFGA), and were acquired by purchase from funds of the Achenbach endowment and through gifts of Moore S. and Hazel Achenbach and other donors. Transfer to the AFGA of the Japanese prints in the M. H. de Young Memorial Museum's collection included the gifts of Carlotta Mabury, Katherine Ball, and Mary Wattis Brown. Under the terms of long-term loans, the AFGA also houses and cares for some works of art on paper that belong to the California State Library and to the San Francisco Art Institute.

1. Kitagawa UTAMARO. Mother blowing a pinwheel for her son. *c.* 1805. From the series *Ten Physiognomic Types of Women.* (K. 11383) AFGA, 1963.30.5610.

2. Kitagawa UTAMARO. Boy clinging on his mother's back. *c.* 1805. From the series *Twelve Types of Beautiful Women Matched with Landscapes.* (K. 11382) AFGA, Katherine Ball Collection, 1964.141.1030.

3. Kikukawa EIZAN. Mother carrying her baby son on her back. *c.* 1810. (K. 11949) AFGA, Katherine Ball Collection, 1964.141.1156.

4. Katsushika HOKUSAI. A baby boy crawls to his mother and interrupts her. 1804. "Akasaka," from a series of views of the Tōkaidō Road. (K. 10499) AFGA, 1963.30.5288.

5. Yanagawa SHIGENOBU. A baby boy tickles his mother and laughs. 1810s. "Narumi," from a series of views of the Tōkaidō Road. (K. 10504) AFGA, 1963.30.5292.

6. Kitagawa UTAMARO. Two women dressing a baby boy like the Abbot Henjō. *c.* 1805. From the series *Modern Children as the Six Immortal Poets.* (K. 11406) AFGA, Carlotta Mabury Collection, 1964.141.1050.

7. Torii KIYOMINE. A boy steals a hand puppet from his mother. 1807. "Autumn," from the series *Flowers for the Four Seasons.* (K. 10607) AFGA, Carlotta Mabury Collection, 1964.141.795.

21. Attributed to Ishikawa RYŪSEN. Children fighting over rice cakes. *c.* 1710s. "First Month," from an untitled series of Twelve Months. (K. 11044) AFGA purchase, 1970.25.33.

22. Ryūsai SHIGEHARU. Tai Shun leaves his family and opens new territory in Western China. *c.* 1830. From the series *Twenty-four Paragons of Filial Devotion*. (K. 11057) AFGA, Carlotta Mabury Collection, 1964.141.38.

23. Katsushika HOKUSAI. A youth performs a religious dance for travelers. 1804. "Nissaka," from a series of views of the Tōkaidō Road. (K. 10487) AFGA, 1963.30.5277.

24. Katsushika HOKUSAI. A son helps his mother and father grind oil. 1804. "Yoshiwara," from a series of views of the Tōkaidō Road. (K. 10476) AFGA, 1963.30.5266.

25. Keisai EISEN. Boys imitate a daimyo's procession crossing Nihon Bridge. *c.* 1820. (K. 11817) AFGA, DeYoung Museum transfer, 1964.141.1145.

26. Utagawa KUNIYOSHI. Children as carpenters raising the roof for a storehouse. 1830s. (K. 10968) AFGA, 1963.30.5503.

27. Suzuki HARUNOBU. Hotei tosses a Chinese boy into the air. Late 1760s. (K. 11907) AFGA, 1963.30.5685.

28. Ryūsai SHIGEHARU. The Osaka actor Nakamura Utaemon III as a renegade nobleman holding his infant son. Early 1830s. (K. 11057.1) AFGA, purchase, 1987.1.187.

29. UNIDENTIFIED NAGASAKI ARTIST. A Chinese boy strikes a gong his father holds out for him. *c.* 1840s. (K. 11662) AFGA purchase, 1978.1.53.

30. Torii KIYONAGA. A servant holds Kuzunoha's son as she departs on her journey. 1784. (K. 10615) AFGA, Carlotta Mabury Collection, 1964.141.809.

31. Utagawa TOYOKUNI. The actor Ichikawa Danjūrō VII holds his new-born son. 1824. (K. 11606) AFGA, gift of Mrs. James Campbell, 1964.141.948.

32. Utagawa KUNISADA. Ichikawa Ebizō VIII as Acorn, a child-priest, holding a secret scroll. 1830. (K. 11574) AFGA, 1963.30.5563.

33. Utagawa KUNISADA. Ichikawa Ebizō VII introducing his fifth son, Kawarazaki Gonjūrō, to the audience. 1858. (K. 10744) AFGA, 1963.30.5470.

34. UNIDENTIFIED EDO ARTIST. Ichikawa Ebizō VII supports his son Danjūrō VIII as he dies. 1854. (K. 11813) AFGA purchase, 1984.1.50.

35. Utagawa KUNIYOSHI. Hitsu no Saishō Haruhira discovers his father. *c.* 1845. From the series *Twenty-four Examples of Filial Devotion in Japan*. (K. 10969) AFGA purchase, 1981.1.56.

36. Tsukioka YOSHITOSHI. Hitsu no Saishō Haruhira discovers his father. 1881. From the series *Twenty-four Accomplishments in Imperial Japan*. (K. 11469) AFGA purchase, 1981.1.57.

37. Tsukioka YOSHITOSHI. Katō Ishidōmaru meets his father. 1881. From the series *Twenty-four Accomplishments in Imperial Japan*. Los Angeles County Museum of Art.

38. Konishi HIROSADA. The ghost of Takechi Samanosuke gives his son an heirloom sword. 1850. From a series of scenes from the play *The Chigo Deeps*. Donald Dame Collection.

39. Tsukioka YOSHITOSHI. Kiuchi Sōgorō says farewell to his wife and three sons. 1885. From the series *A New Selection of Eastern Brocades*. (K. 11723) AFGA purchase, 1982.1.65.

40. Tsukioka YOSHITOSHI. Umewaka collapses on the bank of the Sumida River. 1883. Los Angeles County Museum of Art.

41. Yanagawa SHIGENOBU. Sōjōbō lets Ushiwakamaru study his secret scroll of military strategies. *c.* 1829. (K. 11591) AFGA, 1963.30.5559.

42. Tsukioka YOSHITOSHI. Kintarō clamors for his mother, Yamauba. 1873. From the series *Essays by Yoshitoshi*. (K. 11466) AFGA purchase, 1968.13.9.

43. Yōshū CHIKANOBU. A mother takes her son for a walk during the Russo-Japanese war. 1904. (K. 11749) AFGA, Mrs. Alexander de Bretteville Fund, 1982.1.31.

44. Attributed to Torii KIYOMASU I. The young samurai Atsumori reigns in his horse to answer a challenge. *c.* 1710. (K. 11726) AFGA purchase, 1970.25.430.

45. Torii KIYOMASU I. Kintarō wrestles with a bear. *c.* 1700. Honolulu Academy of Arts.

46. Tsukioka YOSHITOSHI. Wakashima Gon'emon dives into a whirlpool. 1867. From the series *Color Prints for Tales of the Floating World.* (K. 11461) AFGA, Carlotta Mabury Collection, 1964.141.37.

47. Utagawa KUNIYOSHI. Nozarashi Gosuke. Mid-1840s. From the series *Men Worthy of the Name, in Costumes by Kuniyoshi.* (K. 10965) AFGA purchase, 1982.1.67.

48. Attributed to Kitao SHIGEMASA. Kneeling boy holding an hourglass. 1770s. "Bishamon," from an untitled series of children as the gods of good fortune. (K. 11059) AFGA, Carlotta Mabury Collection, 1964.141.866.

49. Okumura MASANOBU. A man with a young male lover. 1710s. From an untitled series of humorous adaptations of legends. (K. 11026) AFGA purchase, 1970.25.34.

50. Okumura MASANOBU. A young male prostitute writes a verse as a female prostitute caresses their patron. 1740s. From an untitled series of hand-colored erotic subjects. (K. 11027) AFGA purchase, 1969.32.20.

51. Suzuki HARUNOBU. Two boy prostitutes discussing a picture book. 1767. "Righteousness," from a series of Five Virtues. (K. 10082) AFGA purchase, 1967.22.17.

52. Ishikawa TOYONOBU. A young male prostitute at night. 1740s. The Mann Collection, Highland Park, Ill.

53. Tsukioka YOSHITOSHI. A statue of the deity Fudō Myōō comes to life and pierces Yūten's mouth with his sword. 1885. Los Angeles County Museum of Art.

54. Isoda KORYŪSAI. An older woman initiates a boy into sex. 1770s. From an untitled series of erotic subjects. (K. 11495) AFGA purchase, 1970.25.45.

55. Kubo SHUNMAN. A father and his son perform a dance with puppets. 1790s. (K. 11598) AFGA, Katherine Ball Collection, 1964.141.967.

56. Tsukioka YOSHITOSHI. Oniwaka watches the carp in the pond. 1889. From the series *New Forms of Thirty-six Supernatural Creatures.* (K. 11480) AFGA purchase, 1981.1.55.

57. Utagawa KUNIYOSHI. Oniwaka gathers courage to kill the giant carp. *c.* 1845. Museum of Fine Arts, Springfield, Mass.

58. Tsukioka YOSHITOSHI. Oniwaka seizes the carp and plunges into the depths of the pond. 1885. (K. 11808) AFGA, DeYoung Museum transfer, 1964.141.129.

59. Tsukioka YOSHITOSHI. Benkei prepares to read the subscription list. 1890. (K. 11811) AFGA purchase, 1981.1.85.

60. Utagawa TOYOKUNI. The actor Seki Sanjūrō II as Musashibō Benkei. 1810s. From a series illustrating a dance with seven quick costume changes. (K. 11312) AFGA, 1963.30.5599.

61. Kitao MASAYOSHI. Benkei prays to protect his master Yoshitsune from the ghost of the warrior Tomomori. *c.* 1790s. (K. 11028) AFGA, Carlotta Mabury Collection, 1964.141.859.

62. Utagawa KUNIYOSHI. Benkei prays to protect his master from the ghosts of warriors. 1853. From a series of episodes from the life of Yoshitsune. (K. 11003) AFGA, 1963.30.5517.

63. Utagawa KUNISADA. A group of actors posing as tattooed ruffians threaten a priest; a parody of the storm at Dannoura. 1860. (K. 11778.1) AFGA purchase, 1987.1.103.

107. Utagawa KUNIYOSHI. The outlaw Kidōmaru. "Ox," from a series of twelve male heroes matched with the animals of the Japanese zodiac. Mid-1830s. (K. 10971) AFGA, 1963.30.1787.

108. Katsukawa SHUNSHŌ. Treasure ship with the seven gods of good fortune. Mid-1770s. (K. 11930) AFGA, 1963.30.5688.

109. Okumura MASANOBU. Shōki, a hero of Chinese folk legend. 1740s. (K. 11787) AFGA, DeYoung Museum transfer, 1964.141.1097.

110. Utagawa KUNIYOSHI. The actor Nakamura Utaemon IV as Bodhidharma. c. 1850. (K. 11017) AFGA, Carlotta Mabury Collection, 1964.141.849.

111. Katsushika HOKUITSU. The god Ōkuninushi slaying a wild eagle. 1824. (K. 11561) AFGA, San Francisco Art Institute long-term loan, L35.1967.

112. Utagawa KUNIYOSHI. The actor Ichimura Uzaemon XII as Inabanosuke and the ghost of his dead lover. c. 1850. (K. 11016) AFGA, 1963.30.1784.

113. Konishi HIROSADA. The Osaka actor Arashi Rikaku II as Osome and Hisamatsu. 1849. Donald Dame Collection.

114. Tsukioka YOSHITOSHI. Prince Ousu dressed as a woman. 1886. "Barbarian's Moon," from the series *One Hundred Aspects of the Moon*. (K. 11474) AFGA purchase, 1982.1.30.

115. Katsukawa SHUNSHŌ. The actors Nakamura Nakazō I and Iwai Hanshirō IV as a priest and a dancer. c. 1770. (K. 11210) AFGA purchase, 1967.22.16.

116. Katsukawa SHUNKŌ. The actor Ichikawa Danzō IV performing a lion dance. 1770s. (K. 11200) AFGA, DeYoung Museum transfer, 1964.141.28.

117. Ippitsusai BUNCHŌ. Members of the audience imitate a graceful gesture by the visiting Osaka actor Arashi Hinaji. c. 1770. (K. 10005) AFGA, gift of Mary Wattis Brown, 1964.141.570.

118. Katsukawa SHUNSHŌ. The courtier Ariwara no Narihira eloping with a lover. 1770s. From an untitled series of illustrations of episodes from the *Tales of Ise*. (K. 11231) AFGA, Carlotta Mabury Collection, 1964.141.887.

119. Okumura TOSHINOBU. The actor Ichikawa Danjūrō II looks down at a pair of lovers. 1720s. (K. 11257) AFGA, Carlotta Mabury Collection, 1964.141.1013.

120. Kitagawa UTAMARO. The oil merchant's daughter, Osome, and her young lover, Hisamatsu. 1790s. From the series *The Essence of the Heart of Love*. (K. 11387) AFGA, Carlotta Mabury Collection, 1964.141.1033.

121. Utagawa TOYOKUNI. A youth lifts a young woman up to the branch of a flowering tree. c. 1800. (K. 11350) AFGA, Carlotta Mabury Collection, 1964.141.984.

122. Suzuki HARUNOBU. Osen playing with a cat held by a visitor to her teashop. Late 1760s. (K. 10083) AFGA, Katherine Ball Collection, 1964.141.593.

123. Mizuno TOSHIKATA. A young couple seated on a porch in the moonlight. c. 1900. (K. 11252) AFGA, 1963.30.5602.

124. Utagawa HIROSHIGE. Aggressive women urging travelers to stay at their inn in Goyū. Mid-1830s. From the series *Fifty-three Stations of the Tōkaidō Road*. (K. 10136) AFGA, 1963.30.5189.

125. Utagawa HIROSHIGE. Cherry trees on the main street of the Yoshiwara brothel district. Mid-1830s. From the series *Famous Sites in the Eastern Capital*. (K. 10369) AFGA, gift of Mary Wattis Brown, 1964.141.623.

126. Eishōsai CHŌKI. Dwarf men competing for the attention of a young man in the brothel district. Early 1790s. Portland Art Museum.

127. Kitagawa TSUKIMARO. The courtesan Takao entertaining the actors Sawamura Gennosuke and Iwai Kiyotarō. c. 1805. (K. 11798) AFGA, 1963.30.5648.

128. Hasegawa MITSUNOBU. A townsman and a courtesan seated beside a picture alcove. *c.* 1740s. From an untitled series. (K. 11030) AFGA, gift of Mrs. G. H. Martin, 1964.141.860.

129. Attributed to Sugimura JIHEI. Couple making love. *c.* 1680s. From an untitled series of erotic prints. (K. 11492) AFGA purchase, 1970.25.41.

129. Attributed to Sugimura JIHEI. Couple making love. *c.* 1680s. From an untitled series of erotic prints. (K. 11492) AFGA purchase, 1970.25.41.

130. Kitagawa UTAMARO. Young man making sexual advances to a courtesan. *c.* 1800. From an untitled series of erotic prints. (K. 11497.1) AFGA, Katherine Ball Collection, 1964.141.927.

131. Attributed to Torii KIYONAGA. A mature man preparing to make love to a young girl. 1780s. From an untitled series of twelve erotic prints. (K. 11761.1) AFGA, 1963.30.5658.

132. Katsushika HOKUSAI. A household maid mocks a would-be lover. 1805–15. From the series *One Hundred Elegant Examples of Comic Verse.* (K. 10556) AFGA, San Francisco Art Institute long-term loan, L16.1967.

133. UNIDENTIFIED EDO ARTIST. A woman throws her lover to the ground during intercourse. Late 1810s. From the series *Acrobatic Spring Amusements.* (K. 11505) AFGA purchase, 1983.1.89.5.

134. Katsushika HOKUSAI. Couple making love. 1810s. From a series of twelve erotic prints. (K. 11500) AFGA purchase, 1969.32.22.

135. Utagawa KUNISADA. Actors as the ghost of the monk Seigen, his lover Sakura Hime, and the servant Yodohei. 1850–52. From an untitled series of scenes from Kabuki plays. (K. 10774) AFGA, 1963.30.5360.

136. Katsukawa SHUN'EI. The actor Ichikawa Komazō III as the obsessed monk Seigen. 1791. (K. 11086) AFGA, Carlotta Mabury Collection, 1964.141.35.

137. Utagawa KUNISADA. The actor Onoe Kikugorō III as the ghost of the obsessed monk Seigen. 1852. Illustration for a verse by Ariwara no Narihira from a series of portraits of actors matched with thirty-six classical poets. (K. 10728.1) AFGA purchase, 1987.1.102.

138. Utagawa TOYOKUNI. The actors Nakayama Tomisaburō and Onoe Matsusuke I as Denbei's wife, Oyae, and Kaji no Ochō. 1800. From an untitled series of portraits of pairs of actors. (K. 11295) AFGA, gift of Mary Wattis Brown, 1964.141.999.

139. Utagawa KUNISADA. The actor Onoe Kikugorō III as the wet nurse Masaoka. 1860. From an untitled series of bust portraits of celebrated actors. (K. 10747) AFGA, 1963.30.5489.

140. Utagawa KUNIYOSHI. Takematsu rows a group of revelers toward Ryōgoku Bridge. *c.* 1850. (K. 10963) AFGA purchase, 1984.1.91.

141. Utagawa HIROSHIGE. Men traveling by torchlight near Hakone. *c.* 1850. From *Fifty-three Stations of the Tōkaidō Road.* (K. 10164) AFGA, DeYoung Museum transfer, 1964.141.679.

142. Utagawa HIROSHIGE. A distant view of Mount Ōyama from the rice fields of Ono, in Hōki Province. 1853. From the series *Pictures of Famous Places in the Sixty-odd Provinces.* (K. 10285) AFGA, gift of Mary Wattis Brown, 1964.141.651.

143. Katsushika HOKUSAI. A long-legged man and long-armed man. Early 1830s. From an untitled series of panel pictures. (K. 10558) AFGA, gift of Osgood Hooker, 1959.124.23.

144. Utagawa KUNISADA and Utagawa HIROSHIGE. "A Snowy Prospect." 1853. From the series *A Modern Prince Genji.* (K. 11753) AFGA, DeYoung Museum transfer, 1964.141.1091.

145. Utagawa KUNISADA and Utagawa HIROSHIGE. "The Night Garden." 1853. From the series *A Modern Prince Genji.* (K. 11828) AFGA, DeYoung Museum transfer, 1964.141.1173.

146. Utagawa HIROSHIGE II. A Dutchman, an Englishman, and an American woman. 1860. (K. 10438) AFGA, gift of Mr. and Mrs. R. E. Lewis in memory of Lewis MacRitchie, 1972.6.6.

147. Katsushika HOKUSAI. Guan Yu, Liu Bei, and Zhang Fei, three Chinese heroes who swore eternal friendship. 1820. (K. 11564) AFGA, Carlotta Mabury Collection, 1964.141.759.

148. Utagawa TOYOKUNI. The actors Seki Sanjurō II and Bandō Mitsugorō III as Sen'emon and Heiemon. 1810s. (K. 11341) AFGA, 1963.30.5665.

149. Utagawa KUNISADA. The actors Kawarazaki Gonjūrō and Ichikawa Ichizō III as Rough Beach Kōji and Wild Lion Denzō. 1861. (K. 10760) AFGA, Carlotta Mabury Collection, 1964.141.1225.

150. Utagawa KUNISADA and Utagawa HIROSHIGE II. The actors Ichikawa Danjūrō VIII and Nakamura Tsuruzō as Scarface Yosaburō and "Bat" Yasu. 1863. "Ryōgoku Bridge," from a series of famous places, products, and actors of Edo. (K. 10910 and 10858) AFGA, 1963.30.5449 and 1963.30.5397.

151. Utagawa HIROSHIGE. Crowds of workmen and travelers at Nihon Bridge. Mid-1830s. From the series *Fifty-three Stations of the Tōkaidō Road.* (K. 10095) AFGA, 1963.30.5155.

152. Katsukawa SHUNZAN. Ebisu oversees a work force of rats storing bales of rice in warehouses. Late 1790s. (K. 11240) AFGA, Carlotta Mabury Collection, 1964.141.881.

153. Utagawa YOSHIKAZU. *Cooking in a Foreign Mansion.* 1860. From an untitled series of pictures of foreigners. (K. 11449) AFGA, 1963.30.5629.

154. Katsushika HOKUSAI. Workman repairing the tile roof of Hongan Temple. Early 1830s. From the series *Thirty-six Views of Mount Fuji.* (K. 10527) AFGA, Carlotta Mabury Collection, 1964.141.729.

155. Utagawa TOYOKUNI. The actors Onoe Matsusuke I and Onoe Eisaburō as Daibutsubōzu Mibu and Issun Denbei. 1805–10. (K. 11721) AFGA, DeYoung Museum transfer, 1964.141.1085.

156. Katsushika HOKUSAI. A family producing lumber in the Tōtomi Mountains. Early 1830s. From the series *Thirty-six Views of Mount Fuji.* (K. 10535) AFGA, Carlotta Mabury Collection, 1964.141.746.

157. Utagawa HIROKAGE. Workman falling into a plaster tub at Onmayagashi. 1860. From the series *Humorous Views of Famous Sites in Edo.* (K. 10088.2) AFGA, gift of Dr. Francis J. Rigney, Jr., 1986.1.4.

158. Utagawa YOSHITORA. Acrobats from central India performing at Yokohama. 1864. (K. 11453.1) AFGA, 1986.1.207.

159. Baidō KOKUNIMASA. *Japan Red Society Hospital Treating the Wounded in the Russo-Japanese War.* 1904. (K. 11862) AFGA, 1963.30.5716.

160. Katsushika HOKUSAI. A fisherman and his son on a promontory at Kajikazawa. Early 1830s. From the series *Thirty-six Views of Mount Fuji.* (K. 10530) AFGA, gift of Osgood Hooker, 1959.124.21.

161. Utagawa KUNISADA. The actor Ichikawa Kyūzō II as a fisherman trying to catch a catfish with a gourd. Mid-1830s. From a series of eight prints. (K. 10687) AFGA, Carlotta Mabury Collection, 1964.141.51.

162. Katsushika HOKUSAI. Ships transporting fish along the coast of Kanagawa. Early 1830s. From the series *Thirty-six Views of Mount Fuji.* (K. 10520) AFGA purchase, 1969.32.6.

163. Utagawa HIROSHIGE. A peasant family at Miyanokoshi. Mid-1830s. From the series *Sixty-nine Stations of the Kiso Road.* (K. 10267) AFGA, Carlotta Mabury Collection, 1964.141.673.

164. Utagawa KUNISADA. A self-portrait of the artist Kunisada before a wall painting of a phoenix. 1865. From a series depicting the four creative arts with Prince Genji. (K. 11780) AFGA purchase, 1981.1.59.

165. Utagawa KUNIYOSHI. A self-portrait of the artist Kuniyoshi surrounded by figures from his sketches. *c.* 1850. (K. 11785) AFGA, DeYoung Museum transfer, 1964.141.44.

166. Utagawa KUNISADA. The actor Ichikawa Danjūrō VIII as Ashikaga Jirō Kanja. *c.* 1850. (K. 10723) AFGA, 1963.30.5469.

167. Utagawa KUNISADA. Memorial portrait of the artist Utagawa Hiroshige. 1858. (K. 10681) AFGA, gift of Mary Wattis Brown, 1964.141.828.

168. Yashima GAKUTEI. Hakamadare Yasusuke stealthily approaches the courtier Hirai Yasumasa. Mid-1820s. From an untitled series of scenes from classical literature. (K. 11542) AFGA, 1963.30.5556.

169. School of Tsukioka YOSHITO-SHI. The bandit Hakamadare Yasusuke prepares to kill the courtier Hirai Yasumasa. Mid-1880s. From the series *Good and Evil, Two Sides of the Same Scabbard.* (K. 11690.12) AFGA purchase, 1987.1.23.

170. Tsukioka YOSHITOSHI. The bandit Hakamadare Yasusuke stalks Hirai Yasumasa on the autumn moor. 1868. "Autumn Moon," from the series *Eight Views of Warriors from Noble Tales.* (K. 11805.1) AFGA, gift of the Graphic Arts Council, 1986.1.28.

171. Tsukioka YOSHITOSHI. "Fujiwara no Yasumasa Playing the Flute by Moonlight," *A Painting in the Exhibition for the Advancement of Pictorial Art in the Autumn of 1882.* 1883. (K. 11805) AFGA purchase, 1982.1.32.

172. Kobayashi KIYOSHIKA. The journalist Fukuchi Gen'ichirō taking notes on the battlefield. 1885. From the series *Foundations of Morality and Success.* (K. 10598) AFGA, 1963.30.5310.

173. Utagawa KUNISADA. The poet Kikaku leaves Mimeguri Shrine after his verse breaks a long drought. Early 1830s. (K. 10676) AFGA, Carlotta Mabury Collection, 1964.141.830.

174. Utagawa KUNISADA. Backstage view of the actors' dressing rooms at the newly rebuilt Ichimura Theater. 1856. (K. 11778) AFGA purchase, 1971.29.5.

175. Shunkōsai HOKUEI. The Osaka actor Arashi Rikan II as Soma Tarō. 1832. (K. 10452.2) AFGA purchase, 1988.1.49.

176. Shunkōsai HOKUEI. The actor Arashi Rikan II as Danshichi Kurōbei. 1832. (K. 10452.1) AFGA purchase and gift of Martha and William Steen, 1988.1.2.

177. Attributed to Utagawa TOYO-HARU. A perspective rendering of the night attack of the forty-seven loyal samurai. 1770s. (K. 11795) AFGA, DeYoung Museum transfer, 1964.141.1098.

178. Tsukioka YOSHITOSHI. *Lin Chū Kills Officer Lu by the Temple of the Mountain Spirit.* 1887. (K. 11810) AFGA purchase, anon. gift, 1983.1.64.

179. Shunkōsai HOKUSHŪ. The actor Nakamura Utaemon III as the farmer Gosaku. 1830. (K. 10590) AFGA purchase, 1978.1.10.

180. Attributed to Katsukawa SHUN-SHŌ. The actor Ichikawa Danjūrō IV as Sugawara no Michizane. 1775. (K. 11215) AFGA, Carlotta Mabury Collection, 1964.141.886.

181. Utagawa YOSHITSUYA. *Yorimitsu Breaks Hakamadare's Magical Spell and Captures Him.* 1858. (K. 11812) AFGA, DeYoung Museum transfer, 1964.141.34.

182. Keisai EISEN. "A Cool Summer Evening at Ryōgoku Bridge." 1830s. From the series *Famous Sites in Edo.* (K. 11818) AFGA, DeYoung Museum transfer, 1964.141.1146.

183. Gigadō ASHIYUKI. Ten actors in a snowfall on Tenjin Bridge in Osaka. 1825. (K. 11814) AFGA, DeYoung Museum transfer, 1964.141.1142.

184. Utagawa KUNISADA and Utagawa HIROSHIGE. "The Plum Orchard." 1853. From the series *A Modern Prince Genji.* (K. 11827) AFGA, DeYoung Museum transfer, 1964.141.1178.

185. Kohishi HIROSADA. The Osaka actors Ichikawa Shikō and Kataoka Gadō II. *c.* 1850. "Moon over the River," from the series *Snow, Moon, and Flowers.* Donald Dame Collection.

186. Utagawa TOYOHARU. *A Perspective Picture of the Seven Gods of Good Fortune Relaxing Together.* 1770s. (K. 11258) AFGA, Carlotta Mabury Collection, 1964.141.1015.

187. Keisai EISEN. The seven gods of good fortune in a weight-lifting competition. 1810s or 1820s. (K. 11582) AFGA, Katherine Ball Collection, 1964.141.936.

188. Utagawa HIROSHIGE. "The Plum Grove at Kameido." Mid-1830s. From *Famous Sites in the Eastern Capital.* (K. 10367) AFGA, gift of Mary Wattis Brown, 1964.141.614.

189. Utagawa HIROSHIGE. "Bridge Railing with a Metal Ornament." 1830s. From the series *Impromptu Shadows.* (K. 10421) AFGA, 1963.30.5025.

190. Utagawa TOYOKUNI. The actor Sawamura Gennosuke studying an illuminated paper model. 1810s. "Seventh Month," from the series *Five Seasonal Festivals with Elegant Actors Off Stage.* (K. 11309) AFGA, San Francisco Art Institute long-term loan, L46.1967.

xviii

191. Utagawa KUNISADA. An actor as the greengrocer Hanbei. 1854. "Darkness of the Mind," from the series *Darkness.* (K. 10734) AFGA, 1963.30.5356.

192. Utagawa KUNIYOSHI. *Strange and Wondrous Immortal Turtles.* *c.* 1850. (K. 11784) AFGA purchase, 1981.1.190.

193. Utagawa KUNISADA. The actor Ichikawa Danjūrō VII folding hand towels into miniature jackets. Late 1820s or early 1830s. (K. 11577) AFGA, 1963.30.5562.

194. UNIDENTIFIED EDO ARTIST. *Nutrition in a Looking Glass.* Mid-1850s. Medical School Library, University of California, San Francisco.

195. UNIDENTIFIED OSAKA ARTIST. *Life in a Modern Playgoer's Body.* Mid-1850s. Medical School Library, University of California, San Francisco.

196. UNIDENTIFIED OSAKA ARTIST. *Child's Play on the Body's Back.* Mid-1850s. Medical School Library, University of California, San Francisco.

197. Katsukawa SHUN'EN. The actor Ichikawa Hakuen as a pilgrim. Mid-1790s. (K. 11096.1) AFGA, California State Library long-term loan, L309.1966.

198. Utagawa KUNIYOSHI. Pilgrims purifying themselves in Rōben Falls. *c.* 1850. (K. 11784.1) AFGA, 1963.30.5827.

199. Utagawa HIROSHIGE. Pilgrims at a stream near Odai. Mid-1830s. From the series *Sixty-nine Stations of the Kiso Road.* (K. 10265) AFGA purchase, 1969.32.17.

200. UNIDENTIFIED SENDAI ARTIST. The Kelp Harvesting Ceremony in Hizen Province. *c.* 1800. (K. 11664) AFGA, Katherine Ball Collection, 1964.141.546.

201. Nishimura SHIGENAGA. Pilgrims pray at Mii Temple. 1720s. From an untitled series of eight views of places near Lake Biwa. (K. 11065) AFGA, 1963.30.5541.

202. Utagawa HIROSHIGE. Self-portrait of the artist as a servant of the god Bishamon. 1857. From the series *One Hundred Famous Views of Edo.* (K. 10308) AFGA, Carlotta Mabury Collection, 1964.141.712.

203. Utagawa KUNISADA. Two geisha watch a pilgrim throw name slips into the Sumida River. Mid-1840s. (K. 10938) AFGA, gift of the Heller family in memory of Ivan Heisler, 1978.1.80.

204. Utagawa TOYOKUNI. Sunrise at Susaki Benten Shrine. Late 1810s or early 1820s. (K. 11883) AFGA, Carlotta Mabury Collection, 1964.141.1217.

205. Tsukioka YOSHITOSHI. *Masakiyo's Difficult Battle, A Scene from the Taiheiki.* 1866. (K. 11805.2) AFGA purchase, 1987.1.33.

206. UNIDENTIFIED EDO ARTIST. Satō Tadanobu uses his *go* board to defend himself. Late 1780s. (K. 11669) AFGA, Carlotta Mabury Collection, 1964.141.511.

207. Toyohara KUNICHIKA. The actor Ichikawa Danjūrō IX as the wrathful spirit of Akugenta Yoshihira. 1896. (K. 11775) AFGA purchase, 1982.1.72.

208. Utagawa KUNIYOSHI. Rage and resentment turn the priest Raigō into a rat. 1830s. "Rat," from the series *Twelve Powerful Men Matched with Animals of the Zodiac.* (K. 10970) AFGA, 1963.30.1786.

209. Konishi HIROSADA. Nakamura Utaemon IV and Nakamura Tomozō as Danshichi Kurōbei and Giheiji. 1850. Donald Dame Collection.

210. Utagawa KUNISADA. Nakamura Utaemon IV as Danshichi Kurōbei. 1855. "Night Darkness," from the series *Darkness.* (K. 10739) AFGA, 1963.30.5348.

211. Tsukioka YOSHITOSHI. Sagara Tōtomi no Kami using a stack of tatami mats as a shield. 1868. From the series *One Hundred Aspects of Battle.* (K. 11464) AFGA purchase, 1981.1.87.

212. Toyohara KUNICHIKA. A Kabuki actor as Yamanaka Fujitarō. 1868. From the series *Good and Evil Demon Men.* (K. 10650) AFGA, 1963.30.1527.

213. Utagawa KUNISADA. The actor Nakamura Fukusuke II as Sugino Jūheiji Harufusa. 1864. From a series of portraits of the forty-seven loyal samurai. (K. 10754) AFGA, San Francisco Art Institute long-term loan, L26.1967.

214. Utagawa KUNIYOSHI. Oyamada Masatatsu. *c.* 1850. From the series *Biographies of Generals in Kai and Echigo Provinces.* (K. 10995) AFGA, 1963.30.1860.

215. Utagawa KUNIYOSHI. Honjō Shigenaga. *c.* 1850. From the series *Biographies of Generals in Kai and Echigo Provinces.* (K. 11000) AFGA, 1963.30.1863.

216. Utagawa KUNIYOSHI. Uno Samanosuke Takamasa. *c.* 1850. From the series *Biographies of Generals in Kai and Echigo Provinces.* (K. 10991) AFGA, 1963.30.1861.

217. Toyohara KUNICHIKA. The actor Ichikawa Danjūrō IX as Oyamada Takaharu. 1892. (K. 11774) AFGA purchase, 1982.1.73.

218. Uda TOSHIHIDE. A Japanese sailor leaps on board a Russian warship and kicks its captain overboard. 1904. (K. 11794) AFGA, 1963.30.5662.

219. Utagawa TOYOKUNI. The actors Nakamura Utaemon III and Bandō Mitsugorō III as Gokumon no Shōbei and Sengoku Chūemon. 1808–10. (K. 11336) AFGA, 1963.30.5667.

220. UNIDENTIFIED ŌTSU ARTIST. Daikoku and Fukurokuju facing each other in a wrestling ring. 1894. From a series of humorous subjects. (K. 11635) AFGA, Carlotta Mabury Collection, 1964.141.533.

221. Utagawa TOYOKUNI. The comic actors Kirishima Giemon and Nakamura Nakasuke as Sajibei and Jirōkichi. 1800–1805. (K. 11303) AFGA, 1963.30.5592.

222. Isoda KORYŪSAI. Man raping a housemaid beside his bathtub. 1770s. From an untitled set of erotic prints. (K. 11496) AFGA purchase, 1969.32.21.

223. Torii KIYOSHIGE. The actors Ichikawa Danjūrō II and Somekawa Kozōshi as a merchant trying to seduce a young girl. 1720s. (K. 10618) AFGA, Carlotta Mabury Collection, 1964.141.803.

224. Tōshūsai SHARAKU. The actor Sakata Hangorō II as Fujikawa Mizuemon. 1794. From an untitled series of twenty-eight half-length portraits of actors. (K. 11053) AFGA purchase, 1967.22.10.

225. Konishi HIROSADA. The actor Onoe Kikugorō III as Shirai Gonpachi. 1848. (K. 10094) AFGA purchase, 1981.1.80.

248. Toyohara KUNICHIKA. The actor Nakamura Sōjūrō as Sawamoto Hikoemon. 1878. (K. 11773) AFGA purchase, 1982.1.74.

249. Tsukioka YOSHITOSHI. Akechi Gidayū prepares himself for suicide. 1890. From *One Hundred Aspects of the Moon.* (K. 11477) AFGA purchase, 1982.1.16.

250. Tsukioka YOSHITOSHI. Danjō Matsunaga Hisahide shouts his defiance. 1883. From the series *Yoshitoshi's Warriors Trembling with Courage.* Los Angeles County Museum of Art.

251. UNIDENTIFIED EDO ARTIST. Female admirers weeping before a large painting of the actor Ichikawa Danjūrō VIII. 1856. (K. 11686) AFGA purchase, 1984.1.87.

252. Nishimura SHIGENAGA. The death of Gautama Buddha. 1720s. Honolulu Academy of Arts.

253. UNIDENTIFIED ARTIST. Posthumous portrait of the priest Kōbō Daishi. Eighteenth century. (K. 11995) AFGA purchase, 1970.25.9.

254. Attributed to Utagawa KUNIYOSHI. Memorial portrait of the Osaka actor Nakamura Utaemon IV as Taira no Kiyomori. 1852. (K. 11687) AFGA, Katherine Ball Collection, 1964.141.517.

255. Utagawa KUNISADA. Memorial portrait of the wrestler Hiodoshi Rikiya. 1839. (K. 10679) AFGA, Carlotta Mabury Collection, 1964.141.50.

This is a new kind of book written to address a new need. Many people want to know more about the experience of being a man. Many of us are also aware that something is seriously wrong with the way most men live today and are seeking wise alternatives.

This book presents some alternatives and suggests some new visions. It invites us to see in new ways: to understand our relation to art and artists in a new light. This volume takes up the single, infinitely reenacted journey of a man's life, rather than a more traditional historical perspective on Japanese art.

The pictures in this book are all woodblock prints, many of them reproduced here for the first time since their creation; all were designed by men. They reveal the way Japanese men saw themselves over a period of more than two centuries and show us a powerful way that men have found to share with other men their visions of a man's life journey.

The artists treat virtually every aspect of a man's life, some more extensively, some more extravagantly or more sympathetically than others, but almost every quality of a man's life, virtually every emotion and every transition or passage, is somehow reflected in the prints. To convey this panoramic view of men's lives, the pictures have been grouped by themes arranged in a sequence that roughly follows man's life cycle from infancy and childhood to maturity, old age, and death. The themes are listed in the table of contents.

The prints have fascinating tales to tell, yet their subjects are often unfamiliar to us, using a different cultural vocabulary and different pictorial conventions. It is easy to feel bewildered as we view them, as though we were listening to a foreign language. For this reason, I have provided some simple factual information about each of them in the captions.

At the same time, however, many of these Japanese pictures look so contemporary to our modern eyes that it is easy to forget they were made by men of another time with different values, goals, and cultural experience. In fact, when we look at these pictures we bring so many unconscious assumptions and habits of seeing with us that it is easy to misconstrue them.

We are not the only people who do this. The Japanese certainly did, and print artists in the eighteenth and nineteenth centuries created a new form of art to consciously address this unconscious set of habits. *Surimono,* as these prints were called, were pictures with poems. They were commissioned by private individuals, often the authors of the verses, to share with their friends at special times, such as the New Year.

The *surimono* artists were observant and intelligent. They noticed that whenever a person encountered a bold picture with delicate script, he (or she) always looked at the image and responded to it before reading the text. The artists also realized that words affected the way a picture was perceived. After people read the verses on the

surimono, they saw the pictures in a new light. A cute bunny, for example, looked quite different after the viewer read an adjacent verse about stewed rabbit. So, many artists deliberately designed images that viewers would see differently before and after they read the accompanying poems.

The short meditations that accompany the pictures in this book have been written in the *surimono* spirit. It is my hope that, after their texts are read, the pictures might look a little different—meaning more and regaining some of their original freshness. These reflections are written in different forms, from different points of view, and in different voices, both to reflect the diversity of Japanese culture and to evoke the multitude of voices that live side by side within each of us.

In these passages I have used the pronoun *we* in an effort to speak in a way that includes the common elements among people's varied life experiences. None of us will have experienced all that is described here, but all, I hope, will recognize much that is true to our own lives.

This book began when The Fine Arts Museums of San Francisco invited me to organize and catalog their collection of some three thousand Japanese woodblock prints in the Achenbach Foundation for Graphic Arts and to prepare a series of exhibitions using these prints.

The theme of a man's life appealed to me because the subject was so fresh and came to life so vividly through the prints in the collection. The subject also attracted me because of my personal involvement with men's issues. As I studied the prints, I saw more and more connections between the Japanese images of men and the challenges we men face today. I saw the book as an opportunity to share some of my discoveries with others.

I have presented as many images of each theme as possible, so each reader might evolve his or her own interpretations. Grouping pictures by subject allows pictures from different periods to appear side by side and highlights some interesting historical comparisons, but this book has been designed to emphasize the common ground we twentieth-century men share with Japanese men of the eighteenth and nineteenth centuries, the synchronous aspects of our experience.

The text that follows is the result of my own inquiries, course of discovery, and reflections. It is offered as an instance of possibility, as one person's response to one rich and varied form of art, and as an invitation to examine the pictures yourself and respond to them in your own particular way. The book is an opportunity to engage some images of the past directly.

Above all, I want to convey a sense that the drama, beauty, wisdom, and emotion you will encounter in the prints address present-day needs, as we continue our own personal journeys.

Introduction

In their own day, the Japanese prints in this volume were called *ukiyo-e,* pictures of the moment, the changing everyday world. People imagined this world as a tiny boat adrift on a vast sea or a broad river over whose flow the passengers in the boat had no control. Life in the floating world was a matter, first, of acceptance: acceptance of the calm and the storm, of the inevitability of change, like weather that no person could affect or coerce.

Out of this acceptance rose a reverence for the moment, a deep pleasure in whatever life presented to the self on its journey. The pleasure was poignant because each moment passed forever; the river kept flowing.

The pleasure was not limited to events or feelings that were intrinsically pleasant. Grief, sorrow and anger, even pain and death were treasured because they were part of the richness of human experience. Accepted, every moment gave each person a chance to live more fully and feel more deeply—to be more of a person.

Ukiyo-e provide a chronicle of this whole-hearted commitment to the present. They also show us the level of creative expression a people can achieve when they have become accepting enough of themselves and their neighbors to remain at peace for nearly three centuries.

As a popular art form, *ukiyo-e* inevitably reflected both the abiding realities and the slightest shifts in the country's cultural climate. From the mid-1600s (when the first monochrome prints were made) to 1859,

Japan effectively sealed itself from foreign influence, enjoying a rare isolation and domestic stability. The prints of the seventeenth and eighteenth centuries convey this sense of peace. The quality becomes more palpable, perhaps, in contrast to later prints that testify to the fracture and disintegration of a stable world with the eruption of civil war and the reopening of contact with the West in the second half of the nineteenth century.

The woodblock prints were published in the cities, principally Edo, then the largest city in the world. Visitors bought them avidly as gifts and souvenirs and carried them to the remotest corners of the country. Sold in publishers' shops and markets and peddled in the streets, they were available to anyone who wanted to buy them. Unlike many European art forms, *ukiyo-e* were the product of a vital system of give-and-take among three groups: the publisher-entrepreneur who financed production and hoped to make a profit; the commissioned artists and craftsmen who brought their experience and vision to the works; and the public, largely the urban merchant class and largely male, which responded to the offerings by greater or lesser demand.

This unique dynamic served to create a stasis of the form, as the public looked for certain standard subjects that the publisher was eager to supply, but it also created a momentum that carried the art forward into new dimensions as artists broached new subjects and styles and the audience responded. As a result, Japanese craftsmen

during the eighteenth and nineteenth centuries developed color printing from wood blocks to a level of skill and sophistication that has never been approached, much less equaled, anywhere else in the world.

Every picture reproduced here was printed from carved wooden blocks, because blocks could be printed over and over and the artists and their publishers wanted to give many people the opportunity to include the images in their lives. Every line in a print, no matter how thin, was cut, not simply drawn or painted. The long, sinuous contour of an actor's face, for example, was printed from a thin ridge on a block from which the rest of the wood had been painstakingly cut away. Each color was printed from a separate block as well.

The artists who signed these prints did not normally carve their own blocks, nor did they print them. The awesome craft of Japanese prints grew out of a strict division of labor. The artist-designers conceived the picture and either prepared a finished outline drawing or supervised its preparation by a student or a professional draftsman. The cutters transferred the drawing to wood and carved a complete set of outline and color blocks (at times as many as fifteen or more). The printers then mixed pigments to achieve the proper color balance and produced a fairly uniform edition of the final image. Practices varied from artist to artist, publisher to publisher, and period to period. A few rare designers like Kubo Shunman (1754–1820) cut and printed their own pictures, but commonly at least

three men coordinated their efforts, and frequently six or more men were involved in producing an edition of a print.

In fact, the success of Japanese prints depended on the level of cooperation and the degree of understanding among the members of these teams. The best designs of the greatest artists could be ruined by careless, unsympathetic cutting and sloppy printing. An amateur's sketch could become a masterpiece in the hands of brilliant craftsmen—which sometimes happened, because many amateurs did design prints. The Japanese have always believed that anyone can make art. It is not an activity reserved for professionals.

Japanese prints fulfill all the criteria of a great art. They combine physical beauty, technical virtuosity, and brilliant design with great originality, boundless vitality, and fascinating content. No wonder they have been universally admired since the middle of the nineteenth century when substantial numbers of them began to appear in the West.

But there is another quality in Japanese prints that gives them a further claim on our attention today, a quality that drew me to them to begin with and sustained my interest. I could not recognize this quality or name it for many years, perhaps because it was not a conscious part of my own tradition or experience.

I have spent over twenty-five years of my life working with Japanese prints, studying, lecturing, writing about them, but for a long time I kept them at a distance. I obviously

cared enough to devote so much time and effort, but when I asked myself why I found it difficult to answer. I had no clear understanding of what drew me to them.

I finally recognized that the prints touch me through my capacity to feel. They possess a power and depth that move me deeply. The value and sustenance I have gained from this work, which has drawn me on all these years, grew from the relationship that developed between myself and the absent makers of these works of art.

This was a surprising discovery. In our culture what we know through feeling is often dismissed by our intellect. When we do not completely understand what we are feeling, and often we do not, our thinking minds can discredit our experience. But I have learned that the head does not always have to understand the heart. The heart can have its own reasons.

Any time we engage anything other than ourselves and the outcome is creative, that is art. There is a transforming quality in art, in the engagement with something or someone other than ourselves, that allows us to be more than we were. And that is something that cannot be defined. When we engage a work of art, there is not a right answer, a correct understanding, or a proper way of looking at it.

As we proceed on our own journey through life, I think it is important for us to realize we are not limited to what we already know or to what is already familiar. There are other places to look, other dimensions of experience to which we have access. There is help and hope for us in other cultures and other times in human history.

The Absent Other

Many Confucian philosophers believe that the human goal is to become a sage and that human beings want to achieve wisdom. People cannot simply create wisdom but they can put themselves into a relationship with a wise person. No one in the present, however, can perform this function. No one a novice knows seems wise; everyone is struggling. These philosophers believe that sages of the past like Confucius can teach wisdom. And they believe that gaining wis-

dom is a process. I would like to describe this process in some detail, because it shows us a considered and effective way to engage the pictures that follow.

People seeking wisdom in this tradition embark on a program of study of the writings of great figures of the past. As they begin to read, however, they have to admit immediately that, in all honesty, they have only the faintest idea of what they are reading. They simply cannot understand such writing from their level of experience. What these people need to do then, the philosophers believe, is to go back to their ordinary daily lives, where they work and engage in simple activities with other people. Then the things that they have read will begin to make more sense. They find that there are things in their reading that can help with their lives, and when they go back to their studies they find that there is more they understand.

This is a lifelong process. By degrees people discover that they understand more and more. Finally they reach a point where their experience is broad enough that they understand the writings completely. Then they are wise themselves.

In this tradition, the examples of wisdom people learn to look to are not only writers like Confucius, but also painters and poets—any artist who has cultivated his (or her) own depth. What makes the work of poets and artists great is the depth of their wisdom and experience. By copying those works, by studying and truly seeing them, a person can learn something— not merely information, but something about the way the artists relate to life or to themselves. The process of going back and forth between experience and a picture or verse, of becoming willing to accept the limitations of ordinary understanding and to accept the wisdom of the absent other, makes it possible to integrate another person's experience with one's own.

When we are willing to stand in a relationship with someone whose experience is different from ours we begin to discover the depths and richness of our own experience. It is through this relationship that messages of hope and healing can come to us.

Japanese prints may be seen as guides for living. The imagery in the pictures, like the myths from which they were drawn, often deals with passages or transitions, situations in people's lives that virtually everyone in that culture or our own would recognize: abandonment, absent fathers, a young person's discovery of inner strengths, initiation, conflict, love, work, aging. Each of these themes is presented through stories and images that are distinctly Japanese, but the issues themselves are universal.

However, the artists did not simply represent archetypal situations. They actually engaged them, and they employed images that made it easier for other people to feel or to understand their engagement. What the artists knew, the viewers felt and understood.

When artists engage their deepest selves, their work speaks to the human condition. They provide guides for living—models. They tell us what we can be. So these prints serve very real, basic human needs.

There are stories in the first section of this book, for example, about the heroic quest. The son of an absent father must still become an adult. Without a male model, he must find hidden resources within himself. He journeys simultaneously out into the world and into the depth of his self. The artists who present these stories are never detached, they never analyze or explain their images. What they present is a dramatic event happening in an eternal present. This is how myth functions and how archetypes live.

Years later, these archetypes are still active. When we take these pictures with their myths and experience them in relation to our own lives, we can feel their empowering, clarifying, and guiding qualities.

Although many of these artists were celebrated in their own time for the originality they brought to traditional themes, that freshness sprang in fact from the degree of connection they achieved between themselves and their own experience. That bond allowed them to take a thoroughly conventional subject and turn it into something that resonated with other people's experience. Myth has to be renewed if it is to function as a mirror of inner life; the story alone is inert. It is in the retelling that the tale comes alive again and becomes important or empowering.

This aspect of the prints was underscored for the Japanese audience because the other form of popular culture in this period was the theater, which functioned in very much the same way. The kabuki theater and the prints were intimately connected, as examples in this volume show. The resonant link was that the prints and the theater both presented mythic situations in a compelling and aesthetic way. Both addressed the deepest levels of being. They connected the accidental, repetitious, mundane experiences of daily life, the human need to get through each day, with the deepest dimensions of human existence: the buried life of the child and the spiritual yearning of the adult.

Japanese artists could provide guides for living because they were deeply intuitive. They understood others' unspoken spiritual and emotional needs because they felt the same longings themselves. They created images that were congruent with their own deepest experience, and when they did, other people responded. Artists were not popular just because their work was considered more decorative, attractive, or original than anyone else's. The resonance between the work and the experience let each viewer think, "Yes, he's telling my story." Or "He's giving me something I need." In times of turmoil like the middle of the nineteenth century, when many pictures in this book were made, certain artists were popular because they could devour the full variety of new experience and remain coherent instead of being fragmented and confused. An entire tradition of exuberance in the Japanese print was based on artists' capacity to welcome change, to absorb and integrate unfamiliar experience, to keep moving without being overwhelmed by the new.

Other artists responded to confusion by creating images of calmness. The serene tradition arose from the artists' response to silence, their acceptance of themselves and circumstances, their ability to stay still without feeling frightened. This tradition shows us people who somehow managed to maintain their inner poise when they reached the disoriented, turbulent sections of life that we each have to face.

Naturally, the prints, like the experiences they addressed, changed over time. The change was continuous, although it was neither steady nor regular. Japanese prints of

the early eighteenth century have a very different content, feeling, and style from prints of the late nineteenth century, as you will see. On the whole there is a quietness and a simplicity about eighteenth-century prints that is very different from the extravagance and complexity of many prints of the nineteenth century. The intense emotion of the late nineteenth-century prints is nearly absent in the earlier pictures.

Fulfillment

When do we experience satisfaction? What would we need in our society, our world, our relationships to anchor our lives in fulfillment? This is a quality of life that shines out at us like a beacon from Japanese prints of the eighteenth century. It was a peaceful era; Japan had been closed to the West for over a century. The countryside was calm; the cities prospered. Neighbors did quarrel and droughts occurred, but war had become a distant memory. Did these conditions create the contentment we can feel for ourselves as we look at the prints? Did men know what they had achieved? Or was this quality unnoticed, something like air or water that they simply took for granted?

What is clear to me is that many prints of the eighteenth century are radiant. An artist cannot draw light without seeing it; he cannot convey warmth without feeling it. What we feel when we look at their pictures, these men lived. They embodied their vision.

How many people do we know today whose lives are fulfilled, who are contented and at peace with themselves? It is easy to think that disappointment, frustration, and anger are natural and that isolation, pain, insecurity, and discontent are the inevitable outcomes of being male in a patriarchal culture. But eighteenth-century Japan was a patriarchy. What was different? The prints give a different sense of being male, which we can draw on today.

I believe that the qualities we feel in these pictures express the deepest values of their makers. And I know that the qualities we value most highly and respond to most deeply can enter our own lives through our engagement with the art they made. When we look at a work and feel the serenity it embodies, we make that serenity part of

us. Whether or not that quality is currently present in our lives, we have access to it through the ancient memories of love, serenity, or unconditional acceptance in our own past. The sleeping child in each of us remembers those experiences. The adult that we have become can reclaim lost or forgotten parts of ourselves through contact with a person who embodies the qualities we seek. Art can give us this contact. This volume contains works that embody important human qualities we can consciously draw on today.

The Transformation of Feeling

The prints in this book also tell another story about the unfolding of a collective consciousness. Artists in the eighteenth century were witnesses to an abiding possibility of human life, fulfillment. But they excluded important parts of their own reality and engaged in a massive denial: the denial of oppression, injustice, and unacceptable behavior and feelings. Perhaps the experience of fulfillment gave them the strength and courage to face their hidden inner life. Perhaps more joy allowed more truth. Perhaps honesty grew out of satisfaction, and self-acceptance from contentment.

As time passed, the Japanese artists addressed more and more areas of human life. They struggled to deal with the treachery and cruel abuse at the heart of patriarchy. The greatest artists broke their denial and came to terms with their own most frightening and unacceptable feelings.

How did the Japanese artists deal with the angry violence, the turmoil, and the abuse of power they began to see? As their peaceful society broke in the latter half of the nineteenth century, how did they engage the very issues that we are struggling to resolve today?

In our own culture, for example, we are confused about power. The term preoccupies us, but we do not know what it is. Part of us identifies power with force, strength, and domination. In an adversarial situation, we think the stronger person is the more powerful. But the visions of this book suggest that power has more to do with inner strength, inner depth, and inner richness; we see it in the affirmative presence of the men in these prints, such as Kunimasa's *Matsuomaru* (fig. 80) or Yoshi-

toshi's *Flute Player* (fig. 171). Domination and control express a wish or a need for power. But genuine power arises from a deep connection with one's true self and expresses itself through gentle influence rather than harsh domination.

Much art in our own culture either exalts feeling or denies it. Japanese prints show us the balance and serenity that can be achieved by a transforming acceptance of feelings. A brave, passionate artist like Tsukioka Yoshitoshi (1839–92) was sometimes overwhelmed by the intensity of his emotions. But he learned that he gained strength, clarity, and power when he surrendered and let himself feel his pain, grief, rage, and fear as well as his gentleness, generosity of spirit, and kindness. His pictures empowered others by letting them feel.

The Japanese artists recognized the length of the journey required to complete the transformation of feeling. There could be no healing as long as pain remained unrecognized. There could be no end to rage and fright as long as sorrow and grief remained submerged. As these artists conducted their heroic, uncertain journeys through art and life, they found a way to heal themselves and share what they had learned with others.

The paradox of men's lives today requires such a transformation. Unendurable feelings dominate our lives, but we are men and we try to deny them. Our society presents us with models for living that are supposed to spare us these uncomfortable, even unbearable, feelings. We are finding that these models do not work.

Rage and grief and the emotions that are connected with our personal past and present are the keys to our power. We need to feel them. Accepting them and ourselves opens the door to creativity, depth, and true strength.

We sometimes think that words are the primary documents of people's lives, but it is visions and images, untempered by words, unlimited by thought, undistorted by language, that give direct access through feeling to the inner reality of another's experience. When we are drawn to a picture we are choosing a vision, guided by an inner sense of what we need. By engaging ourselves with pictures like the ones in this book, we begin to learn what is possible for us. And by continually returning to the artists' experience in the light of our own, we gain an ever-deepening appreciation of their achievement.

In writing this book and dedicating it to fathers, sons, and the men of this generation, I wish to communicate a vision of hope and of healing to the world and, most important, to other men. We men need somehow to experience what our pain and grief and anger and suffering are and have been.

I feel the urgency of our present situation on this planet and the responsibility each of us bears toward its outcome. I have come to feel, as a man, that men have endangered life by projecting false values and the distortions of our childhoods onto the civilization that we have created. It is our denial of true feelings and our inability as men to deal with the forces we have created that have jeopardized the world. We are just learning this. We are just waking up, and we do not know how to face ourselves. We do not know how to endure our pain or control our anger. Something must change. We must.

We men are on a journey, seeking the truth of our own lives. We can no longer live lies of convenience. Life depends on our courage and honesty and on our willingness to know and feel our own truth.

Much of the hope I wish to share comes through my personal engagement and experience with art, particularly with Japanese prints. Something in the experience of art allows us to participate in the hard-earned wisdoms of other peoples. Art gives each of us today a means of healing and fulfillment.

Paper Formats

The hand-made papers used for Japanese prints were manufactured in four fairly standard molds. The finished sheet sizes were roughly as follows:

standard sheet	*c.* 15″ × 20″
smaller standard sheet	*c.* 12″/13″ × 18″
hōsho sheet (for official documents)	*c.* 16″ × 22″
large sheet	*c.* 15″ × 27½″

Nearly all Japanese prints, whether they were published commercially or privately, were printed on papers of standard formats that were regular fractions of the four sheets mentioned above. The measurements are approximate, because all the large sheets were trimmed and cut by hand. Formats are given here in preference to measurements because most Japanese prints lack margins and many were trimmed after publication. The present measurements often obscure the original format. The standard terms currently used in Japan to describe formats included in this volume are

ōban (large) format	*c.* 15″ × 10″	one-half standard sheet
aiban (intermediate) format	*c.* 12″/13″ × 9″	one-half smaller standard sheet
chūban (medium) format	*c.* 7½″ × 10″	one-half *ōban*
	c. 6″/6½″ × 9″	one-half *aiban*
	c. 8″ × 11″	one-quarter *hōsho* sheet
koban (small) format	*c.* 7½″ × 5″	one-quarter *ōban*
	c. 6″/6½″ × 4½″	one-quarter *aiban* or smaller fraction
hosoban (narrow) format	*c.* 12″/13″ × 6″	one-third *aiban*
nagaban (long) format	*c.* 18″ × 6″	one-half smaller standard sheet
panel print format (*chū-tanzaku*)	*c.* 15″ × 5″	one-half *ōban*
pillar print format (*hashira-e*)	*c.* 27½″ × 5″	one-third large sheet
hanging scroll format (*kakemono-e*)	*c.* 24″ × 12″	one and one-third smaller sheets, joined
large *surimono* format (private publication)	*c.* 8″ × 22″ or less	one-half *hōsho* sheet
square *surimono* format (private publication)	*c.* 8″ × 7½″	one-sixth *hōsho* sheet

The Male Journey in Japanese Prints

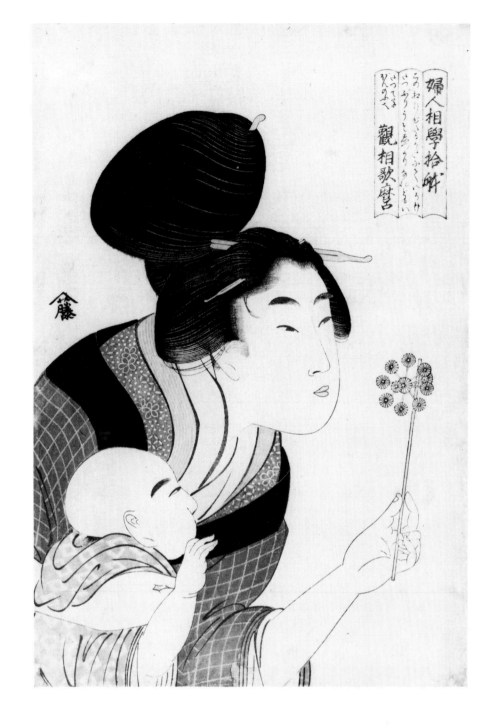

Fig. 1. Mother blowing a
pinwheel for her son.
c. 1805. From the series
*Ten Physiognomic Types of
Women*.
Kitagawa UTAMARO.
Ōban format. The artist,
as a student of charac-
ter, comments that this
type of woman is unre-
fined. She is openly sex-
ual and tells lies, but she
is extremely fond of
children.

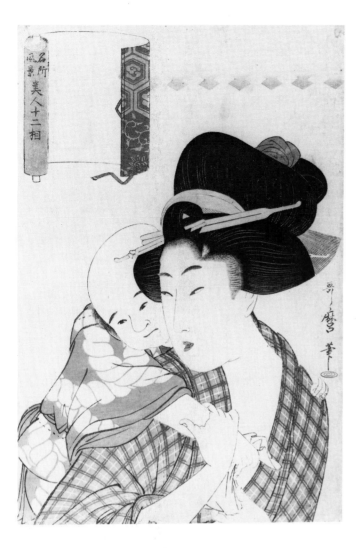

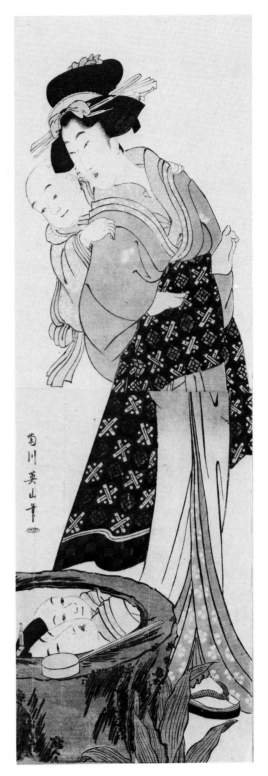

A Place in the World

No matter where we are born, each of us begins life in the same way. We crouch in the dark warm room of our mother's body. For nine months we share her food, her blood, her thoughts and feelings. We are part of her. She is our world. We are not separate. After we are born we still need this intimate contact, and much of our future happiness depends on how much we are held and cherished in our infancy. In patriarchal societies, the parent who holds and cherishes sons consistently is the mother.

In traditional Japan this bond between mother and son was especially deep. Grown men remembered it with affection, not embarrassment, and artists like Utamaro and his followers celebrated it over and over in their prints.

Fig. 2 (*left*). Boy climbing on his mother's back. *c.* 1805. From the series *Twelve Types of Beautiful Women Matched with Landscapes.* Kitagawa UTAMARO. *Ōban* format. On this impression the title and the description of the landscape have been removed from the handscroll.

Fig. 3 (*right*). Mother carrying her baby son on her back and looking into a cistern. *c.* 1810. Kikukawa EIZAN. Vertical *ōban* diptych. The wooden dipper on the edge of the cistern was used for rinsing one's hands.

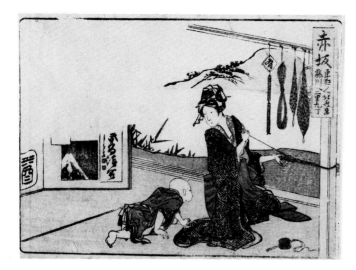

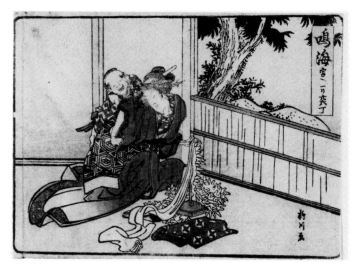

Mothers and Sons

Our mothers hold us with their bodies. They also hold us in their attention. As children we need to be held both ways: to be touched and cherished. Before we can speak we start asking for touch by interrupting mother's work, squirming, tagging along, or teasing. Each time we are held we remember that we are not separate.

The artists who drew these pictures were grown men who vividly remembered the comfort and excitement they felt in their mother's company. Most of the people who bought these prints were probably men, too, with similar memories.

4

Fig. 4 (above left). A baby boy crawls to his mother and interrupts her as she weaves a net bag, a handicraft of the town of Akasaka. 1804. From a series of views of the Tōkaidō Road. Katsushika HOKUSAI. *Koban* format.

Fig. 5 (above right). A baby boy tickles his mother and laughs as he interrupts her work; she is tying silk for dyeing, a handicraft of the area. 1810s. A new version of "Narumi," from a series of views of the Tōkaidō Road designed by Hokusai and originally published in 1804. Yanagawa SHIGENOBU. *Koban* format.

Fig. 6 (right). Two women dressing a baby boy like the Abbot Henjō, a celebrated poet of the ninth century. *c.* 1805. From the series *Modern Children as the Six Immortal Poets.* Kitagawa UTAMARO. *Ōban* format.

Fig. 7 (facing page). A boy steals a hand puppet from his mother and makes a face at her as she holds a color print of an actor out of his reach. 1807. "Autumn," from the series *Flowers for the Four Seasons.* Torii KIYOMINE. *Ōban* format.

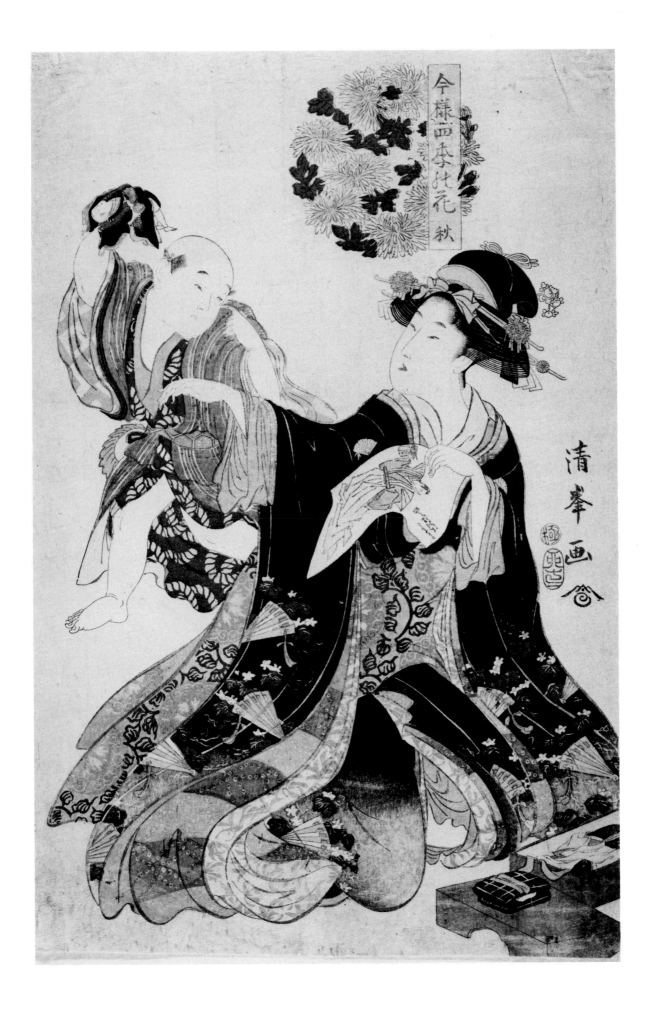

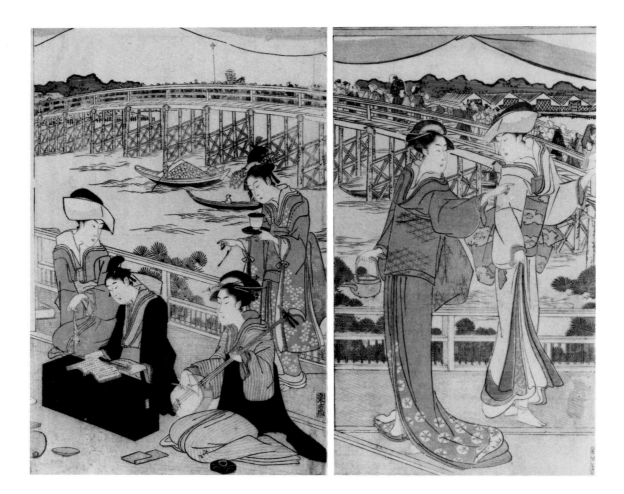

Each of us has a woman inside, because each of us was raised and nourished by a woman. When do we start learning that we should not act like a girl and that we should not be like a woman? Suppose we loved the woman in ourselves instead of fearing her or hating her? What do we hurt in ourselves, what do we lose, what do we gain when we deny the part of ourselves that feels and cares and receives and nourishes? How might we feel if we were gentler to ourselves and kinder?

Japanese men valued pleasure. From their infancy they found it in the company of women. As children, embraced by their mothers and her friends, they learned to be gentle and trusting; by example, they learned to be women. All the while, they knew they were boys who were going to be men. They were never told to choose. They never imagined that they had to deny or conceal or abandon what they loved as children in order to be men.

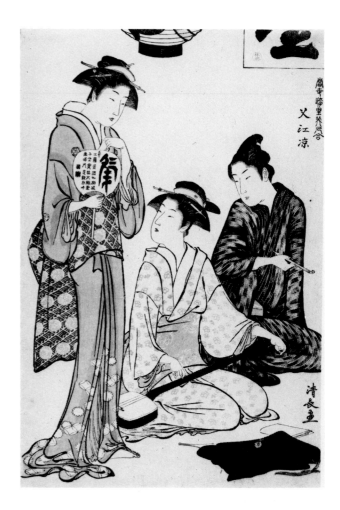

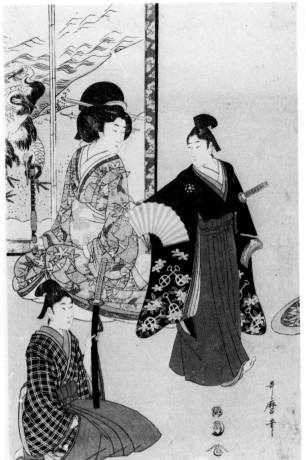

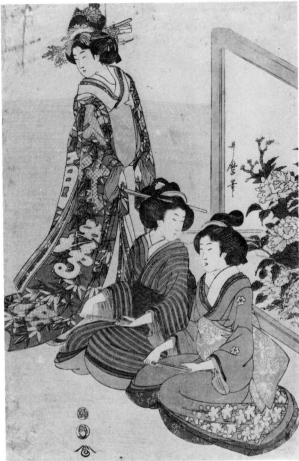

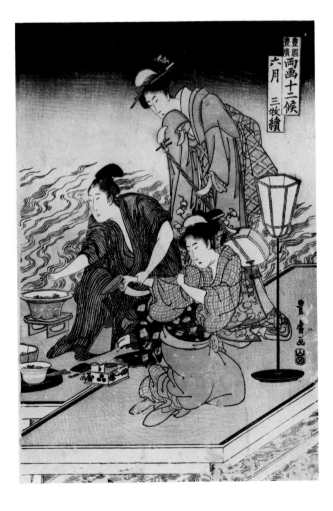

Fig. 8 (*above, facing page*). A young boy of the Tomimoto clan of chanters declaims a text to a roomful of women in a teahouse overlooking the Sumida River. *c.* 1795. Utagawa TOYOKUNI. Two panels of an *ōban* triptych.

Fig. 9 (*below, facing page*). A youth enjoying the company of two geisha at a riverside tea-house in Nakazu. 1783. From the series *Beautiful Women of Modern Plea-sure Quarters*. The youth is holding a pipe; one geisha is holding a fan inscribed with a Chinese verse; the other is tun-ing her musical instru-ment, a *samisen*. Torii KIYONAGA. *Ōban* format.

Fig. 10 (*above*). A boy from a wealthy family performing a formal dance in front of women from his household. The boy kneeling beside him may be a relative. *c.* 1800. Kitagawa UTAMARO. Two panels of an *ōban* triptych.

Fig. 11 (*below*). A youth forces a waitress to have another cup of wine at a summer party on raised platforms over a shallow river. *c.* 1800. "Sixth Month," from a series of Twelve Months designed together with Utagawa Toyokuni. Utagawa TOYOHIRO. Right panel of an *ōban* triptych.

Boys in Japanese prints are practically never alone. They look after each other, hold hands, show tenderness, clown, work, quarrel, fight, and play. They never compete, however, until the end of the nineteenth century, when the government made schooling compulsory and Western games and sports were introduced (see fig. 20).

The Paragons of Filial Devotion were Chinese, but they were a popular print subject in Japan in the late eighteenth and nineteenth centuries. In each of the stories a child takes responsibility and makes a personal sacrifice for his or her parents' happiness. Tai Shun's parents disagreed over child rearing, for example, so he left home to eliminate the cause of their constant arguments (see fig. 22).

Fig. 12 (above left, facing page). Two boys imitating street performers: a drummer and a lion dancer. *c.* 1810. Katsukawa SHUNSEN. *Ōban* format.

Fig. 13 (above right, facing page). A girl chides her younger brother as two boys discuss her behavior. 1770s. The picture alludes to the story of Min Sun, who endured abuse from his stepmother and even defended her behavior toward him in order to protect his stepbrothers. Number 5 from *Twenty-four Paragons of Filial Devotion Seen in the Midst of Children's Games.* Attributed to Ishikawa TOYOMASA. *Chūban.*

Fig. 14 (below, facing page). Two boys making faces in a lacquer door panel as their mother looks on. Mid-1790s. Utagawa TOYOKUNI. Right panel of an *ōban* diptych.

Fig. 15 (above). Young boy blowing a chrysanthemum flower. 1720s. The verse says the child is pretending that the flower is a pinwheel. UNIDENTIFIED EDO ARTIST. Hand-colored print in *hosoban* format.

Fig. 16 (below). Two boys play cat's cradle; their companion holds a marionette in one hand and a glass noisemaker in his mouth. Mid-1790s. Eishōsai CHŌKI. *Aiban* format.

9

Brothers can be comrades, playmates, and companions; they are also unwitting rivals for love and attention.

The rooftop battle is the dream of every pair of siblings, who must struggle in conflict before they can find the strength, depth, and unique beauty of their unchosen bond.

Fig. 17 (below). Actors as the brothers Inukai Kenpachi and Inuzuka Shino battling for a precious sword on the rooftop of Horyūkaku, a tower of Koga Castle. 1852. From an untitled series of scenes from popular plays. Utagawa KUNISADA. *Chūban* format.

Fig. 18 (right, this page). Kenpachi and Shino battle on the roof of Horyūkaku before discovering they are brothers. 1885. The picture was based on a design by Utagawa Kuniyoshi, Yoshitoshi's teacher. Tsukioka YOSHITOSHI. Vertical *ōban* diptych.

Fig. 19 (above left, facing page). Boys quarreling as their mothers gather fruit from a tree. 1805. Utagawa TOYOHIRO. Panel from an *ōban* triptych.

Fig. 20 (above right, facing page). Schoolboys competing on a school athletic day. *c.* 1890s. Inoue TANKEI. *Ōban* format. The boys and their teachers are dressed in Western-style clothing. Each picture is accompanied by the lyrics of a military anthem.

Fig. 21 (below, facing page). Children fighting over rice cakes thrown into the street by a shopkeeper at the New Year. *c.* 1710s. "First Month," from an untitled series of Twelve Months. Attributed to Ishikawa RYŪSEN. *Ōban* format.

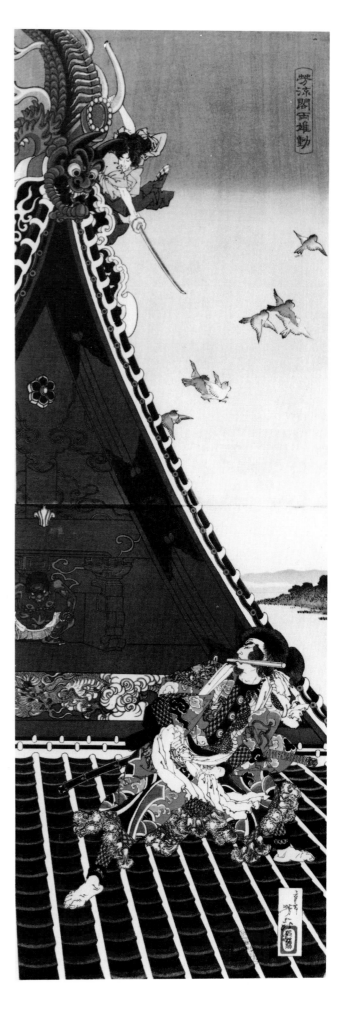

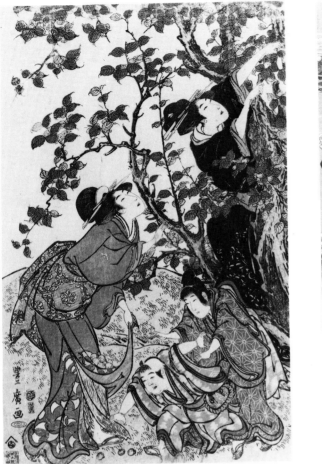

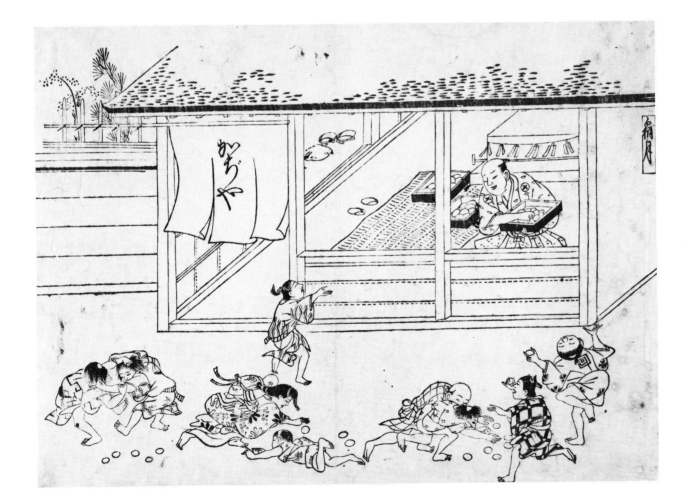

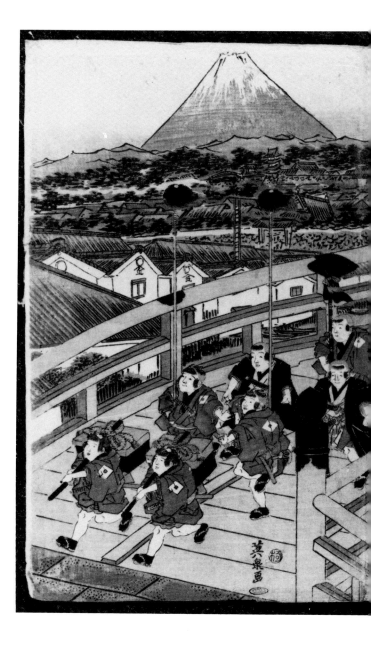

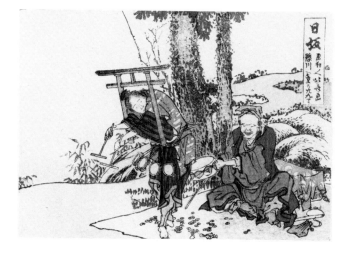

Boys at Work

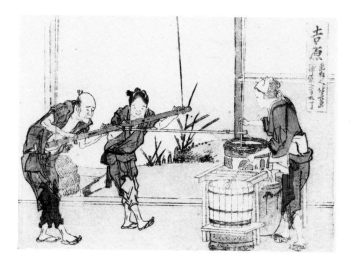

One way adults draw children into their world is by sharing work. Young Japanese children helped their mothers in everyday tasks. As they grew older they worked beside their parents in the family business; sometimes they were employed as performers. Many prints show children avidly engaged in adult occupations. Perhaps their playful zest reminded adults of the pleasure of working in a disciplined group when the everyday reality was more ambiguous.

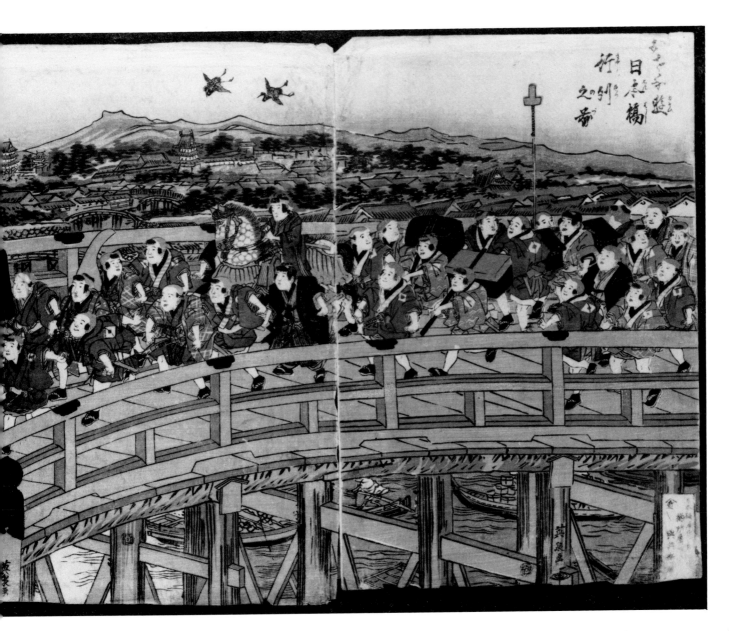

日本橋行列之番

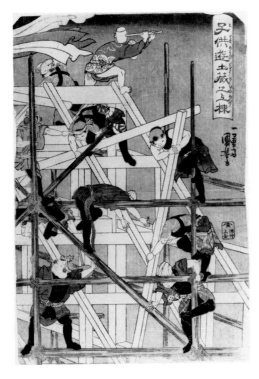

子供遊土蔵之立棟

Fig. 22 (*above, facing page*). After Tai Shun leaves his family to prevent his parents from quarreling over him, he opens new territory in Western China with the help of elephants. *c*. 1830. From the series *Twenty-four Paragons of Filial Devotion.* Ryūsai SHIGEHARU. *Ōban* format. The print was published in Osaka, and the verses at the right were composed by three Osaka poets, Rokugyōen, Hibian, and Matsuya Michiyo.

Fig. 23 (*center, facing page*). A youth at Nissaka performs a religious dance for travelers as an older man accompanies him. The object on his back is a miniature entrance gate to a Shinto shrine; the objects on the mat are coins tossed by spectators. 1804. From a series of views of the Tōkaidō Road. Katsushika HOKUSAI. *Koban* format.

Fig. 24 (*below, facing page*). A son helps his mother and father grind oil from seeds in a workroom at their home in the town of Yoshiwara. 1804. From a series of views of the Tōkaidō Road. Katsushika HOKUSAI. *Koban* format.

Fig. 25 (*above*). Boys dressed as samurai and servants imitate a daimyo's procession crossing Nihon Bridge, the starting point of the Tōkaidō Road in Edo. *c*. 1820. Keisai EISEN. *Ōban* triptych.

Fig. 26 (*below, this page*). Children as carpenters raising the roof for a storehouse. 1830s. Utagawa KUNIYOSHI. *Ōban* format; probably the right panel of a triptych.

Fig. 27 (left). Hotei, one of the seven gods of good fortune, tosses a Chinese boy into the air. Late 1760s. The treasure sack and the stiff fan are two of Hotei's emblems.
Suzuki HARUNOBU. Pillar print.

Fig. 28 (above right). The Osaka actor Nakamura Utaemon III as a renegade nobleman holding his infant son. The rough band of outlaws behind him are his followers. Early 1830s. Ryūsai SHIGEHARU. A privately published *ōban* print with a verse by the actor printed in silver.

Fathers and Sons

Where were our fathers? Do they appear at all in earliest memories? Do we remember their warmth and tenderness? Or do we remember more their stiffness and exuberance, seeing them, as the print artists did, as sturdy protectors and cheerful playmates?

Prints of fathers and sons are especially poignant because there are so few of them: one, perhaps, for every hundred pictures of sons with mothers. Did artists transpose their memories of their fathers into scenes from legend, theater, and myth because there were so few examples of intimacy between fathers and sons in real life? Among these pictures, the Chinese merchant from Nagasaki is the only real man playing with his son; the other pictures are probably based on memory, but they are clothed as fictions.

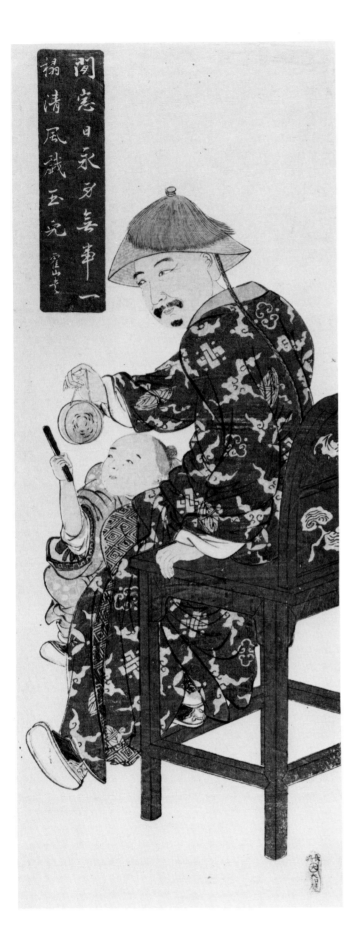

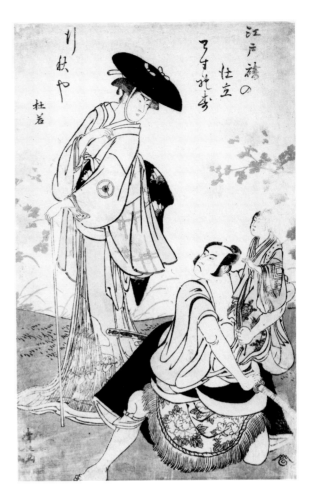

15

Fig. 29 (left). A Chinese boy strikes a gong his father holds out for him. *c.* 1840s. The Chinese couplet by Kakuzan says, "Sunlight eternal through the window of the room, body at ease. One sweep of pure breeze at play with the jade rabbit of the moon." UNIDENTIFIED NAGASAKI ARTIST. Large *hosoban* format.

Fig. 30 (above). A servant holds Kuzunoha's son as she departs on her journey and begins her transformation back into a fox. 1784. The fox had taken human form to thank the man who had saved its life; it bore him a son and lived with him until his real wife returned. Torii KIYONAGA. *Ōban* format.

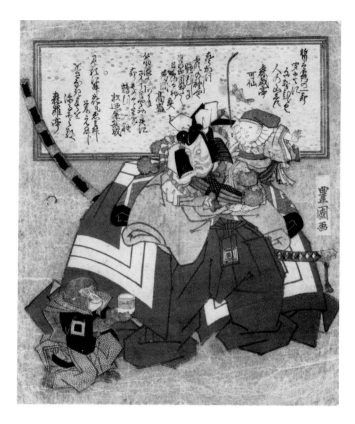

Ichikawa Danjūrō VII (1794–1859) was thirty-one when his first son was born. He was jubilant (fig. 31). Danjūrō worshiped the fierce Buddhist deity Fudō Myōō (fig. 53). He fervidly prayed for his son's success as an actor and then arduously trained him to guarantee that success: the boy was precocious; he began acting at three. By seven he obviously had a mind and acting style of his own (fig. 32). But this style had been painfully acquired, and Kunisada saw the tension between father and son, and the young actor's defiance. When the son was nine, Danjūrō exchanged names with him, an astonishing gesture of deference, particularly from an actor as talented, powerful, and popular as Danjūrō. In a formal proclamation to the audience, Danjūrō admitted that he and his son were different. "When a son differs from his father, we call him a 'demon child.' This demon child only

Fig. 31 (above). The actor Ichikawa Danjūrō VII dressed for a heroic role, holds his new-born son protectively and stares down at a monkey holding a porcelain incense burner. 1824. A white monkey was the Ichikawa clan's totem animal.
Utagawa TOYOKUNI.
This print was privately commissioned. The panel behind the actor contains poems by Shingitei Kasen, Yorozunoto Takamori, Matsunoya Sorenari, and Shinratei Manzō.

Fig. 32 (below). Ichikawa Ebizō VIII as Acorn, a child-priest, holding a secret scroll and striking a defiant pose. 1830. The man glowering down at him is his father, Danjūrō VII, who performed several roles in the same play. Utagawa KUNISADA. A square *surimono* commissioned by the poet Umenoya, whose verse appears at the left edge of the print.

Fig. 33 (facing page). Ichikawa Ebizō VII returns to Edo the year before his death to introduce his fifth son, Kawarazaki Gonjūrō, to the audience as his successor and to beg for their support. 1858. Utagawa KUNISADA. *Ōban* format. Verses by Kōi and Umenoya.

16

親子の掬ふ　　　　荒儀も好きの　　うしは
座身吸物　　掬乃鮭こくわ　梅屋　志まれ産振りや　かうい
　　　　　　　　　　　　　友料理

梓え好みやうせく
豊五國貞

17

lacks his father's vices, and I commend him to you in the hopes that your support will ensure his greatness."

When Danjūrō VIII was twenty, his father was exiled from Edo for defying the government's sumptuary laws during a period of austerity. In the next seven years the son's career blossomed. He won the hearts of his audience with his gentle, elegant demeanor (figs. 150, 166) and in his father's absence so impressed the government with his responsibility and filial devotion that it publicly awarded him a prize with a stipend. When his father was pardoned, Danjūrō VIII journeyed the length of the Tōkaidō Road to Osaka to meet him.

On another visit to Osaka four years later the young man committed suicide. His father had invited him to participate in a joint performance. Patrons organized a parade of boats to carry the two actors to the theater district, where they spent several days in rehearsals and official visits. The night before their performance, Danjūrō retired early. He mentioned pain and asked for a masseur. The next morning he was dead. He had disemboweled himself with a sword he had purchased from a pawnbroker the previous year.

The reasons for Danjūrō's death are still unknown. When the news reached Edo, the city poured its grief into verse, tears, memorial publications, and over three hundred posthumous portraits (fig. 250). We can only imagine the grief of the father who had cherished so much hope for his son. Danjūrō was thirty-one when he died, his father's age when he was born.

A baby boy identifies himself with the person or the people closest to him and present most often, who nurture him. This nurturing creates a bond. Fathers have work to do and other responsibilities. Raising the children, they think, is not their job. They grow distant and feel separate. And this is tragic, because the baby boy identifies with his mother, but the father sees himself in his son. He fills the upsetting distance between them with his hopes and expectations. Both father and son are afflicted, both are helpless, both are hurt when the father's expectations are untempered by an acceptance of the person the child is, when his hopes for his son are unrestrained by love.

Fig. 34. Ichikawa Ebizō VII supports his son Danjūrō VIII as he dies of a self-inflicted wound at their inn in Osaka on the eve of their first joint performance in several years. The innkeeper kneels before them, weeping. 1854. UNIDENTIFIED EDO ARTIST. Long horizontal format. The picture is a memorial portrait. The writing includes the actor's age, date of death, posthumous name, dying verse, and the name of the temple in Osaka where his death was registered. It also includes verses by Umenoya, a family friend, and Kagatoku, the innkeeper. The long text at the left describes the suicide and is overprinted with red as though the actor had fallen forward and stained it with his blood

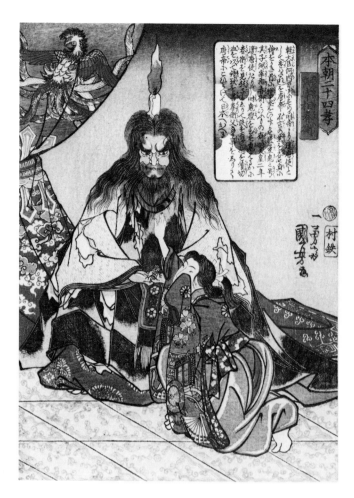

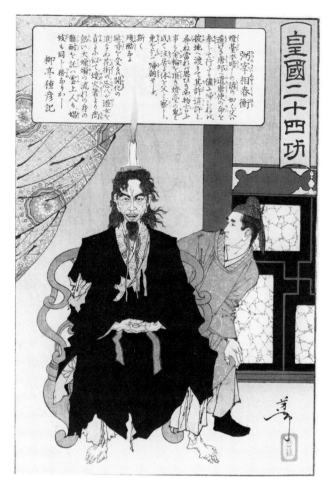

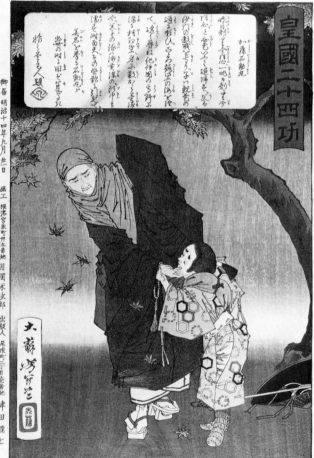

We yearn for our absent fathers, we search for them. Yet our need is not filled when we find them. It cannot be, because the self-centered or self-absorbed man we find as a youth or an adult is never the one we needed as a child. Our fathers are still prisoners. They do not see us. They continue to withhold, to present their own demands, to deny us.

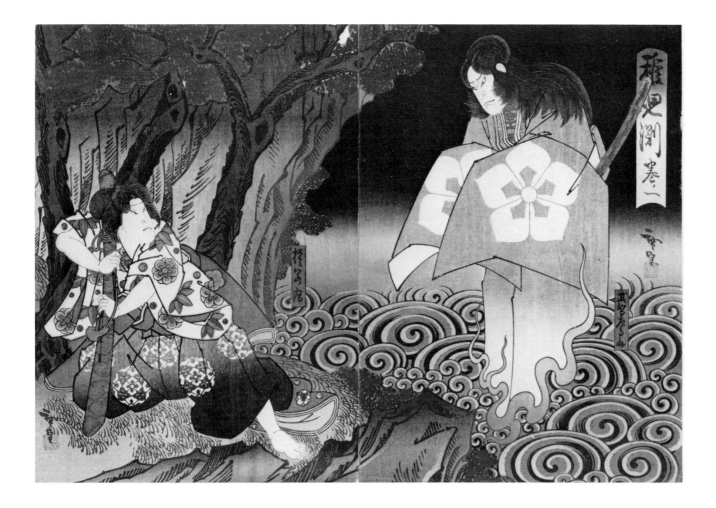

Fig. 35 (above left, facing page). Hitsu no Saishō Haruhira visits the Chinese emperor's court and discovers that his father, a former envoy, has been tortured and driven insane. The emperor humiliates the Japanese more by making the father sit by his side with a candle burning on his head as he greets the legation. *c.* 1845. From the series *Twenty-four Examples of Filial Devotion in Japan.* Utagawa KUNIYOSHI. *Chūban* format.

Fig. 36 (above right, facing page). Hitsu no Saishō Haruhira visits the Chinese emperor's court and discovers that his father is still alive but has been driven insane. 1881. From the series *Twenty-four Accomplishments in Imperial Japan.* Tsukioka YOSHITOSHI, after Utagawa KUNIYOSHI. *Ōban* format.

Fig. 37 (below, facing page). Katō Ishidōmaru finally meets his father for the first time on Mount Kōya, but Dōshin has become a priest. He does not want to return to family life and refuses to recognize his son. 1881. From the series *Twenty-four Accomplishments in Imperial Japan.* Tsukioka YOSHITOSHI. *Ōban* format.

Fig. 38 (above). The ghost of Takechi Samanosuke gives his son Sutewakamaru an heirloom sword and asks him to avenge his death. 1850. Plate 1 from a series of scenes from the play *The Chigo Deeps.* Konishi HIROSADA. *Chūban* diptych.

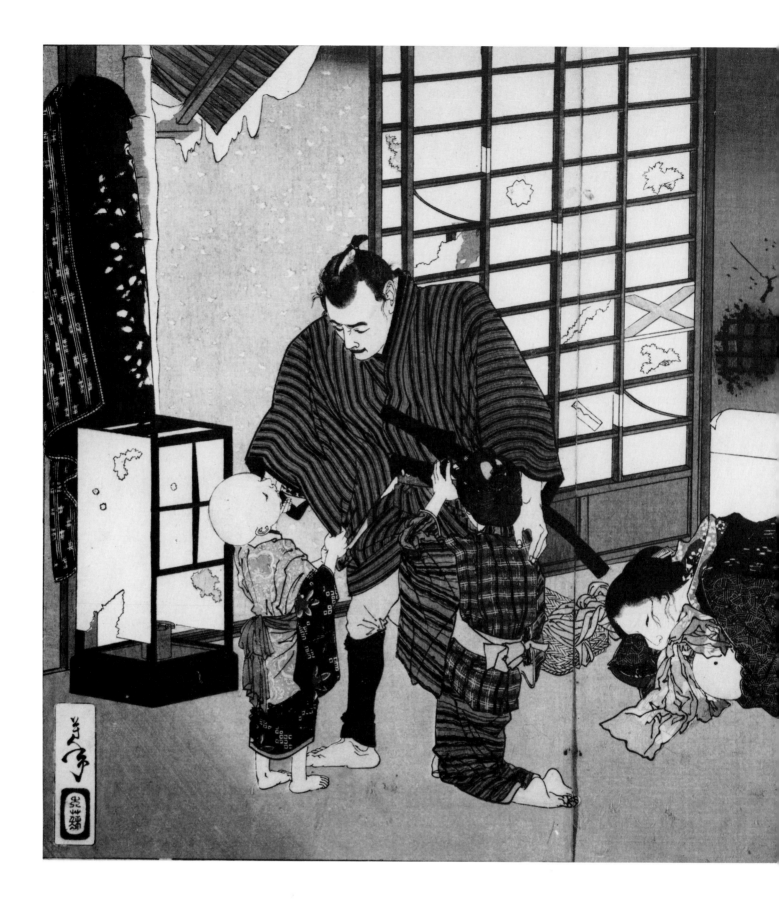

Kiuchi Sōgorō was a headman in a farming
community in Sakura, a rural district of
Kazusa Province, east of Edo, during the
1640s. Hotta Kosukenosuke, the lord who
ruled the province during that period, was
greedy and cruel. Sakura was a fertile area,
but Hotta taxed the farmers so ruthlessly
that they did not have enough food to live
and were dying of starvation. Bands of
them appealed to Sōgorō for help. He peti-
tioned Hotta time after time but never
even received an acknowledgment. Finally,
he decided to travel to the capital to see if
there were a way to petition the central
government. He was told that he could ad-
dress a direct appeal to the shogun. He was
warned, however, that as direct petitions
were legally prohibited, he would be cap-
tured, tried, and put to death, no matter
how just his cause.

Sōgorō returned home downcast to find
that his wife had given away their last pos-
sessions to help the farmers. Now she and
his children were also starving. Everyone
else was helpless. Nothing would change,
everyone would die unless he presented the
petition and sacrificed himself. He tried to
repudiate his marriage vows, to spare his
wife and children from punishment. But
their love was too strong and they could
not agree on a divorce. As he left, snow was
lightly falling. Back in Edo, he stopped the
shogun's procession and presented his peti-
tion. Hotta was punished, removed, and re-
placed, the farmers in Sakura survived, but
Sōgorō and his family were crucified.

23

Fig. 39. Kiuchi Sōgorō
says farewell to his wife
and three sons on a
snowy night before he
leaves to meet certain
death for a noble cause.
1885. From the series *A
New Selection of Eastern
Brocades*.
Tsukioka YOSHITOSHI.
Ōban diptych.

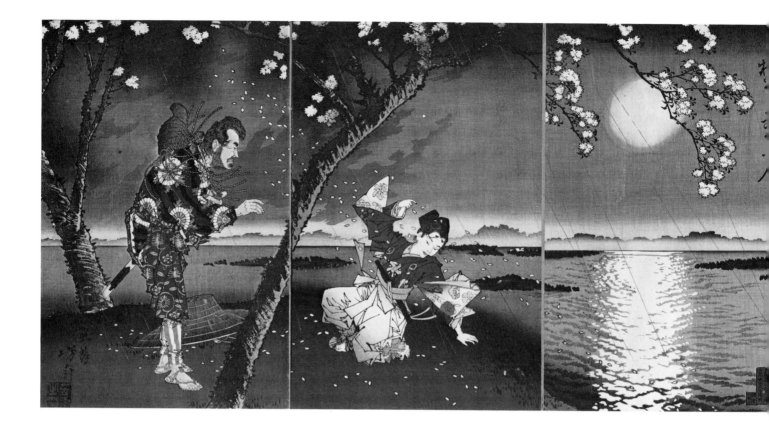

Support and Betrayal

In our father's absence, we look for a man to initiate us. We need someone to help us make the passage to adulthood and empower us as men. We look for a man who will recognize in us what we are still too young to see for ourselves: our truth, our destiny, our essence. We seek a man to whom we are a whole person, who will honor and encourage us even in our confusion and youth and who will not fail or betray us.

Fig. 40. Umewaka collapses on the bank of the Sumida River and raises his sleeve to protect himself from Nobuo Toda, his kidnapper. 1883. Toda was a slave dealer; a temple now stands where Umewaka died beside the river. Tsukioka YOSHITOSHI. *Ōban* triptych.

Fig. 41. The goblin leader, Sōjōbō, lets Ushiwakamaru study his secret scroll of military strategies. *c.* 1829. Ushiwakamaru was the boyhood name of the celebrated general Minamoto no Yoshitsune. When his life was endan- gered, his guardians hid him in a temple on Mount Kurama, where he was befriended by Sōjōbō and a band of goblins who taught him swordsmanship. Yanagawa SHIGENOBU. Square *surimono* format.

26

Fig. 42 (facing page).
Kintarō clamors for his
mother, Yamauba, to
hold him. 1873. From
the series *Essays by
Yoshitoshi.* This picture
was probably based on a
European painting or
print of a Madonna and
Child.
Tsukioka YOSHITOSHI.
Ōban format.

Fig. 43. A mother takes
her son for a walk dur-
ing the Russo-Japanese
war; he wears a sailor
suit and carries a Japa-
nese flag. 1904.
Yōshū CHIKANOBU. Ver-
tical *ōban* diptych.

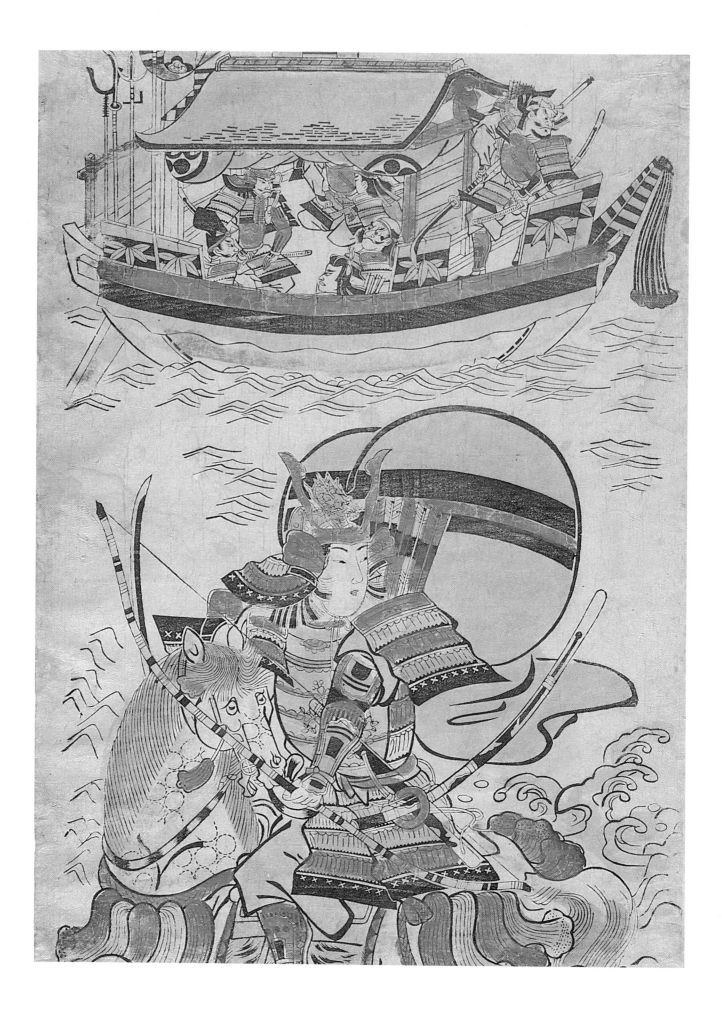

28

Fig. 44. (facing page). **29**
The young samurai
Atsumori reins
in his horse and turns
back from the clan's ship
to answer a challenge
during the battle of
Ichinotani. *c.* 1710.
Attributed to Torii
KIYOMASU I. Hand-
colored print in hanging
scroll format. The lower
portion of the print is
missing; no other im-
pressions are known.

Fig. 45 Kintarō, son of
Yamauba, the Old Moun-
tain Woman, wrestles
with a bear. *c.* 1700.
Torii KIYOMASU I. Hand-
colored print in hanging
scroll format.

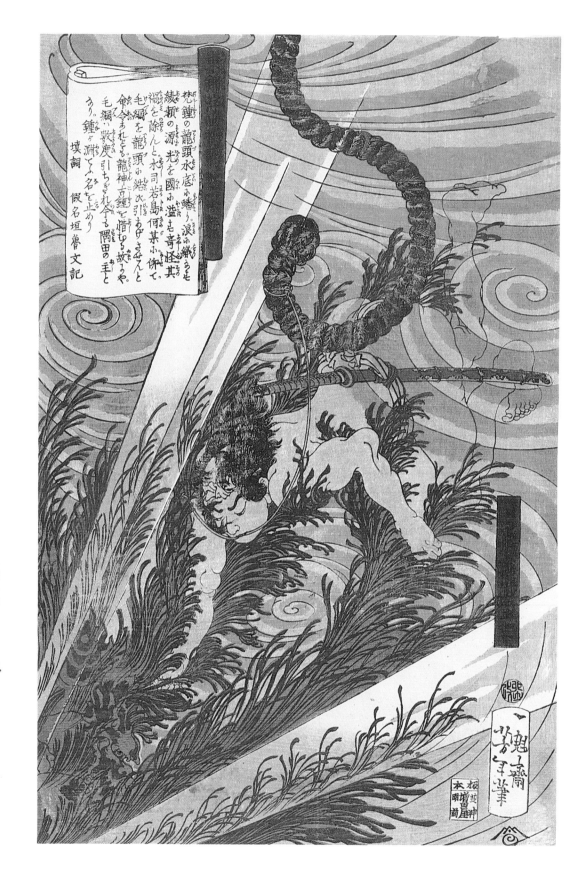

悲
鐘
の
龍
頭
水
底
に
踏
り
浪
に
纏
ふ
も
綾
瀬
の
源
光
を
國
に
溢
を
寺
怪
其
禍
を
除
ん
と
水
司
若
島
何
某
に
依
て
毛
綱
を
龍
頭
に
結
び
に
引
あ
げ
さ
ん
と
餘
今
あ
れ
と
も
龍
神
古
鐘
を
惜
む
る
故
つ
や
毛
綱
に
數
度
引
ち
ぎ
ら
れ
今
も
隅
田
の
主
と
あ
り
。
鐘
ヶ
淵
と
よ
名
を
止
め
り
埃
詞

假
名
垣
魯
文
記

30 *Fig. 46.* Wakashima Gon'emon dives into a whirlpool to retrieve an ancient, dragon-headed bell. 1867. From the series *Color Prints for Tales of the Floating World.* Tsukioka YOSHITOSHI. *Ōban* format. The text by Kanagaki Robun explains that Kanegafuchi, the Bell Deep, an area of the Sumida River in Edo, was named for the discovery of this sacred bell.

Fig. 47. Nozarashi
Gosuke. Mid-1840s.
From the series *Men
Worthy of the Name, in
Costumes by Kuniyoshi.*
Utagawa KUNIYOSHI.
Ōban format. The skulls
on Gosuke's black robe
are composed of cats, a
favorite Kuniyoshi sub-
ject. The verse is by
Ryūkatei Tanekazu.

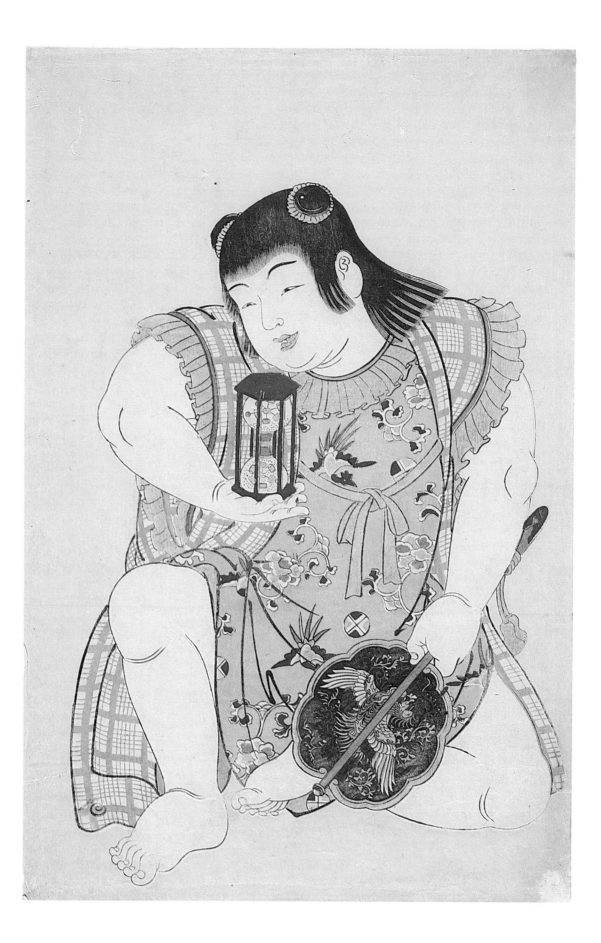

Fig. 48. Kneeling boy holding an hourglass and a Chinese fan. 1770s. "Bishamon," from an untitled series of children holding objects suggesting the attributes of the gods of good fortune. Attributed to Kitao SHIGEMASA. *Ōban* format. Bishamon, a god of strength, is usually dressed in armor; he holds a miniature pagoda and a spear.

32

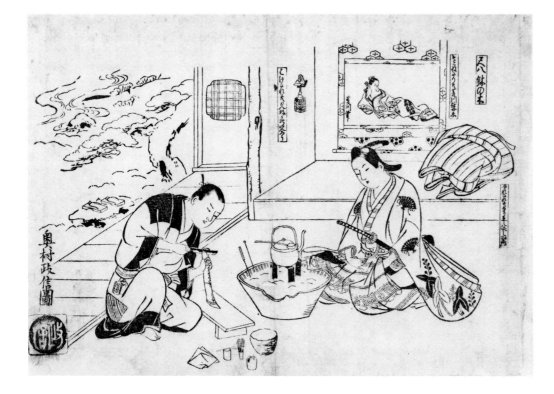

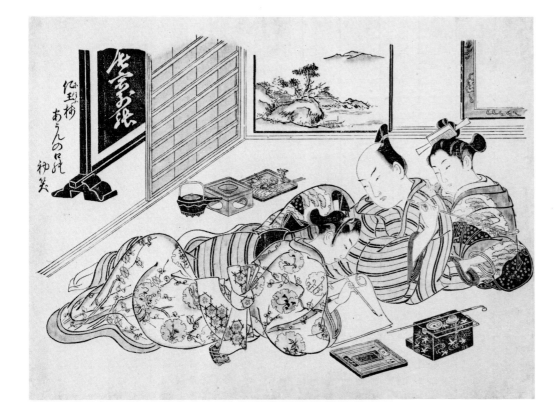

Fig. 49 (above). A man chops his bamboo flute up for kindling to prepare tea and impress a young male lover. 1710s. This is a modern rendering of the legend of a samurai who burned his precious miniature trees to honor an important guest. From an untitled series of humorous adaptations of legends. Okumura MASANOBU. *Ōban* format.

Fig. 50 (below). A young male prostitute writes a verse as a female prostitute caresses their patron. 1740s. The poem compares the two prostitutes with the statues of fierce guardian kings on either side of the main entrance to a temple. From an untitled series of hand-colored erotic subjects. Okumura MASANOBU. *Ōban* format.

34

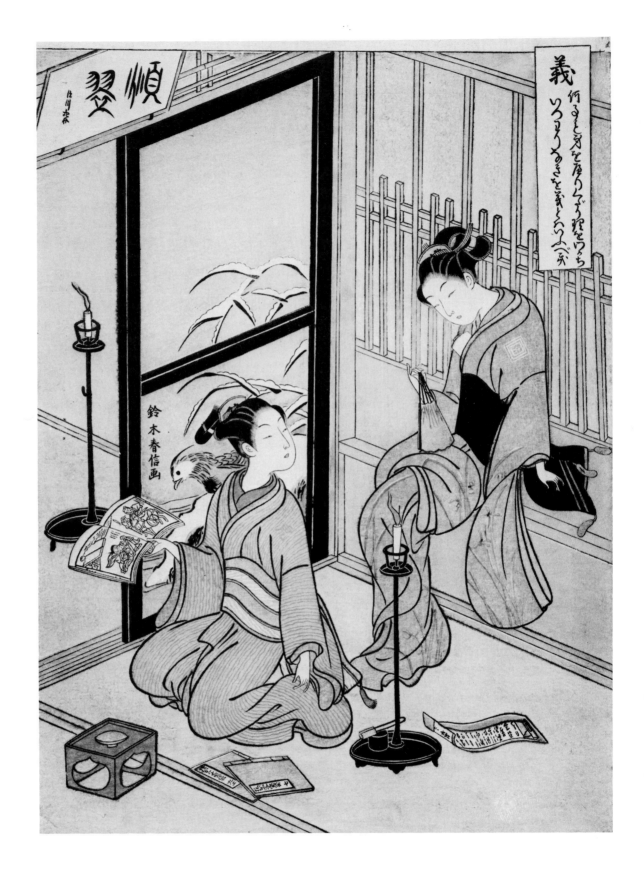

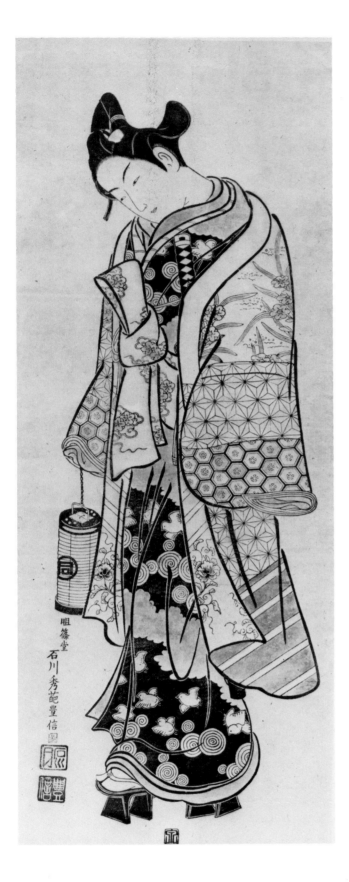

Japanese men in the eighteenth century basked in a glow of sexual freedom. Prostitution was legal, venereal disease was unknown, and a man's sexual life was approved by his peers so long as he did not squander his wealth, disrupt his family, or injure his partners.

Sexual relations between men and boys had been common among priests, samurai, and noblemen for centuries. In the eighteenth century, the wealthy could also experience this "pleasure" by hiring child prostitutes. These beautiful boys, with their graceful gestures and elegant robes, still beguile us in the prints of artists like Harunobu and Toyonobu. Boy prostitutes dressed like women. Sometimes only their hairstyle—a shaved spot at the top of their head or a forelock—or a sword at their waist showed they were men (figs. 50, 52). They were always handsome; they were always sexual objects. Their pain was never acknowledged.

Fig. 51 (facing page). Two boy prostitutes discussing an example of loyalty in a picture book. 1767. "Righteousness," from a series of Five Virtues. Suzuki HARUNOBU. *Chūban* format.

Fig. 52. A young male prostitute at night; he holds a lantern marked with the crest of the popular and handsome young kabuki actor Sanogawa Ichimatsu. 1740s. Ishikawa TOYONOBU. Hand-colored print in hanging scroll format.

Japanese boys became what we might call legal adults in their middle teens during a ceremony called *genpuku,* during which they shaved the tuft of hair across their forehead. But the inner transition from boyhood to manhood also involved initiations, through work, sex, heroism, or spiritual experience. Men usually initiated boys into the world of work. Women usually introduced them to the realm of sex. Deities led them through visions into the domains of spirit.

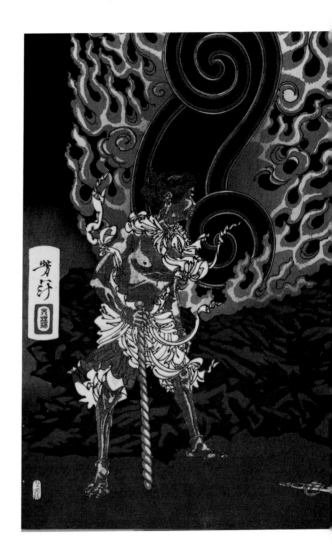

Fig. 53 (above). During a prayer vigil, a statue of the deity Fudō Myōō comes to life and pierces a young novice's mouth with his sword. Later, when Yūten regained consciousness, the sculpture was back in place, but the sword lay beside him on the floor. 1885. Tsukioka YOSHITOSHI. *Ōban* triptych.

Fig. 54 (below left). An older woman initiates a boy into sex. 1770s. From an untitled series of erotic subjects. Iris blossomed in the fifth month of the lunar year and is associated with the Boy's Festival. Isoda KORYŪSAI. *Chūban* format. The woman's short-sleeved, unpatterned robe indicates her age.

Fig. 55 (below right). A father and his son perform a dance with puppets on a cypress stage. 1790s. The puppets represent the aged couple Jō and Uba, symbols of a long and successful marriage. Kubo SHUNMAN. Long *surimono.*

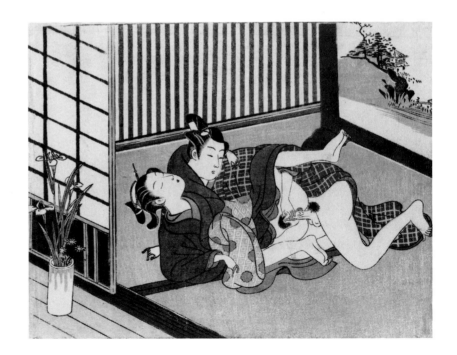

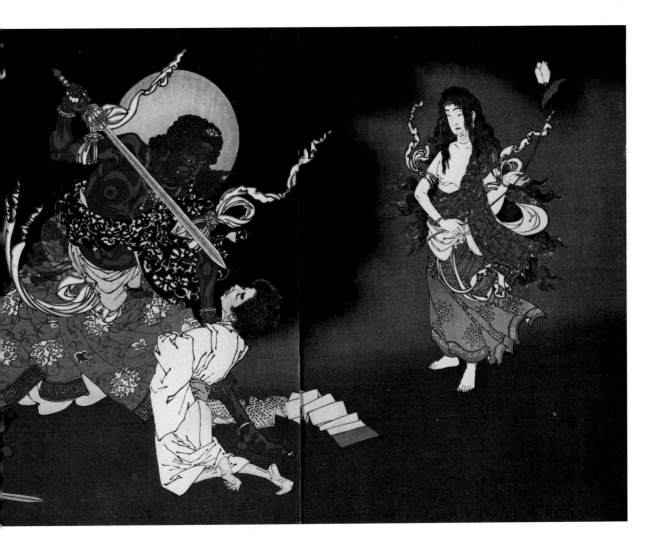

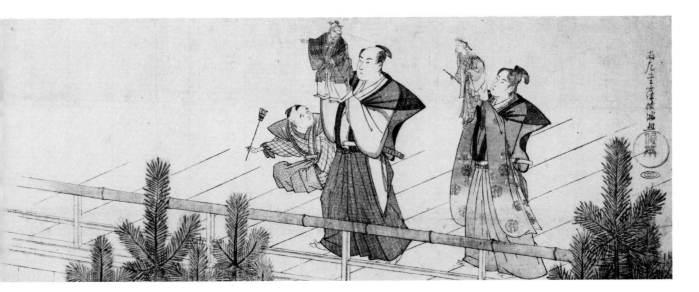

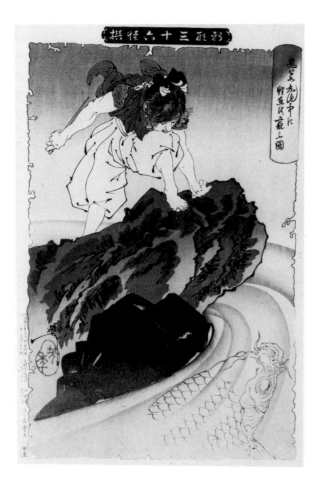

Fig. 56 (above). Oniwaka
watches the carp in the
pond. 1889. From the
series *New Forms of
Thirty-six Supernatural
Creatures.*
Tsukioka YOSHITOSHI,
after Utagawa KUNI-
YOSHI. *Ōban* format.

Fig. 57 (below). Oniwaka
gathers courage to kill
the giant carp that has
eaten his mother; the
woman behind him is
his nurse. *c.* 1845.
Utagawa KUNIYOSHI.
Ōban triptych.

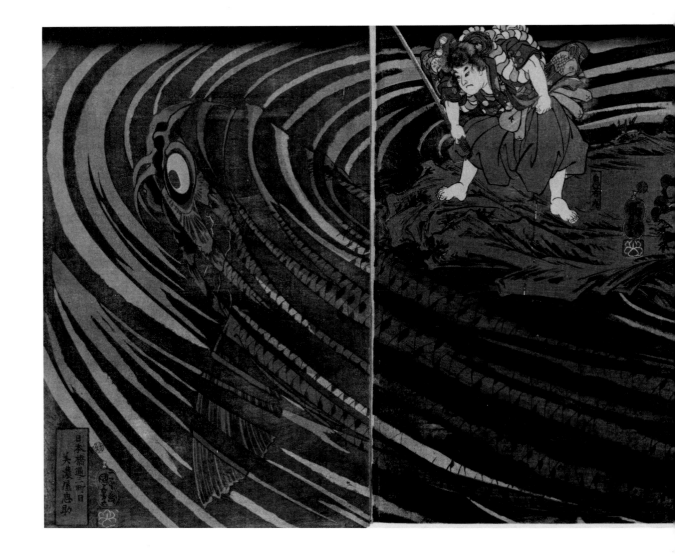

The Hero's Journey: Oniwaka

The boy hero's journey is a self-initiation, a quest in which the child discovers his strength, courage, and other resources by struggling with powerful inner forces that manifest themselves outside. Throughout these myths the boy struggles alone, without help or protection. His father is absent.

Oniwaka, or "Young Devil," was born from a violent union. His mother was imprisoned by the abbot of Kumano Shrine and raped. When Oniwaka was born, the abbot tore him from his mother and gave him to a wealthy relative. At a young age he contracted smallpox and his face was disfigured, so the woman despaired of making him a courtier and sent him to a temple instead.

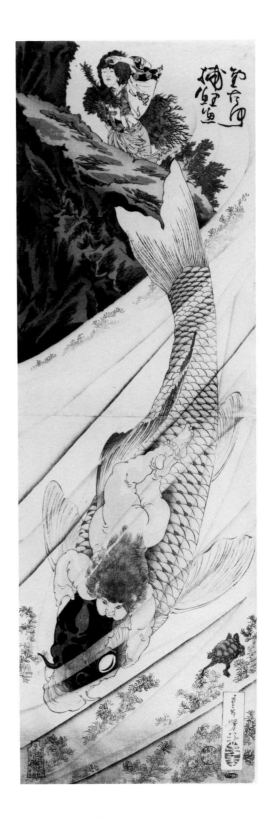

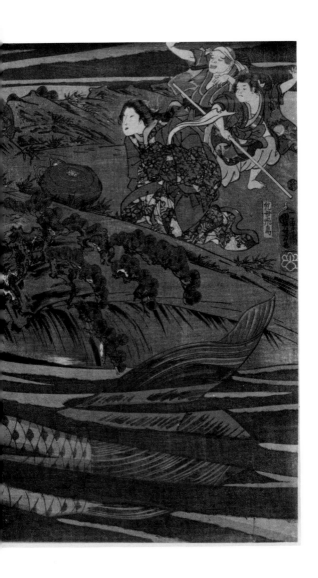

39

Fig. 58. Oniwaka seizes the carp and plunges into the depths of the pond. 1885. Tsukioka YOSHITOSHI. Vertical *ōban* diptych.

The monks at the temple taunted Oniwaka. They told him his father was one of the two giant statues standing beside the entrance to Kumano Shrine. At the age of eight, the boy set out for Kumano to find out if this was true. There too the priests mocked him. His father was not a statue, nor was his mother alive, they said. She had just fallen in the pond below the war god's waterfall and been eaten by the giant fish there.

In these prints Oniwaka runs to the pond. He sees the fish. It is enormous, and his fear magnifies it. He looks down—hesitates. But all the rage of his childhood returns and fury fills him. He risks his life and plunges into the water. The fish carries him down further and further into the depths of his self.

Fig. 59 (above). Benkei begins his last effort to persuade the gate keeper that he and his party are pilgrims. They are actually fugitives; the scroll, which should contain a subscription list, is empty, and the gate keeper will not let them pass until he hears it read. 1890. Tsukioka YOSHITOSHI. *Ōban* triptych. The verse by Keika reads, "The flowers and their fragrance, like travelers' robes, are wet with dew."

Fig. 60 (right). The actor Seki Sanjūrō II as Musashibō Benkei wielding his seven weapons and performing a comic dance. 1810s. From a series illustrating a dance with seven quick costume changes. Utagawa TOYOKUNI. *Ōban* format.

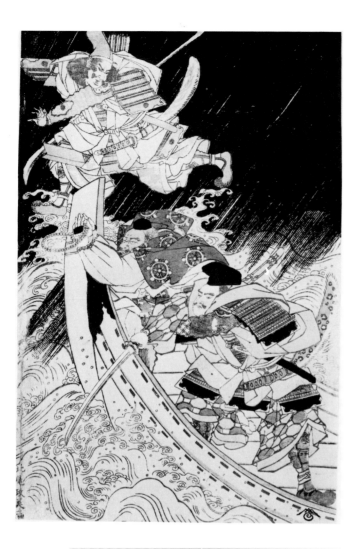

Benkei

Oniwaka continued his search for his father. After his struggle with the carp, he became the powerful warrior Benkei and took service with Yoshitsune, a gentle, cultivated young nobleman. Yoshitsune restored the fortunes of his clan with a swift series of victories in the twelfth century, ending with the naval battle of Dannoura, where hundreds of enemy warriors drowned.

Years later Yoshitsune crossed the width of the straits of Dannoura again to escape the wrath of his elder brother, the shogun. The angry spirits of the dead warriors created a storm that threatened to sink the ship until Benkei's prayers calmed them.

43

Fig. 61 (above left).
Benkei prays to protect
his master Yoshitsune
from the ghost of the
warrior Tomomori as
they cross the strait of
Dannoura. Yoshitsune
won an important naval
victory over the Heike
clan at Dannoura in
1185. As he crossed the
strait later on his flight
into exile, the angry
spirits of the dead
Heike warriors created
a violent storm, which
Benkei calmed with his
prayers. c. 1790s.
Kitao MASAYOSHI. Ōban
format.

Fig. 62 (below left).
Benkei prays to protect
his master from the
ghosts of the warriors he
killed in the Battle of
Dannoura. 1853. From a
series of episodes from
the life of Yoshitsune.
Utagawa KUNIYOSHI.
Ōban format.

Fig. 63 (above). A group
of actors posing as tat-
tooed ruffians threaten a
priest on a boat beside a
bridge in Edo. A parody
of the storm at Dan-
noura. 1860. The huge
wooden swordblade and
the decorated post are
religious devices.
Utagawa KUNISADA.
Ōban triptych.

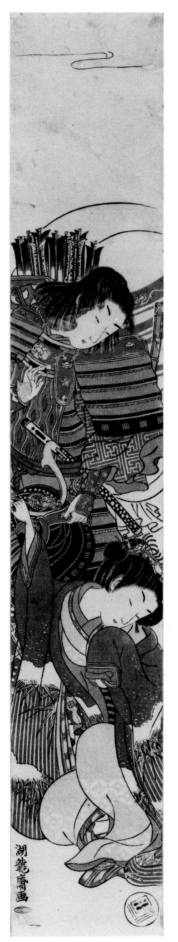

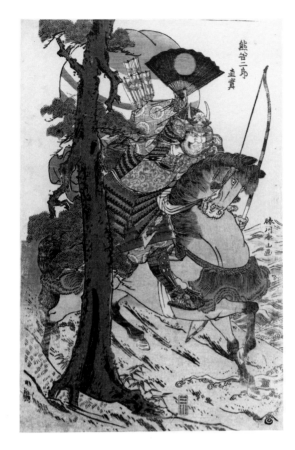

Atsumori

When we are children we have very little
power and very few choices. We cannot
choose our parents and we cannot change
them. We endure our childhood. As we
grow older we gain more freedom to choose,
but we cannot anticipate, much less control,
the outcome of many of our choices. In
order to stay alive and continue our lives
with courage and dignity, we need to feel
that our choices have value or meaning.

The value of a tragic choice cannot be
reasoned or explained. It can never be jus-
tified to the mind. Advice or philosophy or
platitudes cannot console the father who
has lost his son, or the boy who died. And
so we turn to stories and myths, where we
learn that every choice involves more than
we can see at first, that we cannot prevent
tragedies, and that we are not alone in the
midst of the grief and helplessness we feel.

Atsumori, the beautiful, gifted son of a
general of the Taira clan, was fifteen on the
eve of the Battle of Ichinotani in 1184. He
was already famous as a flutist, and the en-
emy soldiers recognized his playing as it

drifted to them through the murmur of
the pine trees around their camp on the
night before the battle. Atsumori's father
loved him deeply. Knowing that the boy
was young and inexperienced, no match
for the veteran soldiers they would have to
fight in the morning, he ordered him to
keep inside the clan's encampment during
the battle. Atsumori agreed, but when the
sun rose and all the Taira warriors sallied
forth he wanted so much to join them and
prove himself that he broke his promise,
borrowed a suit of armor, seized his bow
and quiver, and galloped onto the field of
battle. The commotion filled him with ex-
citement; he felt as though this was the mo-
ment he had lived for, that at last he was a
man, playing the exciting game that the
older men had talked about so often. As
the sun rose higher, the fighting went
against the Taira, and they slowly withdrew
to the fleet of ships their prescient general
had moored offshore. Atsumori joined the
retreat but suddenly remembered that he
had left his precious flute in the camp. He

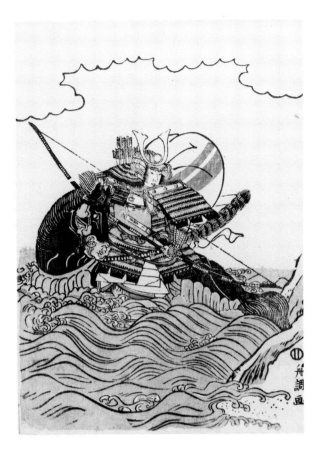

Fig. 66 (*above*). Atsumori turns to meet Kumagai's challenge. 1790s. Tamagawa SHŪCHŌ. *Chūban* format.

Fig. 67 (*below*). Kumagai challenges Atsumori during the Battle of Ichinotani. *c.* 1790s. UNIDENTIFIED EDO ARTIST. *Ōban* format.

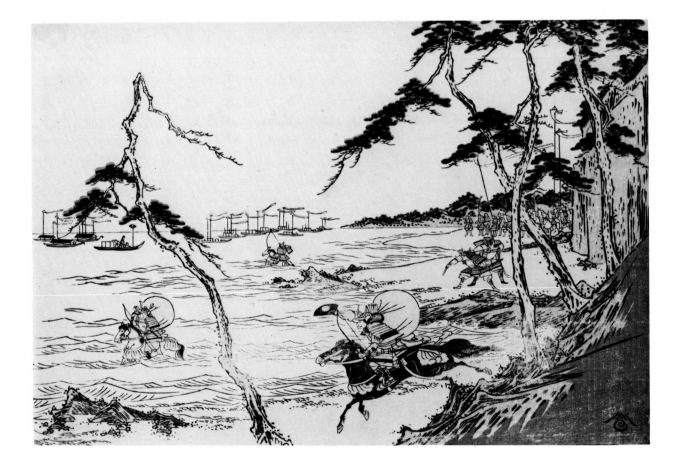

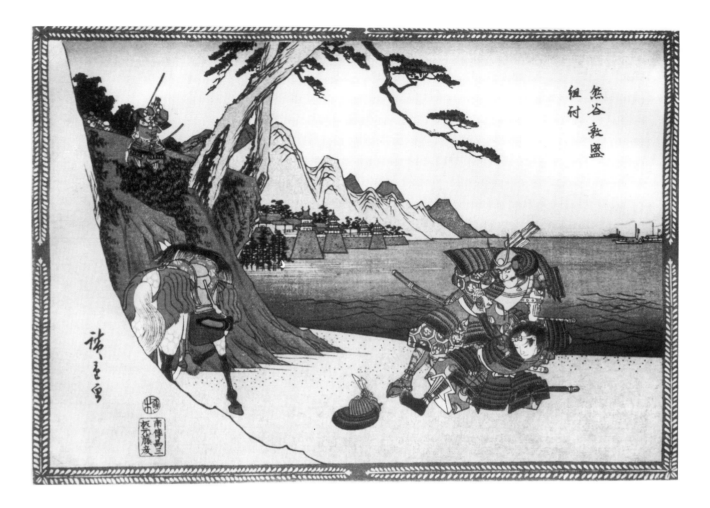

could not leave it behind. He broke rank, galloped to the camp, retrieved his flute, and plunged his steed back into the water. He had nearly reached safety when a cry from shore made him turn. An enemy warrior on horseback was challenging him. In pride and exuberance, the immortality of youth, he turned his horse around and galloped back to meet his challenger.

His opponent, Kumagai, who saw only the horseman's armor, assumed he had challenged a grown man and was surprised that his enemy fell to the ground so quickly. How little he resisted as Kumagai tore his helmet off. And then, as Kumagai raised his sword to deliver the coup de grace, he saw a boy the age of his own son who had just died in battle.

His heart went out to the boy; he faltered and relented. Let the boy go, he thought, what could possibly be served by killing him?

But at that moment his companions galloped up. They taunted him. Had he lost his nerve? they wondered. Hard-hearted Kumagai? His courage failed again, and with a prayer for forgiveness, he swung his sword down swiftly and killed the youth.

The hidden price for Atsumori to become a man was to leave his flute behind and renounce the gentle values of his youth. Atsumori refused. He risked his life to preserve his true self, and he died for it. But his intention survives his death. Do we not feel that he was right to go out into battle and then to gallop back to retrieve his flute? In his joy and confidence, how could he fail to answer Kumagai's call? Atsumori died, but his "useless" death taught Kumagai, and the Kumagai in each of us, the futility of violence and war. The story shows us how people change. Kumagai prepared Atsumori's corpse and returned it to the boy's family with honor and respect. Then he cut his hair and became a Buddhist priest. Finally touched by life, his sense of what was necessary, right, and possible had changed.

Fig. 68 (above). Kumagai kills Atsumori during the battle of Ichinotani. 1830s. From an untitled series of historical subjects. Utagawa HIROSHIGE. Ōban format.

Fig. 69 (right). Kumagai begs Atsumori for mercy, a reversal of the usual theme. The elderly warrior is overcome by the youth's beauty and tugs with entreaty at his skirt of armor. Late 1760s. Suzuki HARUNOBU. *Chūban* format.

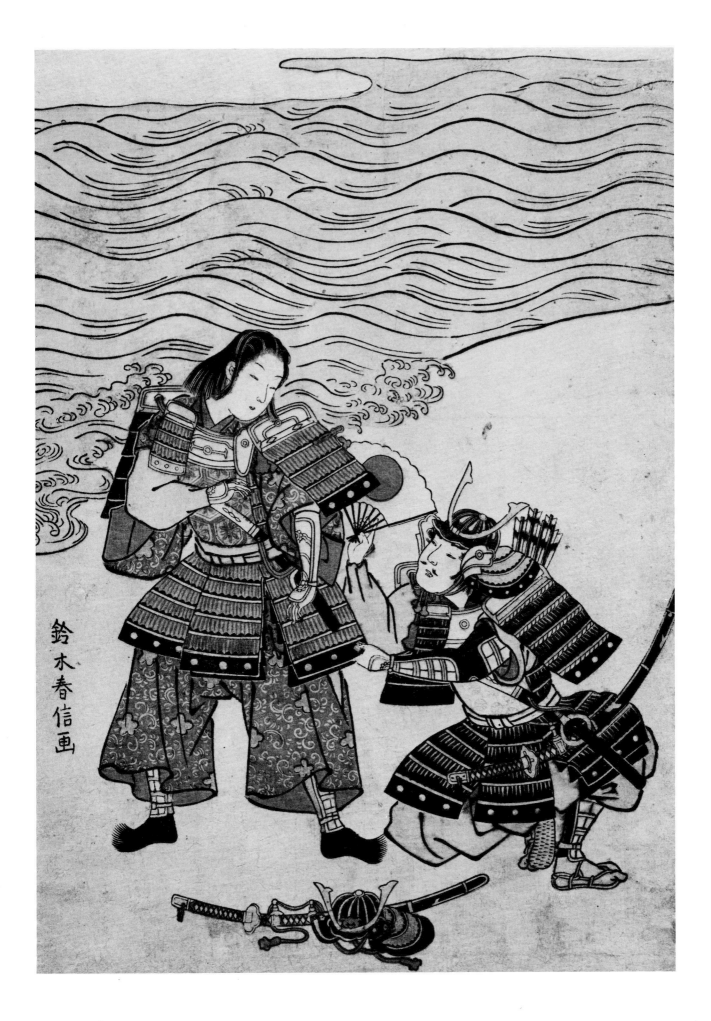

47

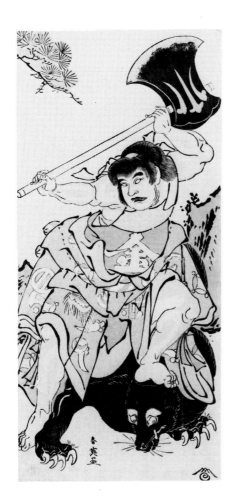

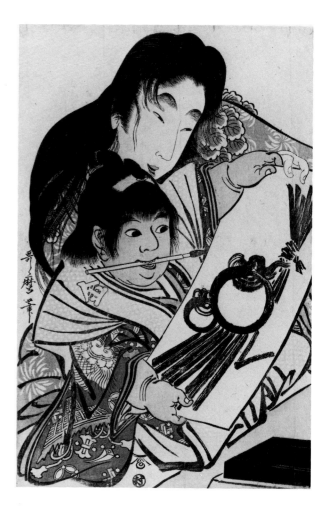

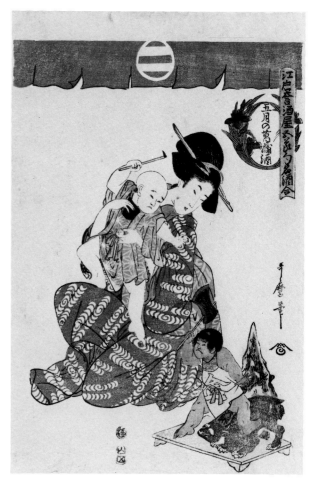

Fig. 70 (above left).
The actor Kataoka
Nizaemon VII in the
role of Kintarō captur-
ing a bear. 1790.
Katsukawa SHUN'EI.
Hosoban format.

Fig. 71 (above right).
Kintarō and his mother,
Yamauba, admire a pic-
ture of two sacred
jewels and a bundle of
stretched abalone strips
(symbols of longevity),
the boy's first painting
of the New Year. Late
1790s.
Kitagawa UTAMARO.
Ōban format.

Fig. 72 (below). During
the celebration of Boys'
Day, a mother helps her
son imitate the pose of a
doll of Kintarō, a child
hero who has captured a
wild boar and is threat-
ening him with his axe.
c. 1810. "Iris Wine for
the Boy's Festival," from
the series *Famous Edo
Rice Wines for the Five
Seasonal Festivals.*
Kitagawa UTAMARO II.
Ōban format.

*Fig. 73 (above, facing
page).* The Old Moun-
tain Woman watches
Kintarō catch birds and
goblins with a limed
stick. 1857. From a se-
ries of illustrations of
legends that the artist
fancifully associated
with chapters of *The Tale
of Genji.*
Utagawa KUNIYOSHI.
Ōban format.

*Fig. 74 (below, facing
page).* Kintarō poses as-
tride a wild boar. *c.* late
1820s. The picture is
printed in light red,
which is difficult to re-
produce. It was pub-
lished as a talisman
against smallpox. The
verse promised a swift
recovery to children
who contracted the
illness.
Utagawa KUNIYOSHI.
Aiban format.

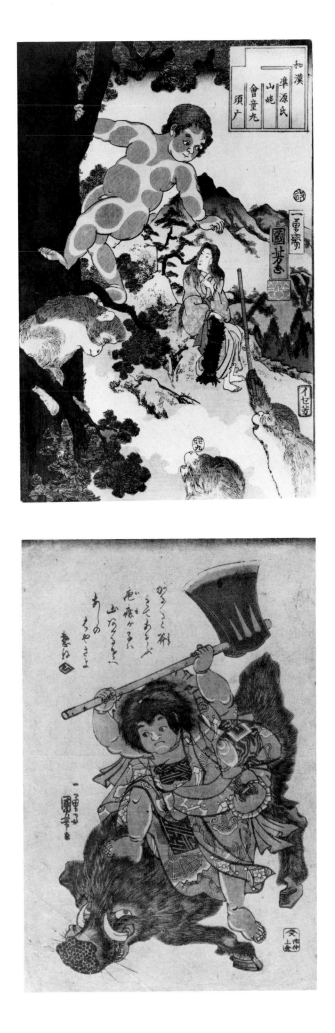

Every boy faces doubts and fears, heart-
aches and struggles. Somehow he has to
find inner strength to keep his integrity
and resilience to keep his balance. Kintarō,
the wild lonely child in each of us, grapples
with ferocious animals (fig. 45). He finally
overcomes them, and in that moment they
shrink, turn tame, and become his servants,
protectors, and companions. He achieves
dominion. He discovers balance and con-
tentment with the gentler animals: mon-
keys and rabbits become allies and play-
mates. Even though he has no father, no
brothers and sisters, and no human friends,
he is never alone in the wilderness.

In their fathers' absence, mothers are
boys' first teachers. By the language they
use, the tone of their voice, the songs they
sing, the toys they choose, mothers give
their sons their first lessons in being men.

The bond between a mother and her in-
fant is colored with sensuality. Why does
this emerge so seldom as a subject of art?
(see fig. 43). Is it perhaps because most art-
ists have been men, and most men have
forgotten the pleasure they gave and felt in
touching their fathers and mothers? The
mother is still the parent who touches her
baby's body most and for the longest period
of time, nursing, lulling, playing, and
comforting.

In Japan, where practically every aspect
of human life was eventually explored in
art, Kitagawa Utamaro depicted the inti-
macy between mothers and infants in doz-
ens of pictures of the wild, abandoned,
mythic Yamauba and her playful, affection-
ate, responsive, sometimes amorous son
Kintarō.

Appreciation nurtures creativity; a par-
ent's attention inspires his or her children.
As I look at Utamaro's picture of Yamauba
sharing Kintarō's pleasure at completing
his first painting of the New Year, I think
of the thousands of Japanese mothers to-
day who take Suzuki violin lessons with
their children and recognize how impor-
tant this quality of parent's attention is to a
child, whose creativity flourishes in an at-
mosphere of delight and acceptance.

49

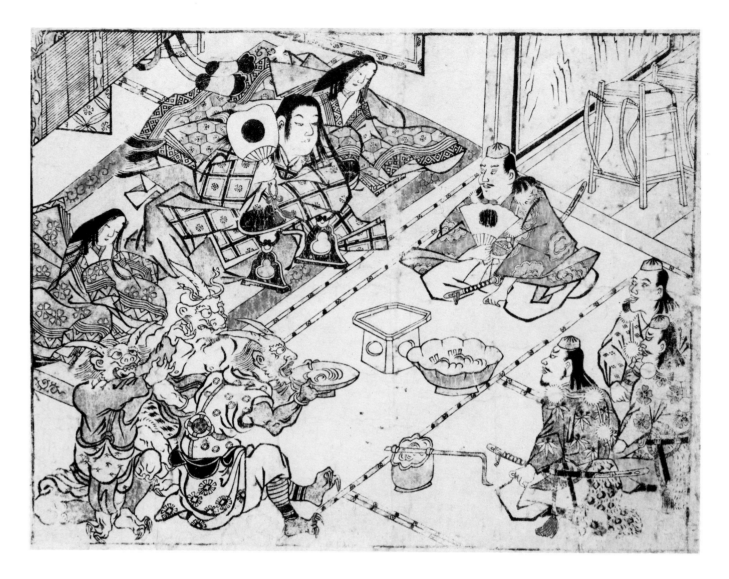

Kintoki and the Alcoholic Youth

Kyoto was alarmed. Night after night a band of outlaws dressed as goblins swept through the city. They stole food and treasure, kidnapped wives and daughters, then retreated eastward to a well-defended fortress in the mountains where they lived with their leader Shutendōji. The citizens begged the court to protect them, and the emperor ordered his general to put an end to these depredations.

The general set out with four trusted warriors. One of them was the grown-up Kintarō, who had taken the name Sakata Kintoki. The five men disguised themselves as priests and entered the wilderness. A woman gave them directions to the fortress, and a god disguised as an old man told them what they had to do in order to survive. They would be invited to a banquet and offered wine, which they must not drink. When their host fell asleep, they could attack him; if they drank the wine, they would be killed and eaten.

Fig. 75 (above). Shutendōji, the Alcoholic Youth, a monster disguised as a handsome young man, entertains Kintoki and his companions at his palace on Mount Ōe. 1680s. Attributed to Hishikawa MORONOBU. Hand-colored *ōban* album sheet.

Fig. 76 (facing page). A praying devil. 1830s. Utagawa KUNISADA. *Ōban* format. The publisher explains that he asked Kunisada to draw a picture of the praying devil, a subject of early Ōtsu painting, as a talisman. If this picture is put up in your home, he continues, it will keep your children from crying at night, make it harder for thieves to enter, and drive away evil spirits.

應需
國貞画

寿加帳

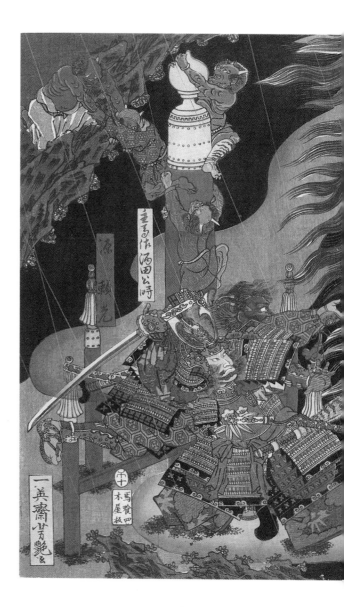

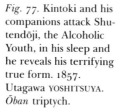

Fig. 77. Kintoki and his companions attack Shutendōji, the Alcoholic Youth, in his sleep and he reveals his terrifying true form. 1857. Utagawa YOSHITSUYA. *Ōban* triptych.

The men reached the fortress, which appeared huge and impregnable. A company of outlaws escorted them into a palatial banquet hall. At one end, on a low dias like a nobleman, sat the leader, a handsome young man who welcomed them graciously and ordered his servants to prepare a banquet to honor them.

The men were awed and charmed. Perhaps, they thought, they had made a mistake. No man this elegant and gracious could have committed such crimes. But they heeded the warning they received, and although they pretended to empty their cups, they actually refused to drink.

Night fell, the torches guttered; the guards withdrew, their host fell asleep. The men whispered to one another quietly, then in a sudden rush leapt up to seize the man. But as they approached, the young man underwent a hideous transformation into a ferocious and gigantic demon (fig. 77).

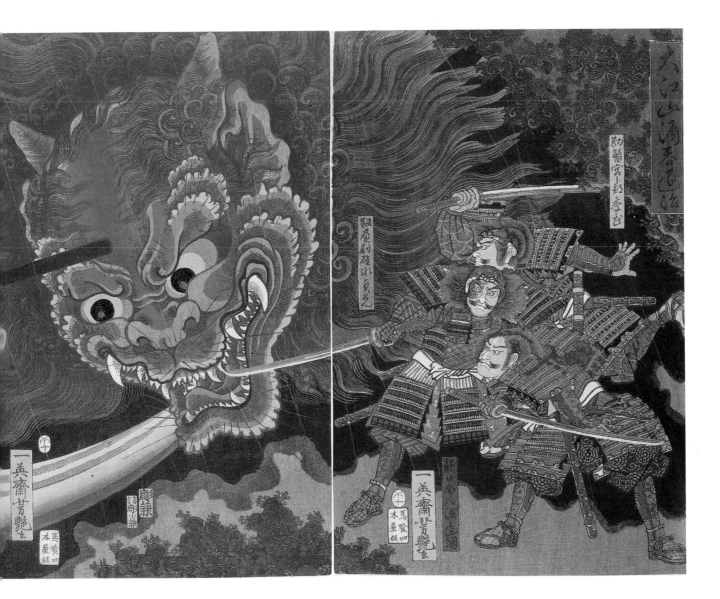

They fought, and the determination of the five men made them strong. The demon's strength ebbed. Eventually the warriors killed him, captured his underlings, released the women, recovered the treasure, and returned to the capital in triumph.

The demon was named Shutendōji. The name is written with two sets of characters: one means the Wine-Drinking Youth, the other means Wine-Crazed Youth. The legend was based on a historical event in the tenth century, but it evolved into a myth to help people understand and cope with alcoholic behavior.

Shutendōji—the Wine-Crazed, or Alcoholic, Youth—appears perfectly normal. He is charming. Meeting him, it is almost impossible to believe the stories that circulate about his terrible, cruel behavior. He drinks and encourages the people around him to drink. After he drinks he undergoes a frightening transformation into a powerful, selfish, vicious monster.

In the myth, anyone who drinks with him is devoured. In real life, family members are devoured when they become codependent on the alcoholic and lose the sense of what they want or need for themselves. They feed the monster, the disease, and lose their power.

Today we have enough experience with alcoholic behavior to recognize the similarity between the warriors' engagement with Shutendōji and the process of an intervention. When family members stay sober and finally confront their alcoholic relative, they often see just this kind of sudden and frightening change. But because they are sober, they ultimately realize that they are not responsible for the behavior; they have been victims. Their distance gives them strength and clarity. However frightening the demon looks, it is powerless over them.

54 *Fig. 78.* The actor
Morita Kan'ya VIII as
Okaru's brother Teraoka
Heiemon in the "Gion
Teahouse" scene in Act
7 of *The Storehouse of
Loyalty.* 1796. From an
untitled series of por-
traits of actors in three
contemporary perfor-
mances of the play.
Katsukawa SHUN'EI.
Ōban format.

Fig. 79. The Osaka actor Nakamura Utaemon III as Gosaku, a farmer (a disguise of the outlaw Ishikawa Goemon) kneeling before an heirloom sword. 1830. The print was privately commissioned to commemorate Utaemon's performance with the visiting Edo actor Ichikawa Danjūrō VII. In his verse he modestly compares himself to a winter plum tree which wants to blossom and show itself even though its flowers are only pale. Ryūsai SHIGEHARU. Ōban format.

55

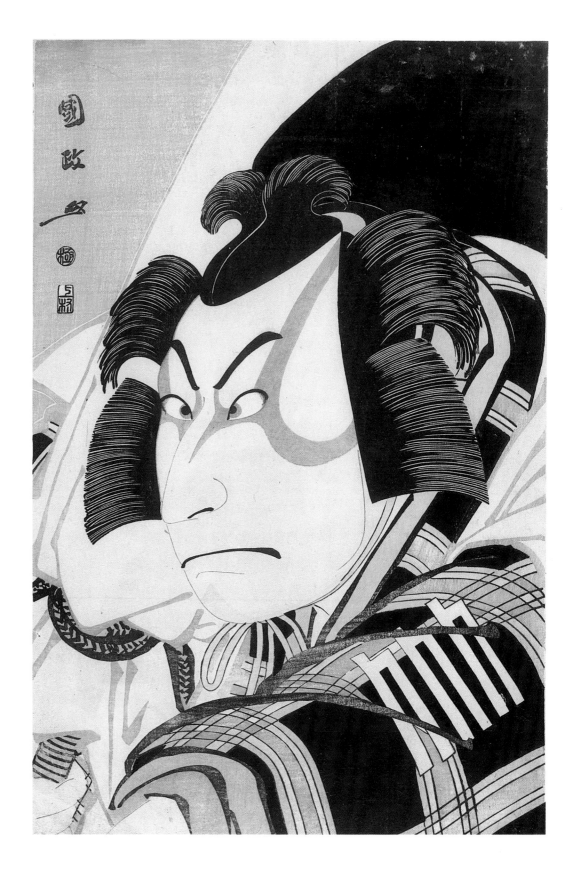

56 *Fig. 80.* The actor Nakamura Nakazō II as Matsuomaru in the "Carriage-Stopping" scene from the play *Sugawara's Secret.* 1796. In this scene, Matsuomaru protects his lord's carriage from an attack by his two brothers (who serve a rival). Utagawa KUNIMASA. *Ōban* format. The right panel of a triptych.

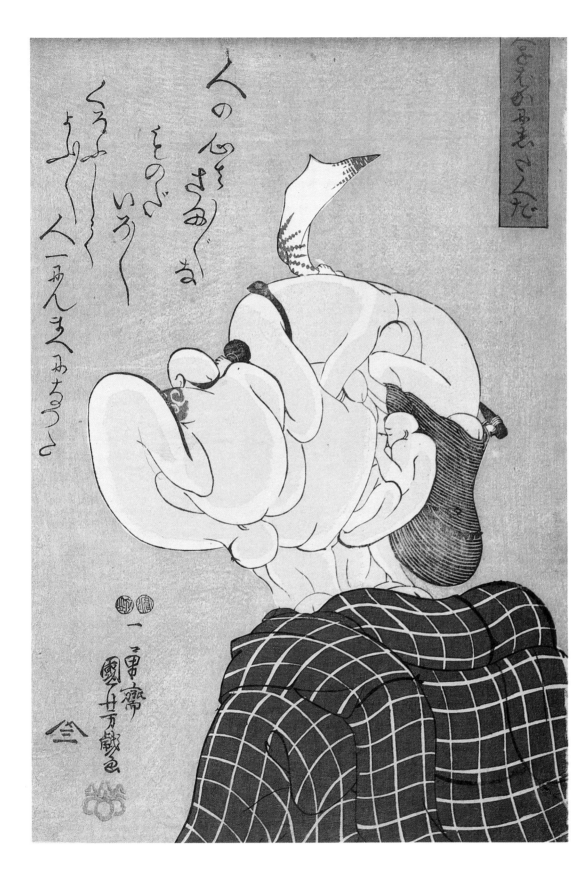

Fig. 81. Profile of an old man whose head and body are composed of many smaller human figures. *c.* 1850. "People Made a Fool Out of Him," from an untitled series of composite human figures. Utagawa KUNIYOSHI. *Ōban* format. The inscription says, "People have very different natures. Gradually, by various efforts, they become real individuals."

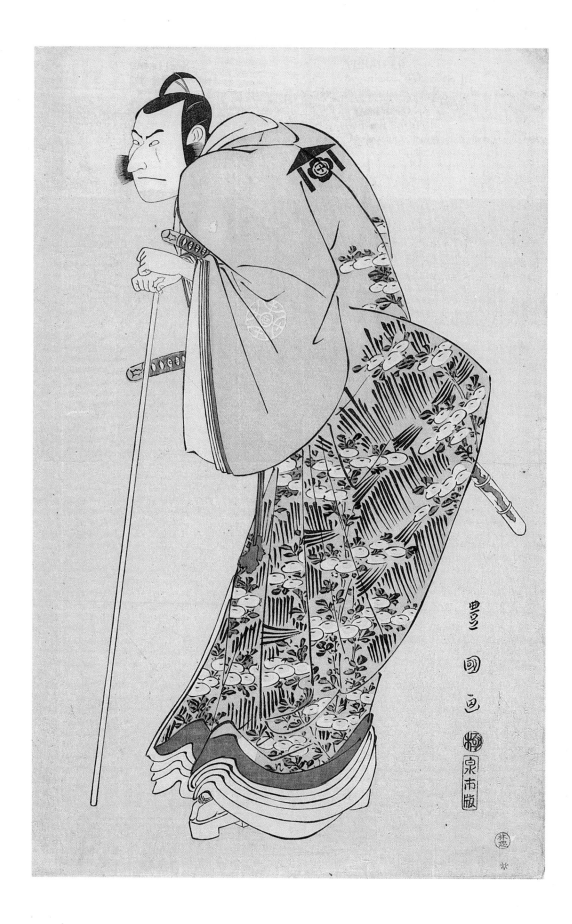

58 *Fig. 82.* The actor
Nakamura Nakazō II as
Kudō Suketsune, the
man who killed the
father of the Soga
brothers and became
the target of their re-
venge. 1795.
Utagawa TOYOKUNI.
Ōban format.

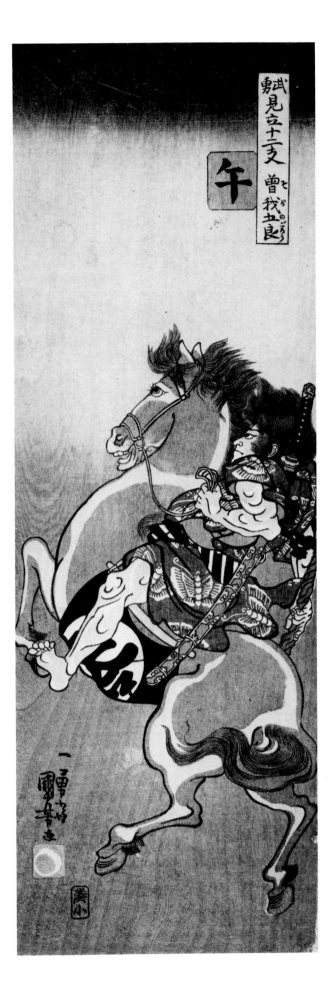

Each of us, however confident, hesitates for a moment in the face of the unknown. The Soga brothers had sworn to avenge their father's death by killing Kudō Suketsune, his murderer (fig. 82). As they came of age, the brothers displayed different temperaments. Jūrō, the older boy, was diplomatic, graceful, reserved, and elegant. Gorō was rough, boisterous, tasteless, and impetuous. Jūrō appeared frequently in public and disarmed suspicion since he was so skillful at dissembling his anger. Gorō was so transparent and unpredictable that his family secluded him at a temple in the mountains where he trained himself for the role he had to play as an adult.

One morning as he sat sharpening his arrows, Gorō dreamed that his brother was in terrible danger. The dream was so vivid that he sprang to his feet, burst out of the temple building, seized the only horse in sight—a nag that had been tethered in the field by a local farmer—and galloped to the coastal town where he knew his brother was attending a banquet.

In fact, Jūrō was not in any danger, and Gorō almost ruined their plans for vengeance by his sudden appearance. But for both artists, the danger is real. In Kuniyoshi's print, Gorō hesitates. His horse rears up in the face of the unknown. Yoshitoshi (fig. 84) shows us Gorō's brave determination. Nothing will distract him from his commitment. After years of preparation, the youth is full of confidence; he leaps eagerly forward into adulthood.

Fig. 83. Soga no Gorō's horse rears before plunging forward. Mid-1830s. "Horse," from a series of twelve male heroes matched with the animals of the Japanese zodiac. Utagawa KUNIYOSHI. Panel print.

59

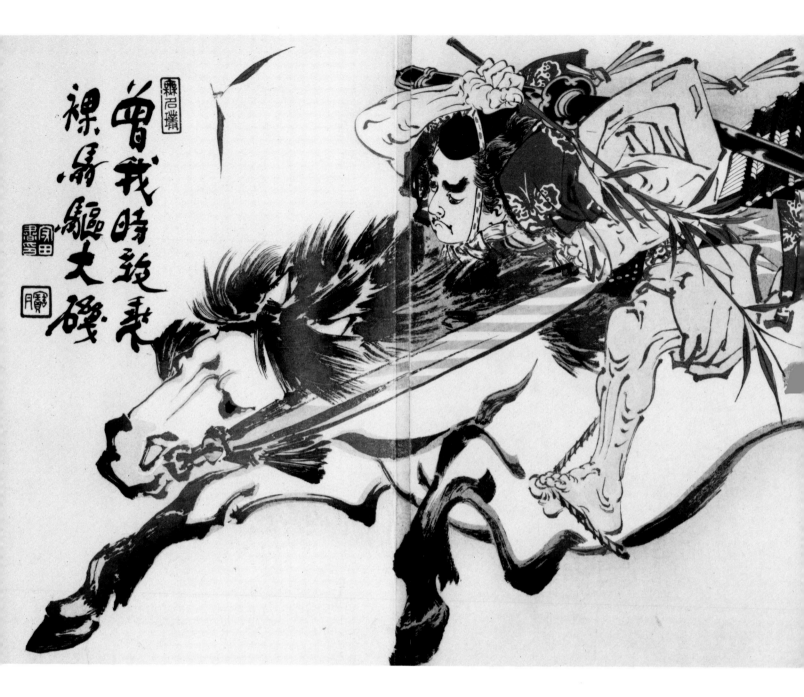

Fig. 84. Waking from a dream in which his brother was in danger, Soga no Gorō leaps on a farmer's horse and gallops headlong from his mountain temple to Ōiso, a coastal town, to rescue him. 1885. The inscription at the left in the form of a Chinese couplet reads, "Soga Tokimune rides bareback and gallops to Ōiso."
Tsukioka YOSHITOSHI. *Ōban* triptych.

Maturity

The artist, in exploring the themes for his art, draws first and most richly from his own experiences. What is it to be a man? What qualities must he possess? How must he meet and present himself to the world?

By images, the artist describes the drama of a man's engagement with life. He captures the familiar scenes and daily tasks that make up the essential elements of his world. Every emotion—courage, rage, and pride, but also tenderness, humor, and warmth—finds expression.

Contemporary viewers recognized themselves and one another. Now in a historical setting, now in the retelling of a favorite legend, or in the face of a popular actor—no matter what predicament the actor was in and whether he wore court robes, armor, or modern dress.

In each print, the unique quality of *presence* comes through—a strength drawn from the experience of Japanese manhood. With a calm dignity and a sense of self-worth, the inner man emerges from behind the posture of the nobleman, the bandit, the prince, or the farmer and stands before the world.

We look now and wonder, journeying to a different time and place. In human terms, these images speak to us also.

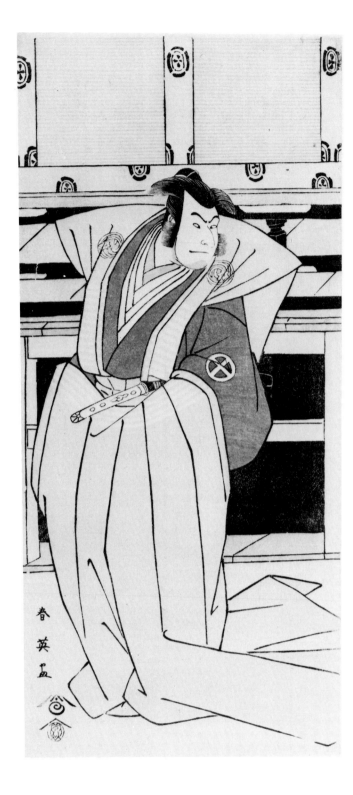

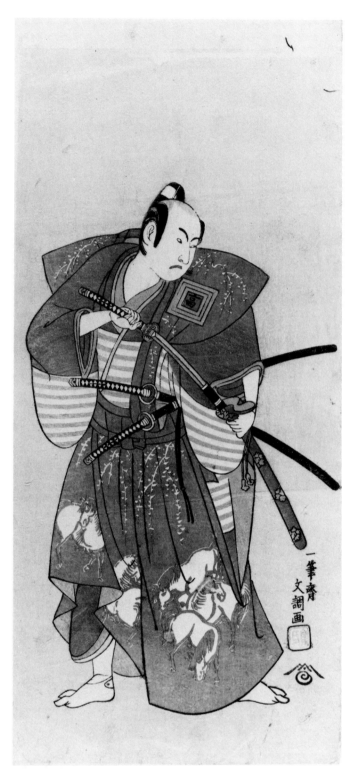

Nobility

Dramatic faces—the courtly, the dangerous, the elegant—increase our sense of life's drama. We yearn at times to enter the legends, to battle the insuperable and reveal the courage and sacrifice of which we are capable. The daily workings of our own lives are seldom as grand; our quiet routines seldom seem to require so much. For us, these great characters exemplify the qualities we most admire, fear, or desire, and we draw from them new courage and understanding for our simple tasks.

Yet, the artist seems to tell us, the feudal lord, the brave warrior, and the evil murderer are drawn from each of us—for it is we who give them life.

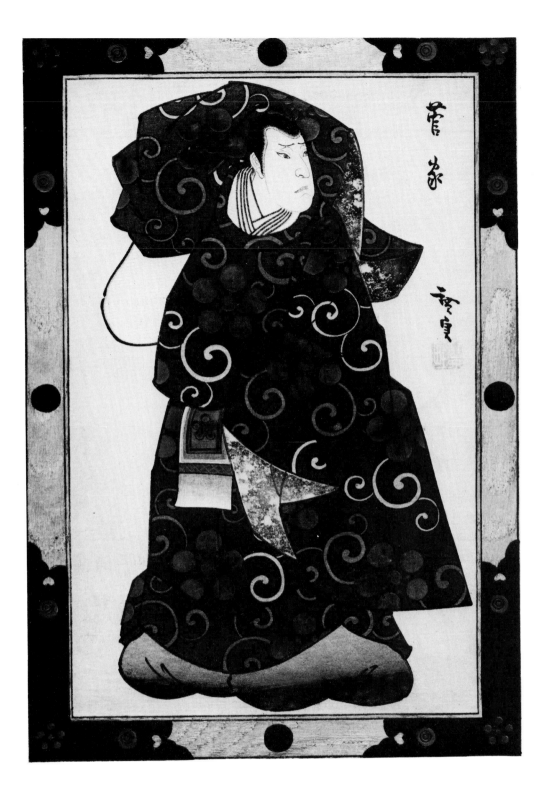

Fig. 85 (far left, facing page). The actor Ichikawa Komazō II as a samurai. 1768–70. Ippitsusai BUNCHŌ. *Hosoban* format.

Fig. 86 (left, facing page). The actor Ōtani Oniji in the role of a feudal lord standing beside a palace veranda. 1790. Katsukawa SHUN'EI. *Hosoban* format. Panel from a polyptych.

Fig. 87 (this page). A print simulating a framed votive painting of the Osaka actor Mimasu Daigorō IV in the role of the courtier Sugawara no Michizane (845–903). 1850. Konishi HIROSADA. *Chūban* format.

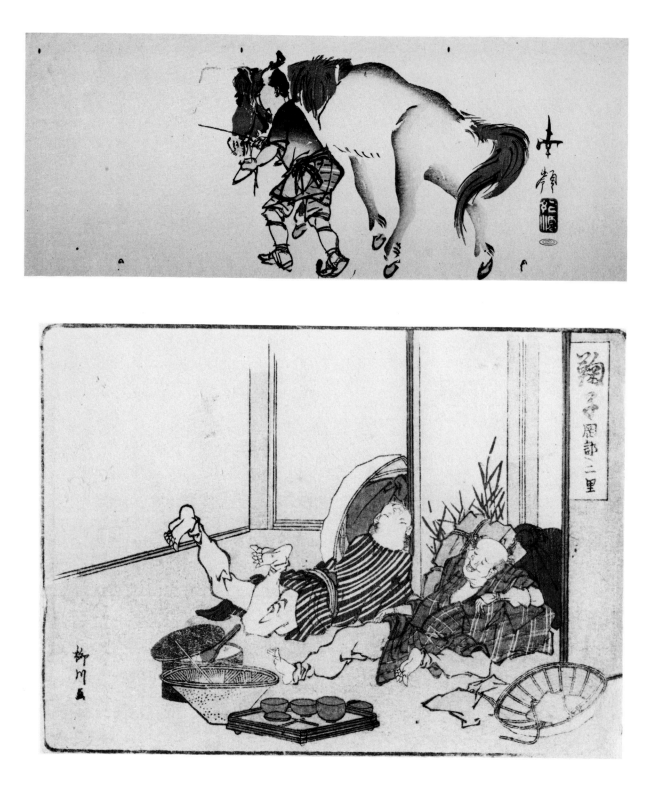

64

Fig. 88 (above). Horse
and groom. *c.* 1820s.
Suzuki NANREI. A pri-
vately published print,
lacking verse.

Fig. 89 (below). Travelers
resting after a meal at
an inn in the town of
Mariko. 1810s. A new
subject for a series
of scenes along the
Tōkaidō Road originally
designed by Hokusai
and published in 1804.
Yanagawa SHIGENOBU.
Koban format.

*Fig. 90 (above, facing
page).* Ferryboat pulling
away from one bank of
the Sumida River at sun-
rise on New Year's Day.
c. 1810s. The seven men
represent different so-
cial classes and are
drawn in different tech-
niques and historical
styles.
Kitakasa SHIGENOBU.
Long *surimono,* lacking
text, published to com-
memorate a poetry gath-
ering or a musical
performance.

*Fig. 91 (below, facing
page).* A wealthy Osaka
merchant hanging a
painted scroll in a pic-
ture alcove. 1862. A pic-
ture calendar published
by the group of poets
whose New Year's verses
are printed at the left
(but not shown here).
The numbers for the se-
quence of long and
short months in 1862
are concealed in the
painting.
Satō HODAI. *Chūban*
format.

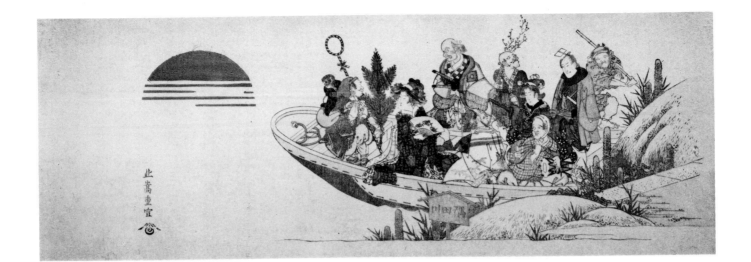

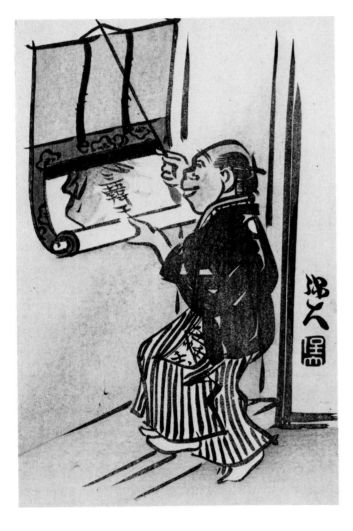

Commoners

We have a special affection for the average man. Our social betters command our reverence; the larger-than-life hero our admiration and envy. But our fellow travelers relaxing in their inn, our fellow laborer aided by the strong back of his able horse, bring us a comfortable smile and a feeling of camaraderie.

The Japanese artist expressed this enjoyment. His respect and affection are contagious. The lines are less formal, the humor and warmth more evident, the entire scene more accessible. As he encounters many different characters in different scenes, the artist employs a variety of styles to capture and convey the humanness of each. Without a word, we see and understand.

66

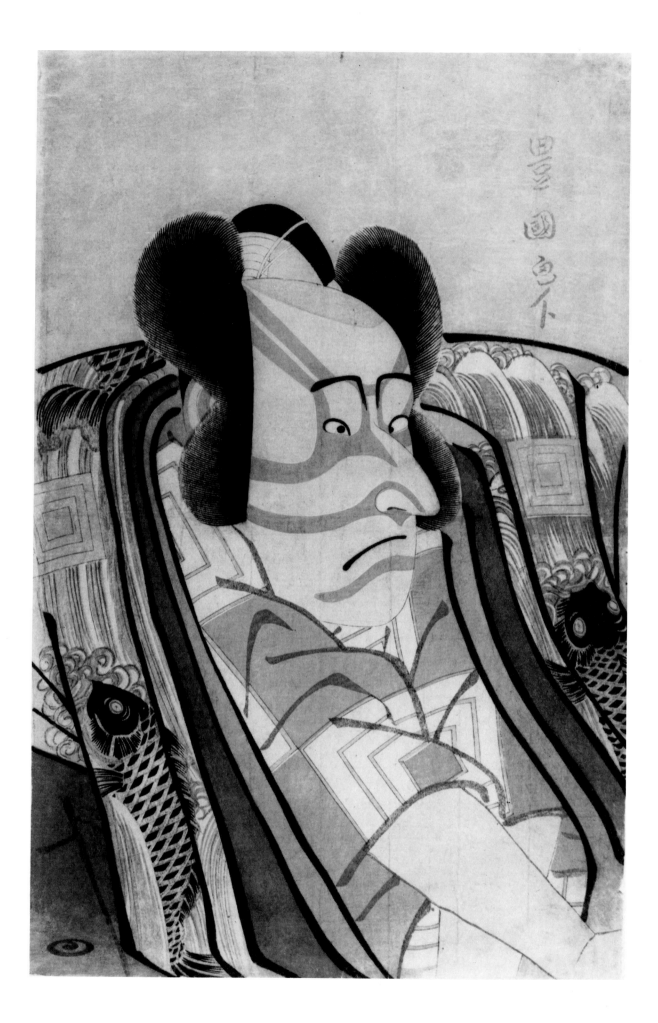

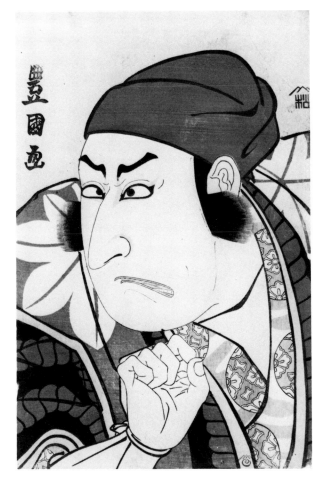

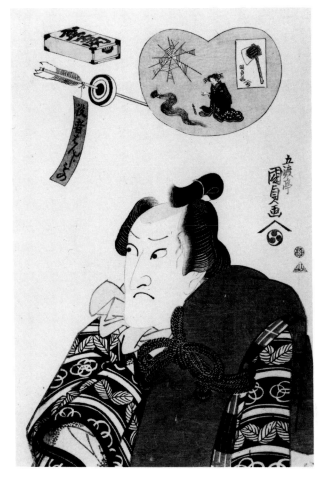

Character and Presence

The eyes of the Kabuki actors are focused just out of our sight. Who is it they see? What is about to happen? We cannot see, but only imagine. We sense the impending encounter and are subtly drawn in. Seeing through eyes other than our own, we discover new vistas.

The characters and actions on stage are not ourselves, but are strangely related. Intensified, they give back to us what we experience in our own lives. The seamless continuity between life and art reveals to us the breadth and the possibilities of manhood.

Years after its creation, the artist's invitation to participate engages us; the drama continues.

Fig. 92 (facing page). The actor Ichikawa Danjūrō VI as Danpei, a young samurai in the service of a feudal lord. 1796. Utagawa TOYOKUNI. *Ōban* format. The red, blue, and purple colors on this impression have been reprinted from new blocks and the white mica seems to be a modern addition.

Fig. 93 (above left). The actor Ichikawa Omezō as the woodcutter Sekihei, a disguise of the evil courtier Ōtomo no Kuronushi in *The Barrier Gate.* 1797. Utagawa TOYOKUNI. *Ōban* format.

Fig. 94 (above right). The actor Onoe Matsusuke III as a townsman. 1810s. From the series *Rebuses for Actors;* the pictures at the upper right spell out the actor's name. Utagawa KUNISADA. *Ōban* format.

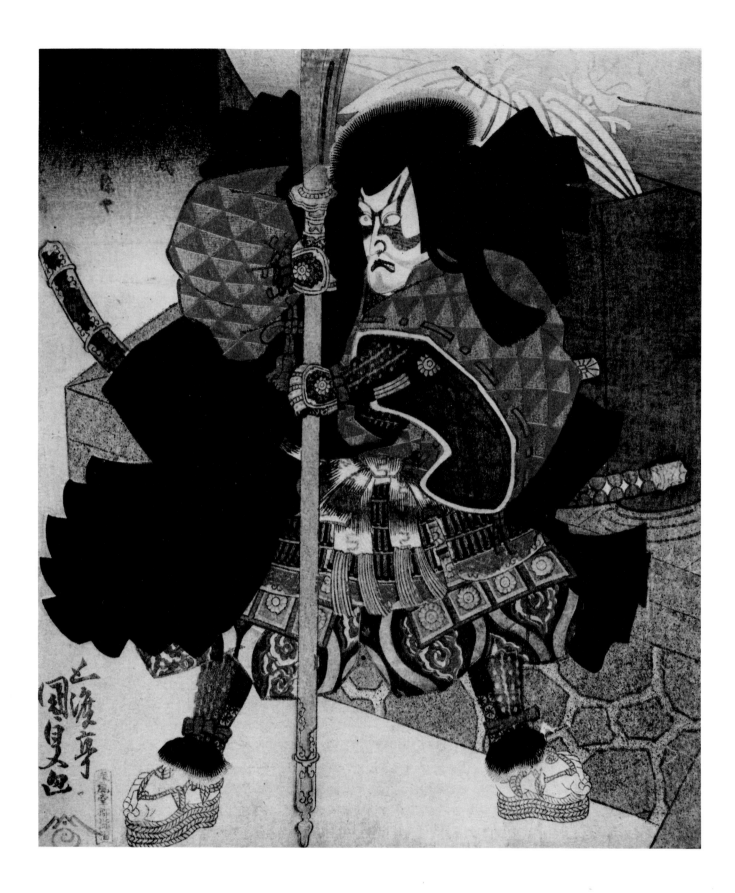

68

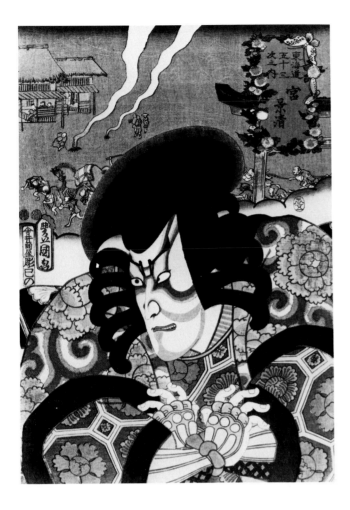

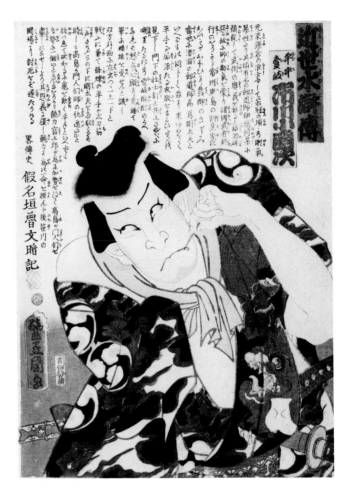

Fig. 95 (facing page). The actor Ichikawa Danjūrō VII as the medieval warrior general Akushichi-byōe Kagekiyo. 1820s. Left panel of a privately published diptych of the confrontation in the twelfth century between Kagekiyo and his clan's enemy, the shogun Minamoto no Yoritomo, at Tōdai Temple in Nara.
Utagawa KUNISADA. Square *surimono* format.

Fig. 96 (above left). The actor Ichikawa Danjūrō VIII as the medieval warrior Kagekiyo. 1852. "Miya," from a series of portraits of actors matched with the stations of the Tōkaidō Road.
Utagawa KUNISADA. *Ōban* format. The background scene of a festival at the Atsuta Shrine near Nagoya was copied from a print designed by Hiroshige in the early 1830s. The shrine precincts suggest Kagekiyo's confrontation with Yoritomo at Tōdai Temple.

Fig. 97 (above right). The actor Ichikawa Kodanji as Hirade Iki, a contentious urban samurai. 1862. From a series depicting heroes of the *Modern Suikoden*.
Utagawa KUNISADA. *Ōban* format. The inscription is a biography of Hirade by Kanagaki Robun.

Men are created by history as surely as men bring about historical events.

In the middle of the nineteenth century, Japan showed strain after 250 years of peace. Factions formed and tensions between the emperor's and the shogun's sides brought dissension and increased government control. Forbidden to comment on the events around them, dramatists and artists recounted history and legends that spoke to the current need.

Tales of celebrated, larger-than-life heroes from an ancient embattled time were reworked, their heroes brought forward to do battle in the present day. These archetypes taught by examples how a man can live in dignity regardless of the outcome of larger battles. Men can prove themselves virtuous by their steadfast loyalty and bravery, these prints say, even when their cause is doomed and their defeat certain.

As the political climate tensed, new strange and sinister characters—snarling, threatening, and obnoxious—appeared in the artists' work.

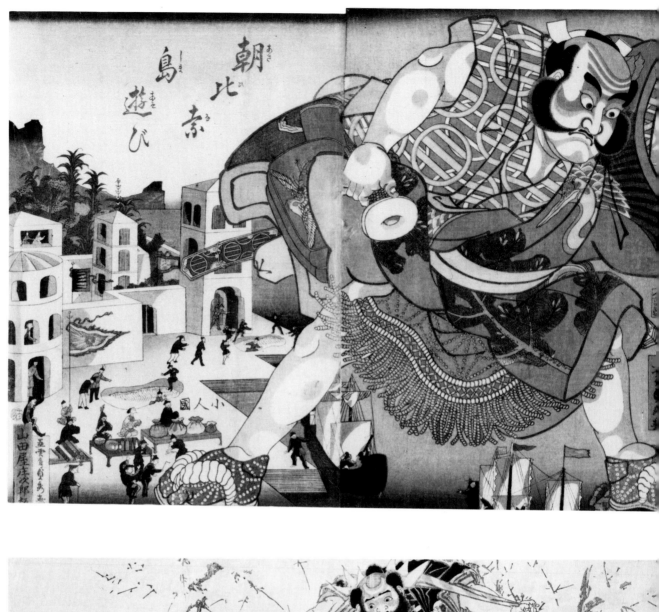

70

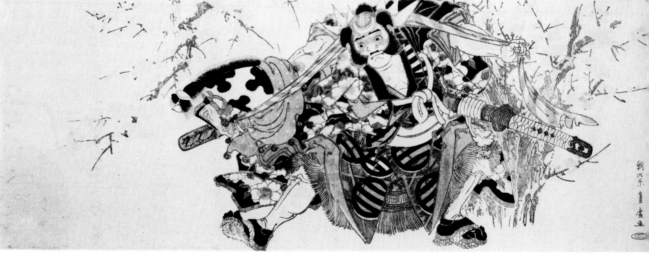

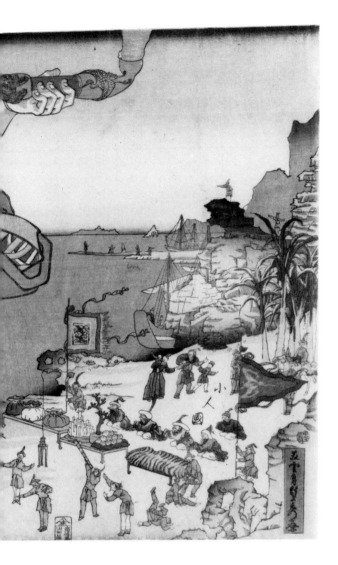

Humor

Our lives are built of many moods. The artist finds humor in our situation, renders it in a new light, and gives it back for our examination. "Look closely," he says.

Are we the gross giant, tottering between two islands, unsure where to take our next step? Or are we instead the amazed inhabitants of a miniature world, paying the giant tribute and hoping he will not cause much trouble?

Perhaps we have grown familiar with the traditions of the past. "Look again," the artist cautions. The single figure in Kuniyoshi's print (fig. 81) is really many; the larger image becomes fragmented and absurd.

71

Fig. 98 (*above*). Kobayashi Asahina awes the inhabitants of the Land of Dwarves who offer him tribute. 1860. A fantasy novel about Asahina's travels in imaginary countries outside Japan was popular when Sadahide designed this print.
Hashimoto SADAHIDE. *Ōban* triptych.

Fig. 99 (*below, facing page*). Asahina performs a New Year's pony dance beside a flowering plum tree. 1822. This was the twenty-fifth consecutive print of Asahina designed annually by Toyohiro for the writer Sakuragawa Jihinari to distribute at the beginning of the New Year.
Utagawa TOYOHIRO. Long *surimono* format, lacking text.

Fig. 100 (*below, this page*). Asahina falls asleep on a wine cask after drinking its contents to celebrate New Year's Day. 1820s. Keisai EISEN. Square *surimono* format. The turtle in the wine cup is the emblem of Komendō Sennan, the poet who commissioned the print. The other verse is by Shūchōdō Monoyana.

Fig. 101 (left). The chamberlain Yurano-suke looks up at the courtesan Okaru as the enemy spy reads the secret list of conspirators in Act 7 of *The Storehouse of Loyalty.* Mid-1790s. Chōkyōsai EIRI. Pillar print.

Fig. 102 (right). The courtesan Okaru and an enemy spy watch Yuranosuke read the secret list of samurai conspiring to avenge their master's death in Act 7 of *The Storehouse of Loyalty.* 1780s. Katsukawa SHUNCHŌ. Pillar print.

Fig. 103 (facing page). Teraoka Heiemon decides to kill his sister Okaru to preserve the conspirators' secret, but Yuranosuke prevents him. Plate 7 from a series of pictures of the eleven acts of *The Storehouse of Loyalty* designed with western perspective. 1800–1810. Katsushika HOKUSAI. *Aiban* format.

72

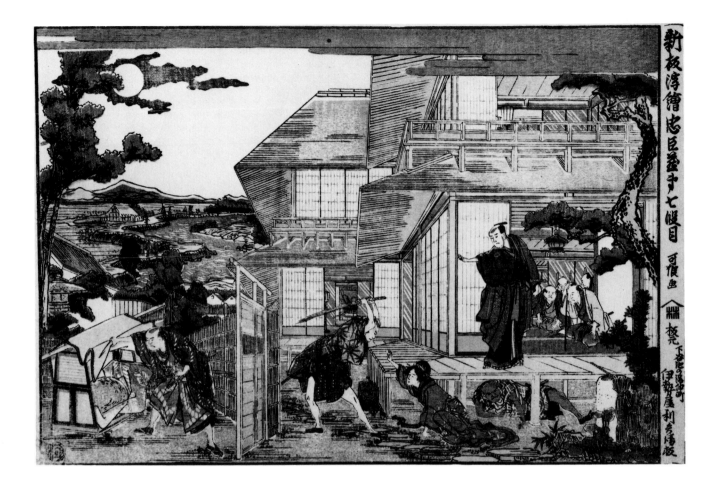

Dignity and Pathos

Throughout human history, men have warred against their fellow men. Deadly conflicts have engulfed countless lives and generations, whole families, whole nations. Such conflicts continue to surround us today.

Some of the epic tales provide hope. The legend of the forty-seven loyal samurai, dramatized as *The Storehouse of Loyalty* (*Chūshingura*), reassures its viewers that there can be an end to tragedy: order can be restored and evil expiated once and for all. We achieve this peace, however, only at great cost, perhaps only at the greatest cost of all—the sacrifice of our lives or the lives of loved ones.

There is great pathos in the attitude of the brother who wishes, for honor's sake, to kill his sister. There is great tragedy, and

yet great comfort, in the noble samurai who yield to their own judgment and take their own lives after avenging their master's death (fig. 177). At the tale's conclusion, we are released from sorrow, and the world around us is made whole again.

We all have roles to play. At times we may be asked to do or give more than we believe we can. Art and legend remind us that others have been asked more; they give us new strength to live our lives.

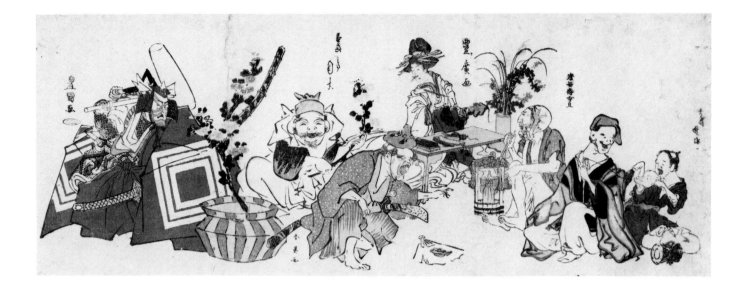

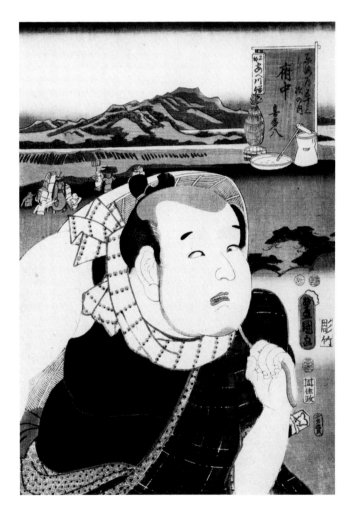

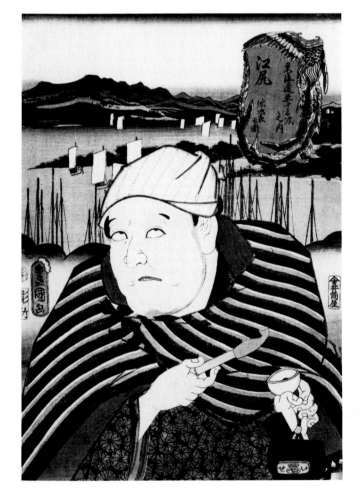

Homeliness

Not every man is a poet or prince; not all are graceful and gallant. The observant artist includes the homely, perhaps even the ridiculous or the ugly. He captures the lascivious fun of street dancers playing for elegant, wealthy ladies, or the tender moment when an ugly man accepts his hideous face.

A man's days are often filled with frustrations: things will not go right, and he is at odds with the world. At such times he revels in the misadventures of fellows like himself.

Fig. 104 (above, facing page). Five men, a woman, and a boy in activities related to the long months of the year 1810.
Utagawa TOYOKUNI, Utagawa TOYOHIRO, Katsukawa SHUN'EI, and three artists from other schools of painting. A picture calendar in long *surimono* format, lacking text. The "long" months in the Japanese calendar contained thirty days. Their sequence changed every year.

Fig. 105 (below, facing page). Actors as Kitahachi and Yajirōbei, heroes of the comic novel *A Shanks'-Mare Tour of the Tōkaidō,* on the road between Ejiri and Fuchū. 1852. From a series of portraits of actors matched with the stations of the Tōkaidō Road.
Utagawa KUNISADA.
Ōban diptych.

Fig. 106 (below left). Two street entertainers performing a dance to celebrate the New Year. *c.* 1800.
Utagawa TOYOKUNI.
Left panel of an *ōban* triptych.

Fig. 107 (below right). The outlaw Kidōmaru wearing a cowhide for warmth and gazing at his reflection in a stream. Mid-1830s. "Ox," from a series of twelve male heroes matched with the animals of the Japanese zodiac.
Utagawa KUNIYOSHI.
Panel format.

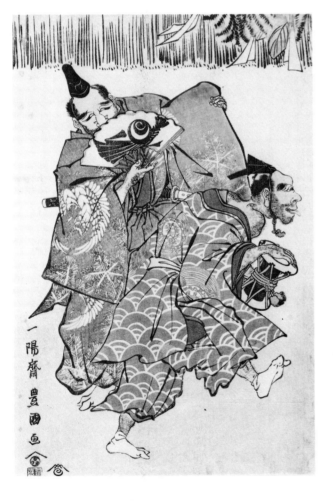

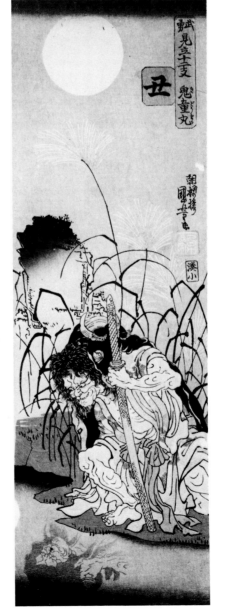

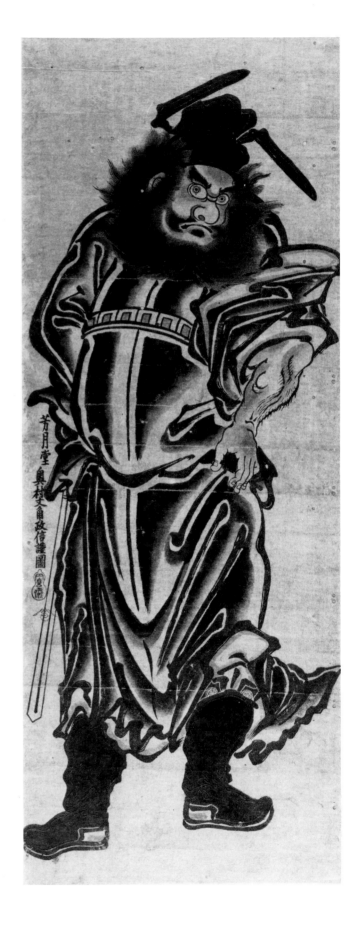

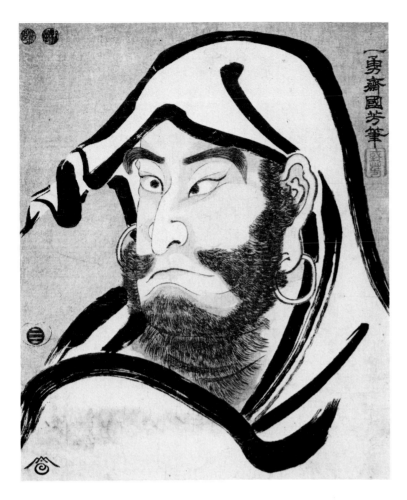

Japanese gods and demons took many forms: the revered and the scorned, the heroic and the comic. Some represented what every man wanted, others what every man wished he could be. Some were special, whimsical friends.

Their messages could be comforting. The fierce, jagged-toothed demon who came like a pilgrim to pray, figure 76 for example, showed how the least deserving might yet find redemption. For boys, the story of the failed civil servant who, after death, found recognition and honor as the emperor's sword-wielding demon slayer (fig. 109) proved that they must never give up hope; each boy might find a way to serve, regardless of his failings. Perseverance and loyalty might yet come to his rescue, even after death.

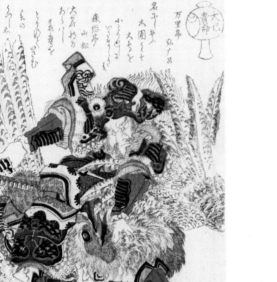

Fig. 108 (far left, facing page). Treasure ship with the seven gods of good fortune. Mid-1770s. Katsukawa SHUNSHŌ. Pillar print.

Fig. 109 (left, facing page). Shōki, a hero of Chinese folk legend, was revered in Japan because he protected boys and inspired them to be brave. 1740s. Okumura MASANOBU. Hand-colored print in hanging scroll format, probably sold and displayed in the fifth month during the Boy's Festival.

Fig. 110 (above). The actor Nakamura Utaemon IV as Bodhidharma, the first patriarch of Zen Buddhism. *c.* 1850. Utagawa KUNIYOSHI. *Ōban* format, trimmed.

Fig. 111 (below). Ōkuninushi, the chief deity of Izumo Province during the Age of the Gods, slaying a wild eagle. 1824. Katsushika HOKUITSU. Square *surimono* format. A privately commissioned print with verses by Shinratei Manzō, Banritei Hiromaro, and Shinsōtei Sanshō.

77

78

Female Impersonation

We often say that men must acknowledge their feminine side and women acknowledge their masculine selves. We try to bridge the separation that our words and concepts insist on.

On the Japanese stage, the dance unites the actors. Now male, now female, the dancer changes costume quickly and easily: male, female, lover, beloved, male, female. In the midst of the dance, the difference disappears for the audience as well.

Fig. 112 (facing page). The actor Ichimura Uzaemon XII as the lord Inabanosuke and the ghost of his dead lover, a courtesan. *c.* 1850. The actor transformed himself from a man to a woman to a ghost by making quick costume changes. Utagawa KUNIYOSHI. *Ōban* format.

Fig. 113. The Osaka actor Arashi Rikaku II as the oil merchant's daughter, Osome, and her young lover, the apprentice Hisamatsu. 1849. The actor performed both roles by making quick costume changes. Konishi HIROSADA. *Chūban* diptych.

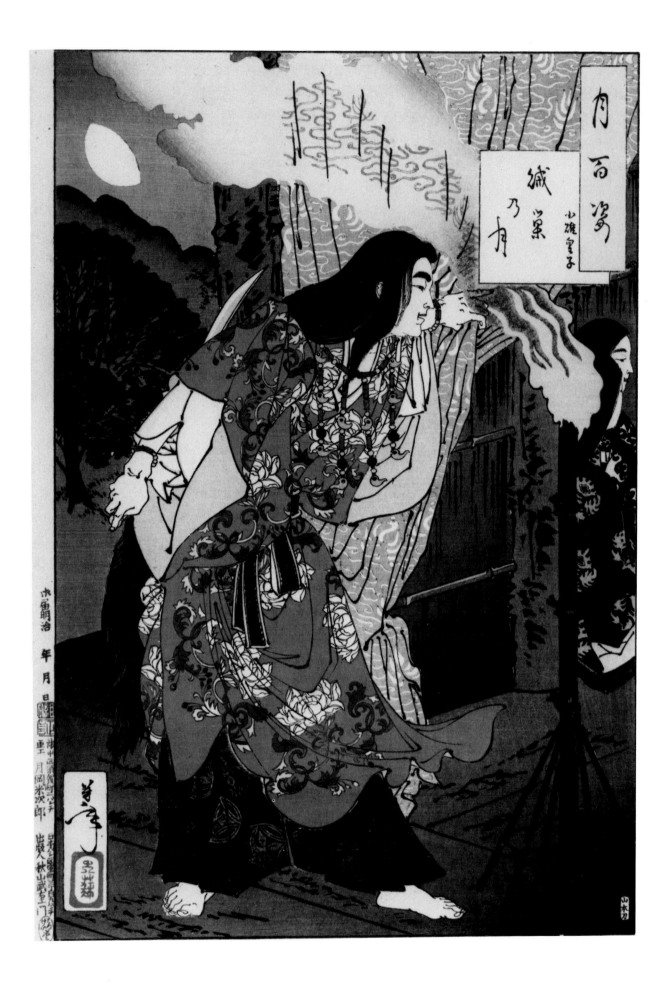

80

On the traditional Japanese stage, all women characters were played by male actors. Once an outgrowth of male prostitution, female impersonation came to hold a place of its own in traditional Kabuki theater. The art, by now divested of its original sexuality, lent a new dimension to the drama and its characters.

Like any tradition, female impersonation had its masters. An actor would play women's roles as a lifelong calling, only occasionally accepting men's roles. In some cases, it became a legacy that was handed down from father to son.

Fig. *114* (*facing page*). Prince Ousu dresses himself as a woman to enter his enemy's camp without suspicion. 1886. "Barbarian's Moon," from the series *One Hundred Aspects of the Moon*. Ousu was the boyhood name of Yamato Takeru, a son of the twelfth Japanese emperor. He disguised himself as a dancer to conquer two brothers in the adjacent land of Kumaso.
Tsukioka YOSHITOSHI.
Ōban format.

Fig. *115* (*above left*). The actors Nakamura Nakazō I and Iwai Hanshirō IV as a priest and a dancer struggling over a precious sword. *c.* 1770.
Katsukawa SHUNSHŌ.
Hosoban format.

Fig. *116* (*above center*). The actor Ichikawa Danzō IV in a female role as the spirit of a lion dancing among butterflies in an adaptation of the Nō play *Stone Bridge*. 1770s.
Katsukawa SHUNKŌ.
Hosoban format.

Fig. *117* (*above right*). Members of the audience imitate a graceful gesture by the visiting Osaka actor Arashi Hinaji. *c.* 1770.
Ippitsusai BUNCHŌ.
Hosoban format.

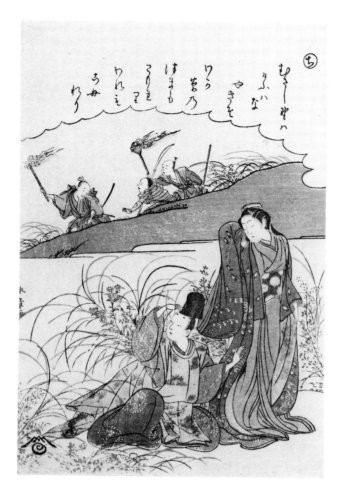

Relationships

In love, we succumb to the new self within
ourself: the lover. Our thoughts and ac-
tions, our very features, soften under love's
influence.

In Japanese prints, lovers are open and
sensitive, forever tender and youthful. The
aggressive warrior, the greedy merchant,
and the treacherous nobleman are not seen
in the lover's chambers.

At times, the union of lover and beloved
is so complete that they seem but two
halves of a whole—two dancers in a single
dance.

Fig. 118 (above left). The
courtier Ariwara no
Narihira eloping with a
lover and hiding from
pursuers. 1770s. From
an untitled series of il-
lustrations of episodes
from the *Tales of Ise*.
Katsukawa SHUNSHŌ.
Small *chūban* format.

Fig. 119 (above right).
The actor Ichikawa
Danjūrō II looks down
from a wisteria arbor at
a pair of lovers. 1720s.
The young man wears
the crest of the actor
Ichikawa Monnosuke I.
The large lantern is
decorated with the em-
blem of the Nakamura
Theater.
Okumura TOSHINOBU.
Hand-colored print in
hosoban format.

Fig. 120 (facing page).
The oil merchant's
daughter, Osome, and
her young lover, Hisa-
matsu, an apprentice in
her father's shop. 1790s.
From *The Essence of the
Heart of Love*, a series of
imaginary portraits of
famous lovers from his-
tory and legend.
Kitagawa UTAMARO.
Ōban format.

Men in Love

Sometimes, the game of love appears to be a treacherous contest between the pursuer and the pursued. The inexperienced youth, man or woman, is especially hesitant and uncertain.

Perhaps there are so many scenes in Japanese prints of the desirable, beautiful woman seeking the man because there were so many men suffering the vulnerability of being the pursuer. How wonderful to be asked, to be wanted! How wonderful to imagine the game as simply enjoyable.

Fig. 121 (above). A youth lifts a young woman so she can tie a poem slip to the branch of a flowering cherry tree. *c.* 1800. Utagawa TOYOKUNI. *Ōban* format, probably a panel from a triptych.

Fig. 122 (below). Osen playing with a cat held by a visitor to her tea-shop at the entrance of the Kasamori Shrine. Late 1760s. Osen was a girl in her mid-teens, one of the most celebrated beauties in Edo in the late 1760s. Harunobu designed over forty pictures of her before she eloped with a samurai in 1770. Suzuki HARUNOBU. *Chūban* format.

Fig. 123 (above, facing page). A young couple seated on a porch in the moonlight. *c.* 1900. Mizuno TOSHIKATA. *Aiban* format. Frontispiece for a romantic novel.

Fig. 124 (below, facing page). Aggressive women urging travelers to stay at their inn in Goyū. Mid-1830s. From the series *Fifty-three Stations of the Tōkaidō Road*. Utagawa HIROSHIGE. *Ōban* format. Detail.

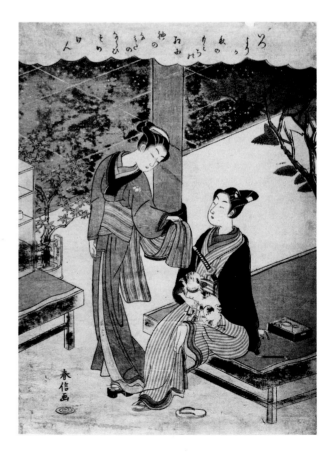

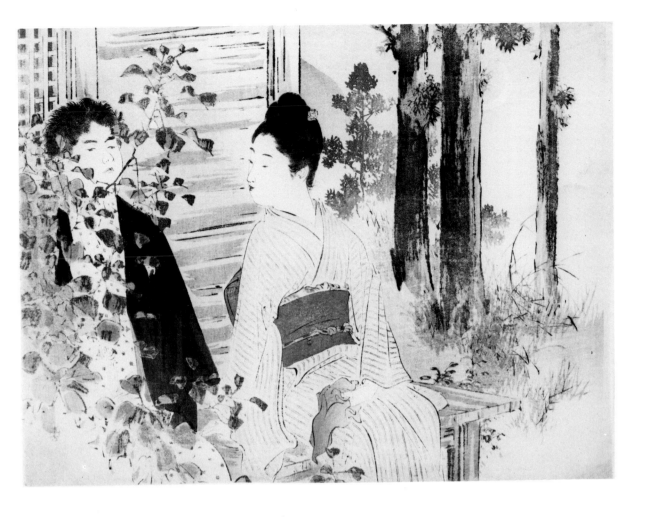

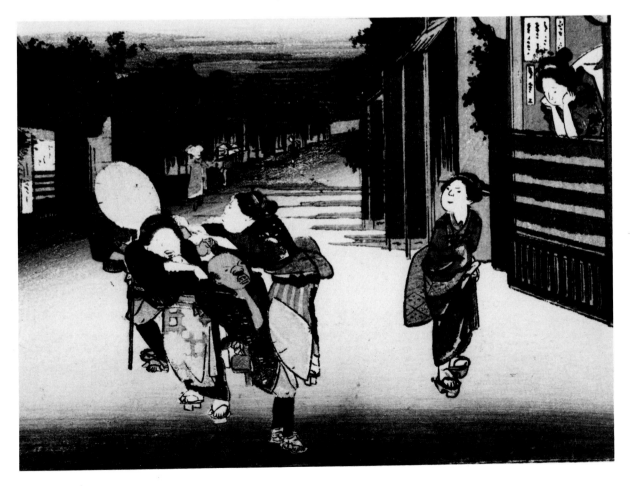

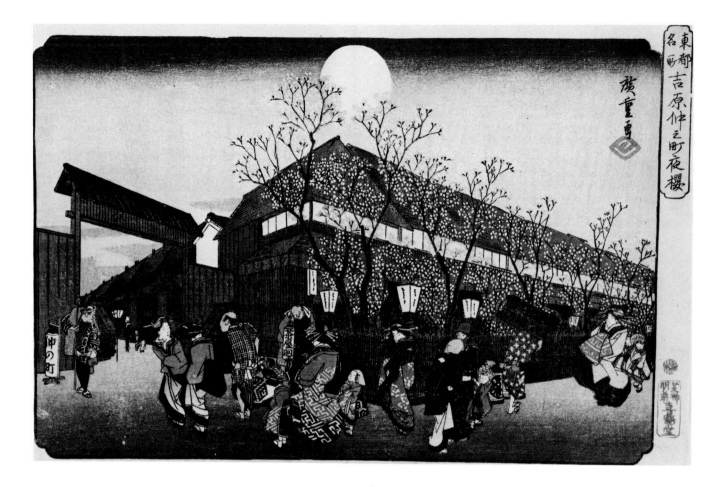

86

Fig. 125 (above). Cour-
tesans, employees, visi-
tors, and clients strolling
at night beneath the
cherry trees on the main
street of the Yoshiwara
brothel district in Edo.
Mid-1830s. From the se-
ries *Famous Sites in the
Eastern Capital.*
Utagawa HIROSHIGE.
Ōban format.

*Fig. 126 (above, facing
page).* Dwarf men with
faces saying "Good" and
"Evil" competing for the
attentions of a young
man in the brothel dis-
trict. Early 1790s.
Eishōsai CHŌKI. *Ōban*
format.

*Fig. 127 (below, facing
page).* The courtesan
Takao and her atten-
dants entertaining the
actors Sawamura
Gennosuke and Iwai
Kiyotarō at the Miuraya,
a brothel in the Yoshi-
wara quarter. *c.* 1805.
Kitagawa TSUKIMARO.
Ōban triptych.

Grown men have been a long time without
the total, caring warmth of their mothers.
Once, wrapped in the security and love of
their mothers, they were safe and happy.
But years have passed since they were ca-
ressed, cuddled, and served in anticipation
of their every wish.

Such comfort in the company of women
—a pleasure and relief beyond sexual re-
lease—was available to Japanese men in the
intoxicating hours spent in the brothels.
This wonderful indulgence was very ex-
pensive, and yet so irresistible that some
men were actually bankrupted by it.

The brothel district was a familiar one,
even to those who did not frequent its
houses. Not everyone approved. At first
glance the setting (fig. 126) looks static and
unremarkable, but when we look more
closely we see good and evil battle for a
young man—should he go in?

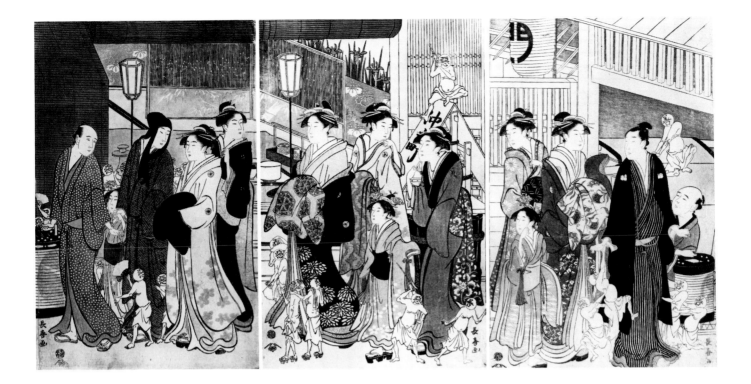

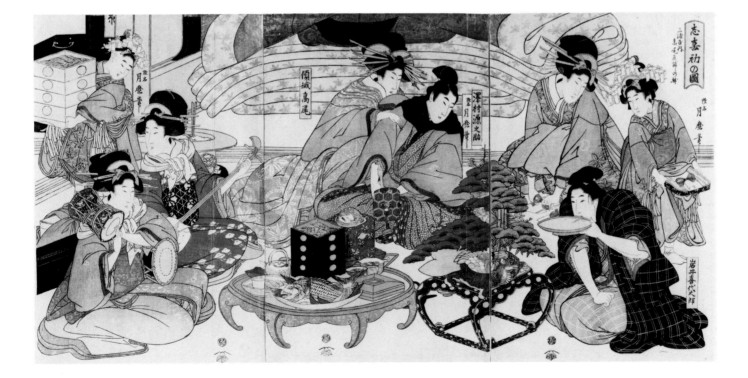

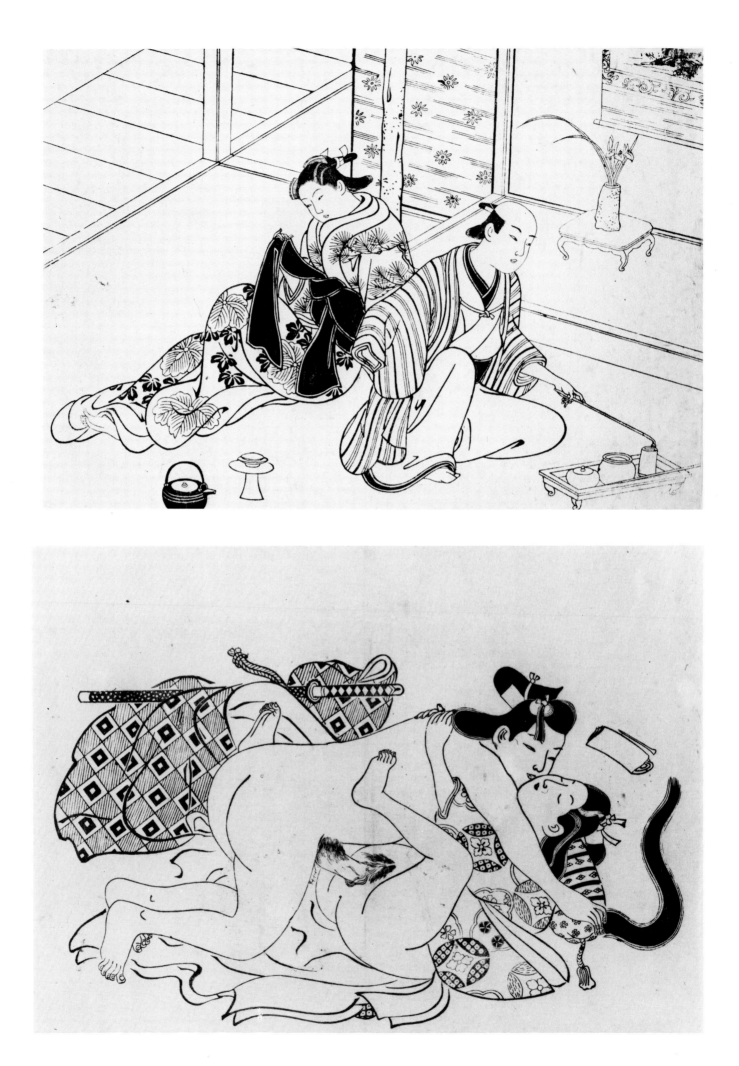

88

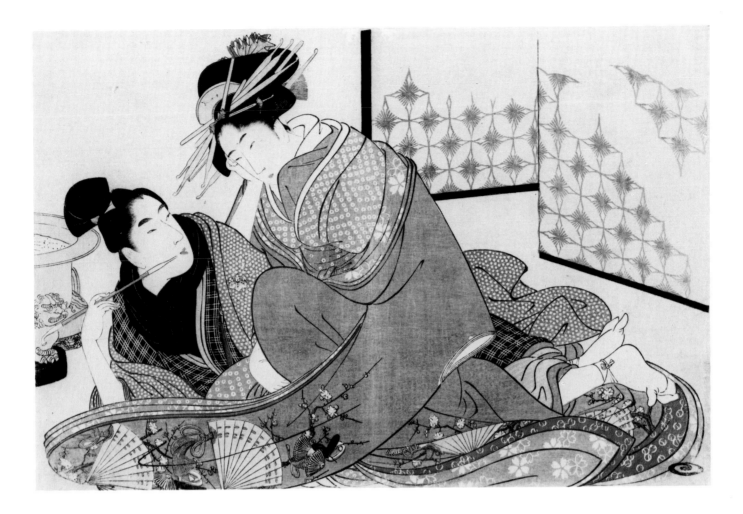

Sexual Love

Lovers meet in intimate chambers, sheltered from the world and its myriad details. Protected for a time, they relax and yield to each other.

In early prints, we glimpse sexual engagement as mutual gratification: equal partners, equally engaged.

In their timeless embrace, the lovers discover again in the bond of man to woman the ineffable coupling of one spirit with another. Beyond the poetry of their relationship, beyond their serenity and release, they sound the depths of human experience.

Fig. 128 (above, facing page). A townsman and a courtesan seated beside a picture alcove. *c.* 1740s. From an untitled series. Hasegawa MITSUNOBU. *Ōban* format.

Fig. 129 (below, facing page). Couple making love. *c.* 1680s. From an untitled series of erotic prints. Attributed to Sugimura JIHEI. *Ōban* format.

Fig. 130 (above). Young man making sexual advances to a courtesan. *c.* 1800. From an untitled series of erotic prints. Kitagawa UTAMARO. *Ōban* format.

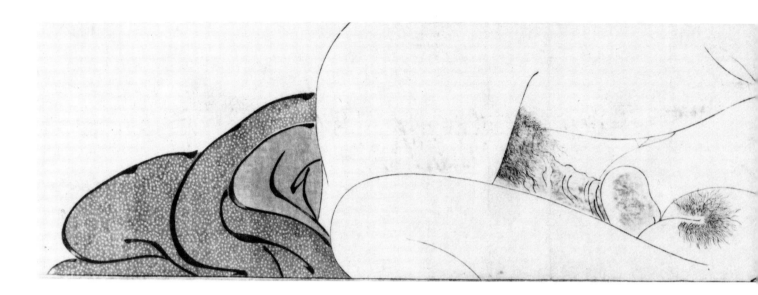

Something so vital as sexual engagement can be enjoyed in many forms: a man gently overcoming a girl's shyness; rapacious prostitutes vying for customers (fig. 125); the topsy-turvy view of male eroticism as the woman traps her partner in a judo hold; the elusive object of a man's fancy laughing at his advances; a couple losing any sense of shame or decorum in their mutual pleasure.

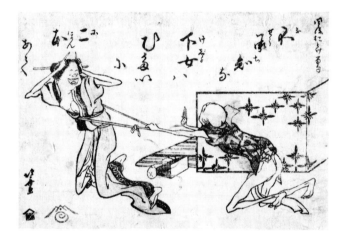

Fig. 131 (above). A mature man preparing to make love to a young girl. 1780s. From an untitled series of twelve erotic prints. Attributed to Torii KIYONAGA. Horizontal pillar print.

Fig. 132 (upper right). A household maid mocks a would-be lover. 1805– 15. From the series *One Hundred Elegant Examples of Comic Verse.* Katsushika HOKUSAI. *Koban* format. The verse was probably written by the artist. It reads, "The housemaid flatly refuses and lifts two fingers to her brow."

Fig. 133 (lower right). A woman throws her lover to the ground with a judo hold during intercourse. 1824. From the series *Acrobatic Spring Amusements.* UNIDENTIFIED EDO ARTIST. *Koban* format. A picture calendar, with the numbers for the short months inscribed between the flowers on the woman's costume.

Fig. 134 (facing page). Couple making love. 1810s. From a series of twelve erotic prints. The lovers' thoughts and exclamations are written at the top of the picture. Katsushika HOKUSAI. *Ōban* format.

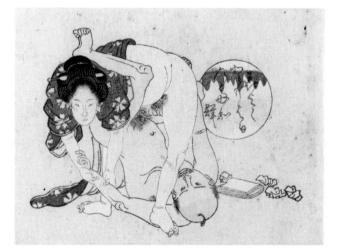

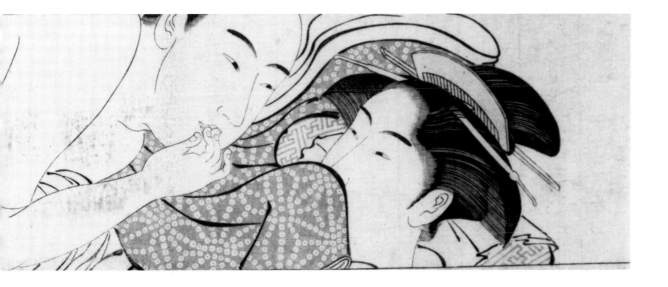

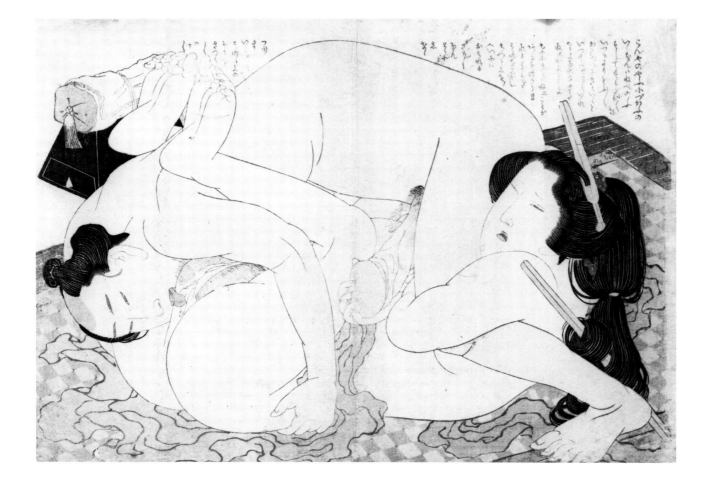

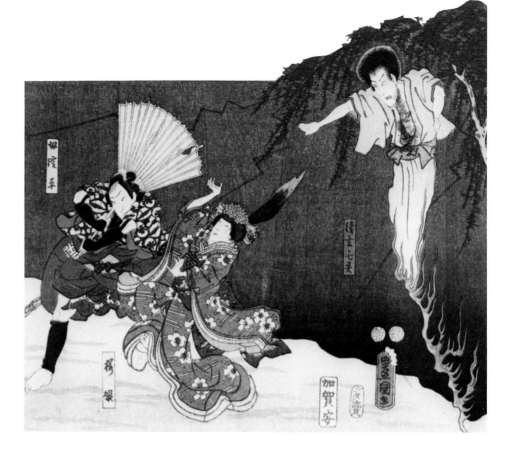

Sexual Obsession

Fig. 135 (above). Actors as the ghost of the monk Seigen frightening his former lover, Sakura Hime, and Yodohei, her servant companion. 1850–52. From an untitled series of scenes from Kabuki plays. Utagawa KUNISADA. Irregular half-block format.

Fig. 136 (below). The actor Ichikawa Komazō III as the obsessed monk Seigen. 1791. Katsukawa SHUN'EI. *Hosoban* format.

What is it to love so deeply that all else pales into insignificance? Overwhelmed, we abandon work, responsibility, social standing, even reason?

Who has not wanted to experience such an exquisite passion?

Legends of star-crossed lovers abound; plays faithfully retrace their fatal steps. We are at once indulged and forewarned: this is the deadly outcome of such rapture.

As individuals we may be startled at the strength of our emotions. There is a time and place for passion, the pictures seem to say, but not to excess. Reluctantly—with relief, perhaps—we resume our temperate lives, shoulder our particular duties, and carry on.

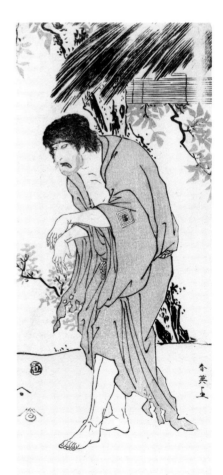

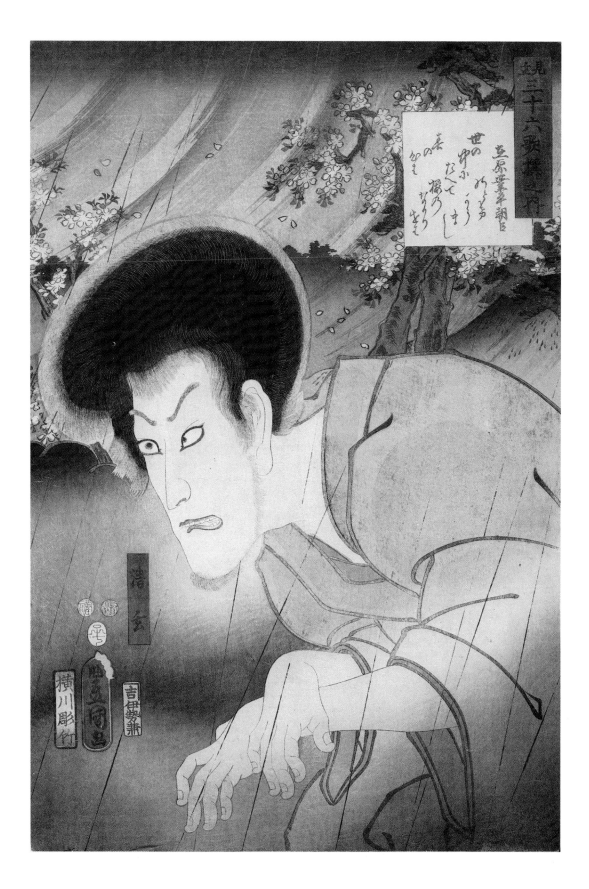

Fig. 137. The actor Onoe Kikugorō III as the ghost of the obsessed monk Seigen. 1852. Illustration for a verse by Ariwara no Narihira from a series of portraits of actors matched with thirty-six classical poets. Utagawa KUNISADA. *Ōban* format. Seigen's lover was named Cherry Blossom; the verse asks how the human heart could endure the spring without cherry blossoms.

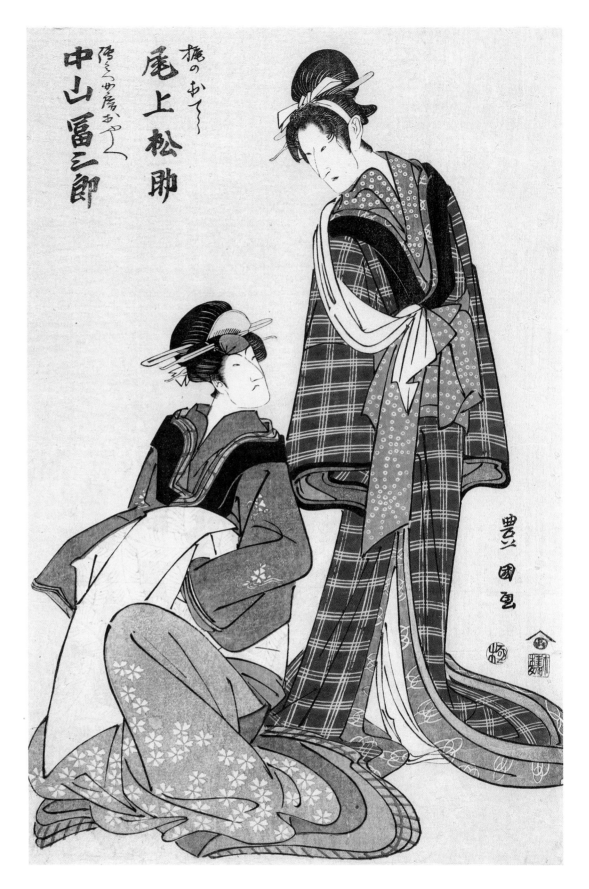

中山冨三郎
隠くの世店おやく

尾上松助
撫のお～

豊国画

94 *Fig. 138*. The actors
Nakayama Tomisaburō
as Denbei's wife Oyae
and Onoe Matsusuke I
as Kaji no Ochō, a
waitress at the Ōgiya
brothel. 1800. From an
untitled series of por-
traits of pairs of actors
in scenes from plays.
Utagawa TOYOKUNI.
Ōban format.

Fig. 139 (facing page).
The actor Onoe
Kikugorō III as the wet
nurse Masaoka. 1860.
From an untitled series
of bust portraits of cele-
brated actors, past and
present, in famous roles.
Masaoka, a lady-in-
waiting in the court of
the Date clan in Sendai,
saved the clan's young
heir from an assassina-
tion attempt by prepar-
ing his food and sacrific-
ing her own son.
Utagawa KUNISADA.
Ōban format. Kikugorō
died in 1849, eleven
years before Kunisada
designed this portrait.

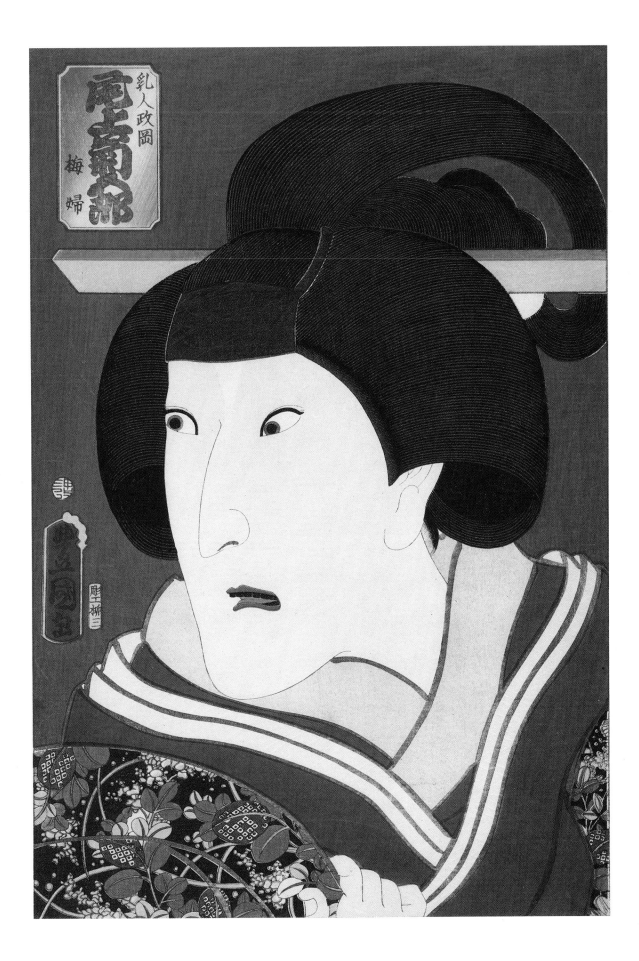

95

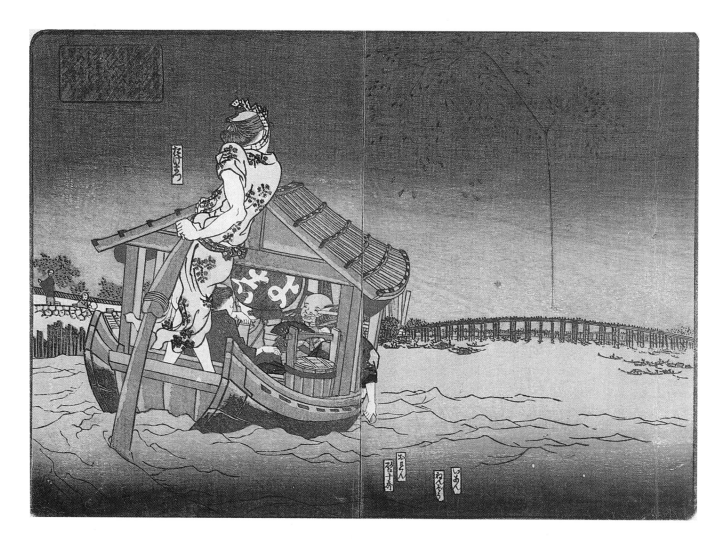

96

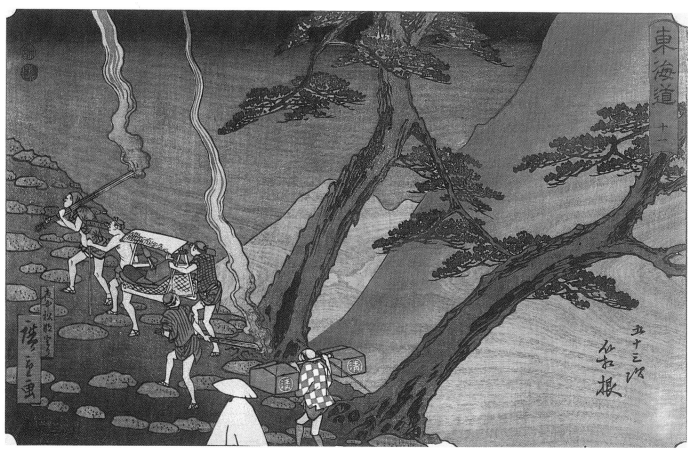

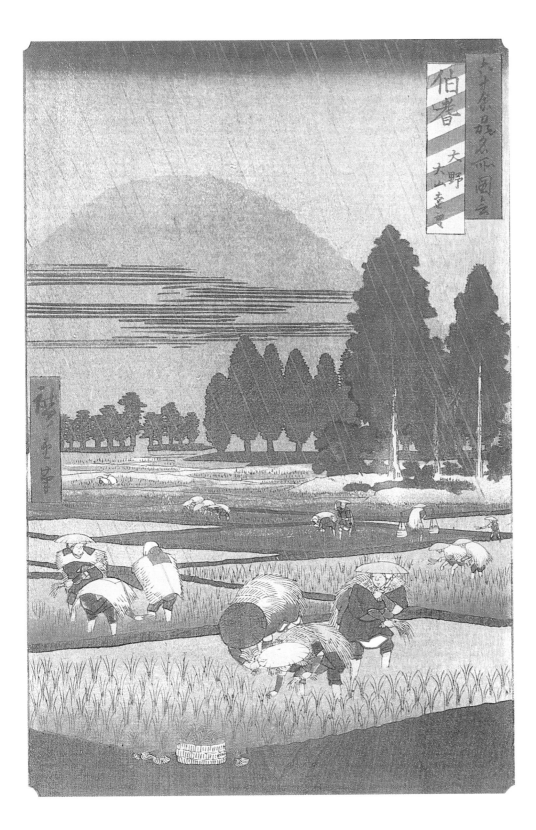

Fig. 140 (*above, facing page*). Takematsu, a boatman, rows a group of revelers toward Ryōgoku Bridge during a display of fireworks. *c.* 1850. Utagawa KUNIYOSHI. Double-page book illustration.

Fig. 141 (*below, facing page*). Men traveling by torchlight through the mountains near Hakone. *c.* 1850. Plate 11 from *Fifty-three Stations of the Tōkaidō Road.* Utagawa HIROSHIGE. *Ōban* format.

Fig. 142 (*this page*). A distant view of Mount Ōyama from the rice fields of Ono, in Hōki Province. 1853. From the series *Pictures of Famous Places in the Sixty-odd Provinces.* The farmers are planting rice seedlings. Utagawa HIROSHIGE. *Ōban* format.

97

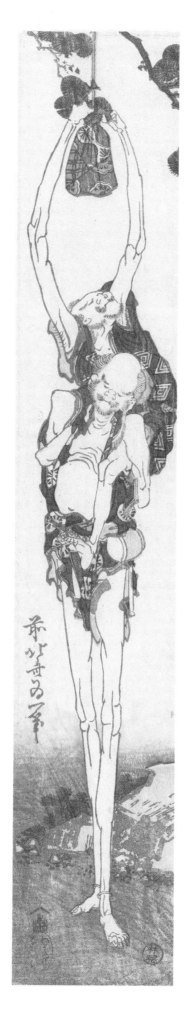

Fig. 143 (*this page*). A long-legged man and a long-armed man cooperate to reach a brocade bag hanging in a pine tree. Early 1830s. From an untitled series of panel pictures printed in shades of blue. Katsushika HOKUSAI. Narrow panel format.

Fig. 144 (*above, facing page*). An elegantly dressed couple standing on a hill overlooking a river. 1853. "A Snowy Prospect," from the series *A Modern Prince Genji*. Many prints of extravagantly dressed young men enjoying their leisure were inspired by a popular novel based on the *Tale of Genji* with illustrations by Kunisada, published between 1829 and 1842. Utagawa KUNISADA (figures) and Utagawa HIROSHIGE (landscape). *Ōban* triptych.

Fig. 145 (*below, facing page*). Young lovers on a summer evening. 1853. "The Night Garden," from the series *A Modern Prince Genji*. Utagawa KUNISADA (figures) and Utagawa HIROSHIGE (landscape). *Ōban* triptych.

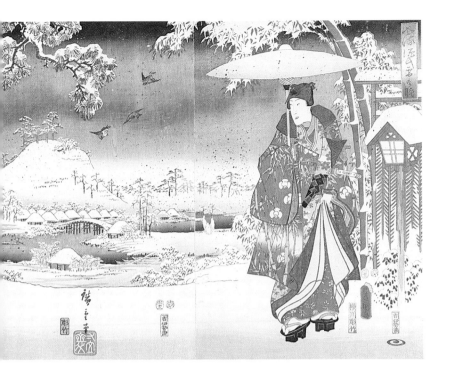

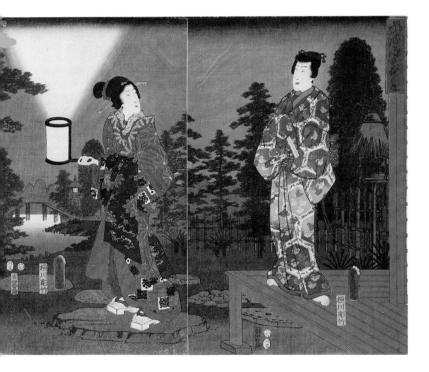

99

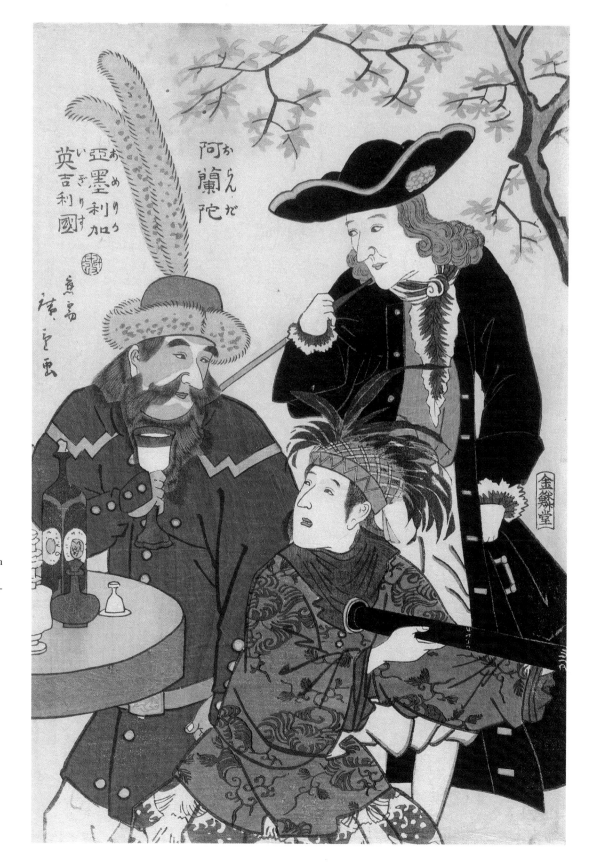

阿
蘭
陀
お
ら
ん
だ

亞
墨
利
加
あ
め
り
か

英
吉
利
國
い
ぎ
り
す

100 *Fig. 146.* A Dutchman with a pipe, an Englishman drinking spirits, and an American woman holding a telescope and wearing an Indian headdress. 1860. Prints of foreigners were popular in Edo for a few years after the port of Yokohama was opened to trade in the summer of 1859.
Utagawa HIROSHIGE II.
Ōban format.

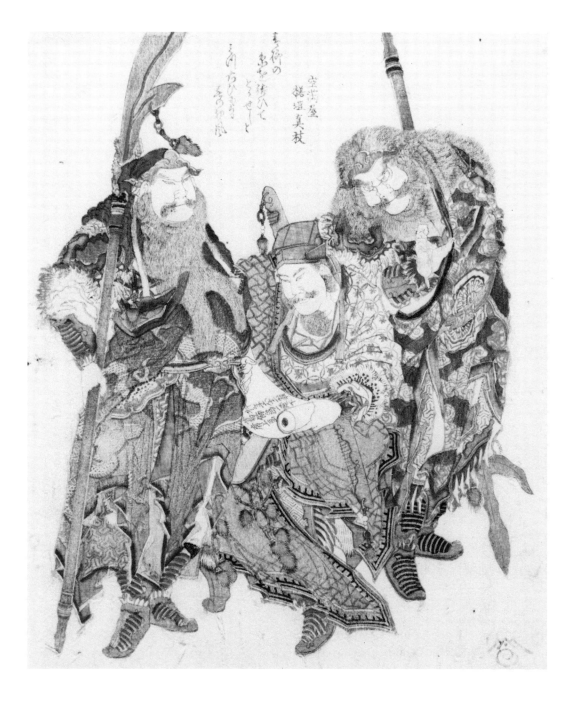

Friendship

Out in the world, we take our place beside
colleagues, friends, and neighbors. Among
other men, we keep our thoughts close and
present a sterner aspect. We have much to
do, and many responsibilities. Our friends
are those we meet in our daily tasks, men
whose lives are like our own.

Our friendship is fast and our dedication
is unquestioned, yet we seldom speak of
our love or need for one another.

But the loyal oaths of legendary com-
rades speak our hearts' desire.

Fig. 147. Guan Yu, Liu
Bei, and Zhang Fei,
three Chinese heroes
who swore eternal
friendship. 1820.
Katsushika HOKUSAI.
Square *surimono* format.
Verse by Kūman'ya
Tadagaki Maeda.

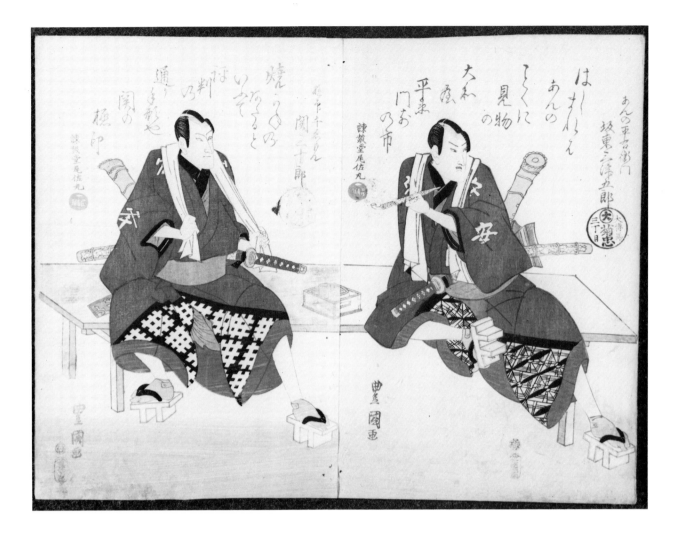

Men's Groups

Townsmen formed small groups of friends who dressed alike and spent their leisure time together. Some of these bands championed causes and helped people who were poor, weak, and disenfranchised.

Fig. 148 (above, this page). The actors Seki Sanjūrō II and Bandō Mitsugorō III as Sen'emon and Heiemon, members of a band of five friends who fought injustice in Edo. 1810s. Utagawa TOYOKUNI. Two *ōban* from a set of five.

Fig. 149 (above, facing page). The actors Kawarazaki Gonjūrō and Ichikawa Ichizō III as Rough Beach Kōji and Wild Lion Denzō, members of a band of five friends. 1861. Utagawa KUNISADA. Two *ōban* from a set of five.

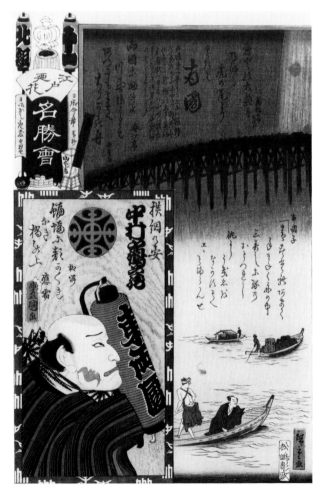

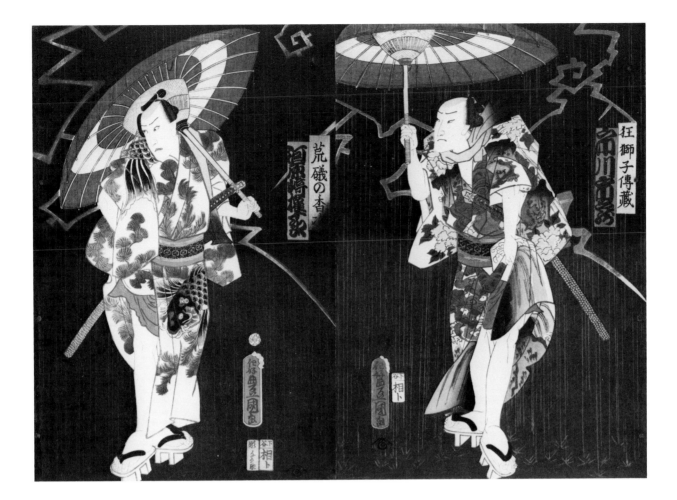

Loyalty

In stories and in life, loyal friends can be counted on. When Yosaburō's face was mutilated by a jealous gang leader, most of his acquaintances deserted him. In desperation, he became a petty thief to support himself. His friend Yasu, with his ugly, bat-shaped mole, refused to abandon him.

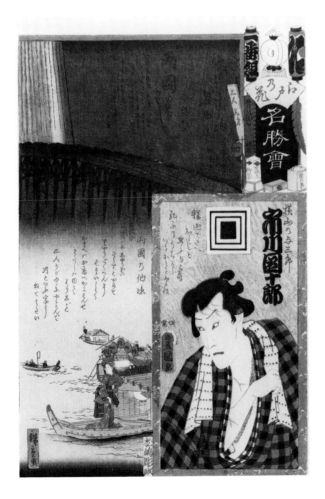

Fig. 150. The actors Ichikawa Danjūrō VIII and Nakamura Tsuruzō as the thief Scarface Yosaburō and his henchman "Bat" Yasu. 1863. "Ryogoku Bridge," from a series of famous places, products, and actors of Edo. Utagawa KUNISADA and Utagawa HIROSHIGE II. Two panels of an *ōban* triptych.

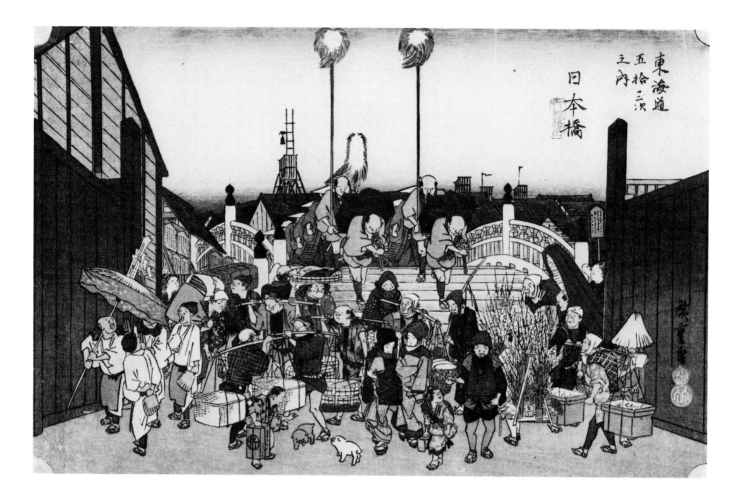

東海道
五拾三次
之内

日本橋

Work

As Western men, we are preoccupied throughout our adult lives with the work we do. We take our primary self-definition from it: we work to earn a living, to achieve, to belong, and to avoid feeling.

When we look at these pictures of Japanese men, we see many warriors, noblemen, and lovers, but few carpenters or bookkeepers—until we look more closely.

Then we see that landscape prints are seldom pure landscape. They show us people working at their daily tasks. They present a person's work not solely in relation to the worker or even merely in relation to other human beings. Rather, work becomes an activity that takes place in relation to the world at large.

Many workers in many occupations kept Japan alive. In city and country, on land and sea, men pursued their livelihoods. In the prints revelers dine and sing on their pleasure barge, while the oarsman bends to

his task (fig. 140). Porters pause in their journey through the night (fig. 141); their muscular forms merge with the landscape and are part of it.

Such pictures as these gave wealthy and plebeian townsmen alike a chance to contemplate how people fared in other stations of life.

Fig. 151 (above). Crowds of workmen and travelers at Nihon Bridge in Edo. Mid-1830s. From the series *Fifty-three Stations of the Tōkaidō Road.* Utagawa HIROSHIGE. *Ōban* format.

Fig. 152 (facing page). Ebisu, a god of fortune, oversees a work force of rats storing bales of rice in warehouses. Late 1790s. Katsukawa SHUNZAN. Fan print. Because of their association with stored grain, rats were symbols of wealth and abundance and were companions of the god Ebisu.

Merchants

In the bountiful peace between 1600 and 1850, Japanese merchants prospered. Lower in status than the nobility, below the productive farmer, the protective warrior, and the skillful craftsman, the merchant sold, bought, and grew rich. As his wealth increased, he bought prints, commissioned art, and enjoyed his affluence.

Unlike the miser trapped by his gold, the wealthy Japanese merchant enjoyed a life of gratification and fulfillment. Money, he knew, had no inherent value. Across Japan, men were paid first in rice, a tangible item, valuable because it sustained life. Excess rice was converted into gold and silver, yet these metals were nothing in themselves.

They were only a means to enhance life, to purchase art, refinement, and pleasure.

Merchants did not particularly want to see daily tallies, bookkeeping, and trading in their prints. They preferred legends, lovers, landscapes, and fantasies. What fun to see the god of wealth—one of the seven gods of good fortune—watch a work force of rats, his familiar animal, take care of the granaries as ship after ship arrives, bringing ever greater riches and abundance.

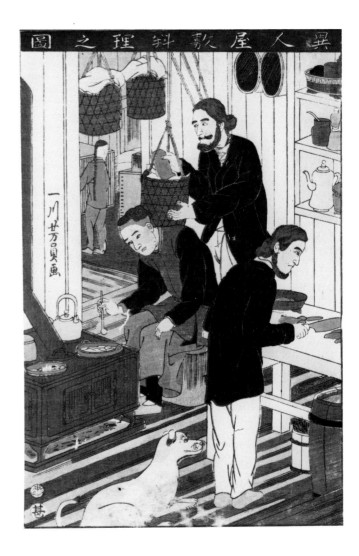

Cooperation

Fig. 153 (above). Cooking in a Foreign Mansion. 1860. Portraits of two European men and a Chinese servant. From an untitled series of pictures of foreigners. Utagawa YOSHIKAZU. Ōban format.

Fig. 154 (above, facing page). Workman repairing the tile roof of Hongan Temple in Asakusa, Edo. Early 1830s. From the series Thirty-six Views of Mount Fuji. Katsushika HOKUSAI. Ōban format.

Fig. 155 (below, facing page). The actors Onoe Matsusuke I and Onoe Eisaburō as Daibutsu-bōzu Mibu and Issun Denbei, a priest and a townsman, struggling over a giant carp. 1805–10. Utagawa TOYOKUNI. Ōban diptych.

People do not live in isolation but in relation to one another and the world. Japanese artists continually depicted this important truth by showing people at work together.

The long-legged man holds the long-armed man on his back to share a treasure neither could reach by himself (fig. 143). Even the strange Western men who sailed to Japan in the latter half of the nineteenth century worked together, cooking their own food in curious kitchens without women.

Are we not all short-legged or short-armed? Do we not all keep reaching for things beyond our grasp? Roofers at the top of the world, rivals bent on the capture of a carp, we all need one another's long arms or legs.

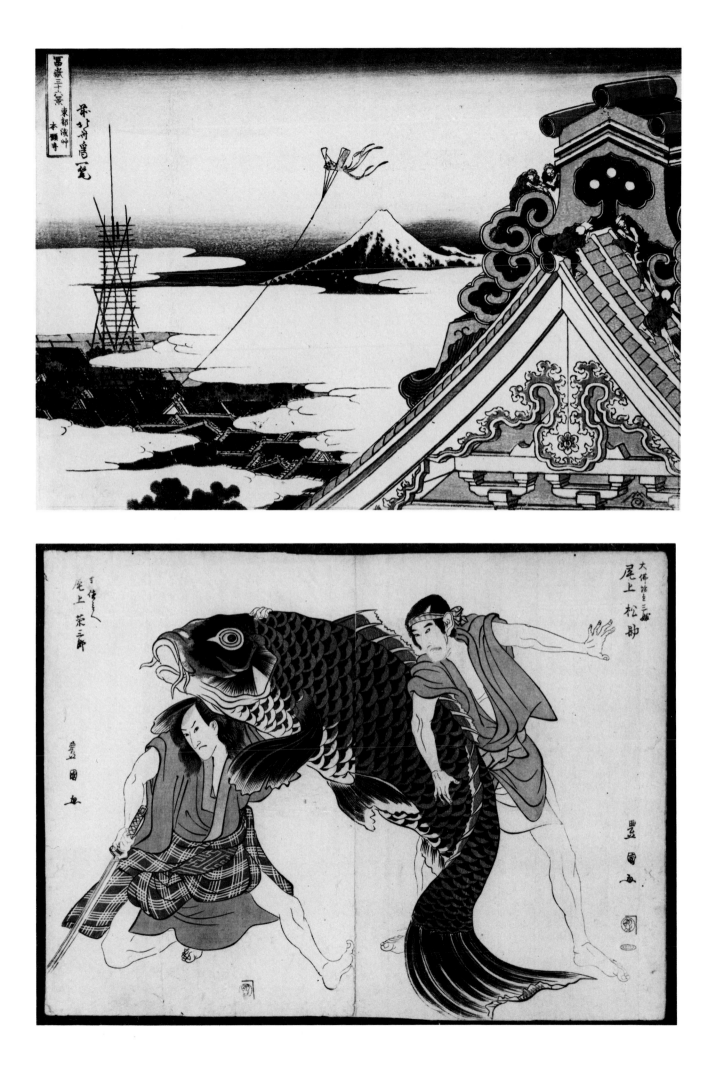

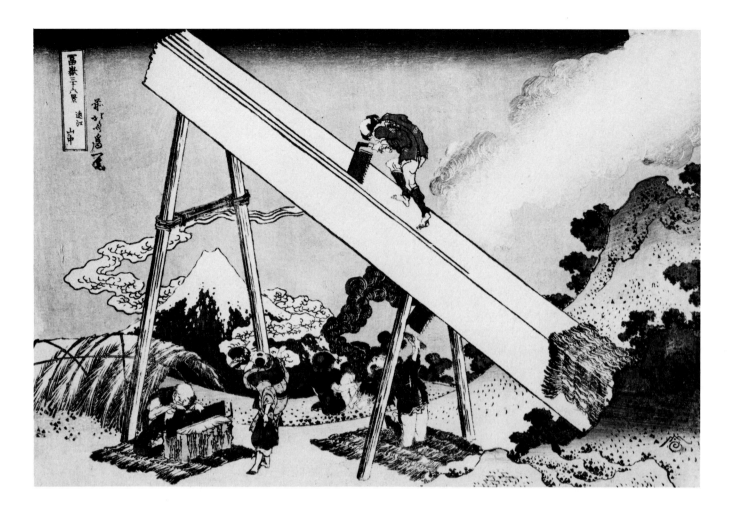

Unusual Occupations

The glittering knives dance and fall into
the Westerner's hands. He is never cut. His
companion spins round and round. What
magical motions! What curious men!

 Foreign acrobats provided glorious sub-
jects for the ever-curious, ever-exploring
printmakers, and so did the ingenious con-
trivances of sawyers in the mountains and
the comical mishaps of laborers closer to
home.

Fig. 156 (above). A fam-
ily producing lumber in
the Tōtomi Mountains.
Early 1830s. From the
series *Thirty-six Views of
Mount Fuji.*
Katsushika HOKUSAI.
Ōban format.

Fig. 157 (below). Work-
man falling into a plas-
ter tub at Onmayagashi.
1860. Number 42 from
the series *Humorous
Views of Famous Sites in
Edo.*
Utagawa HIROKAGE.
Ōban format.

Fig. 158 (facing page).
Acrobats from central
India performing at
Yokohama. 1864.
Utagawa YOSHITORA.
Ōban format.

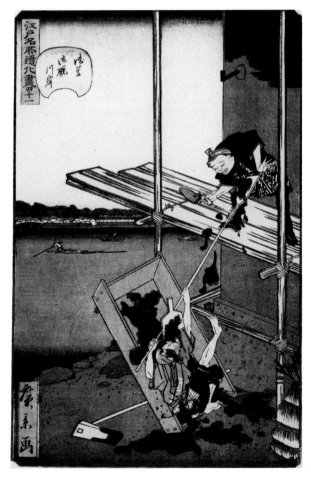

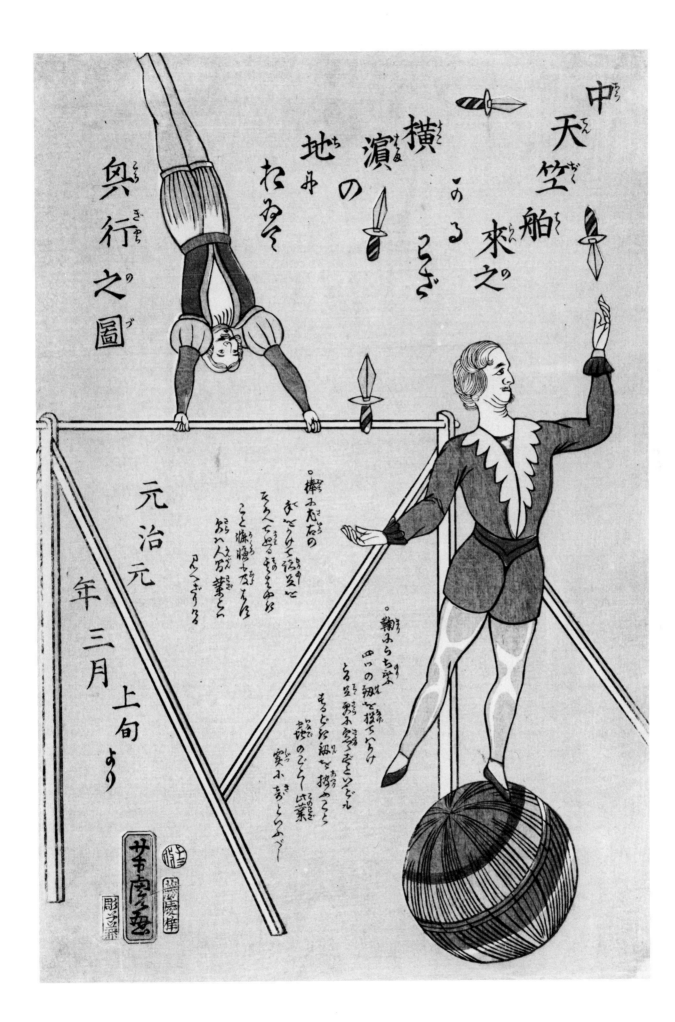

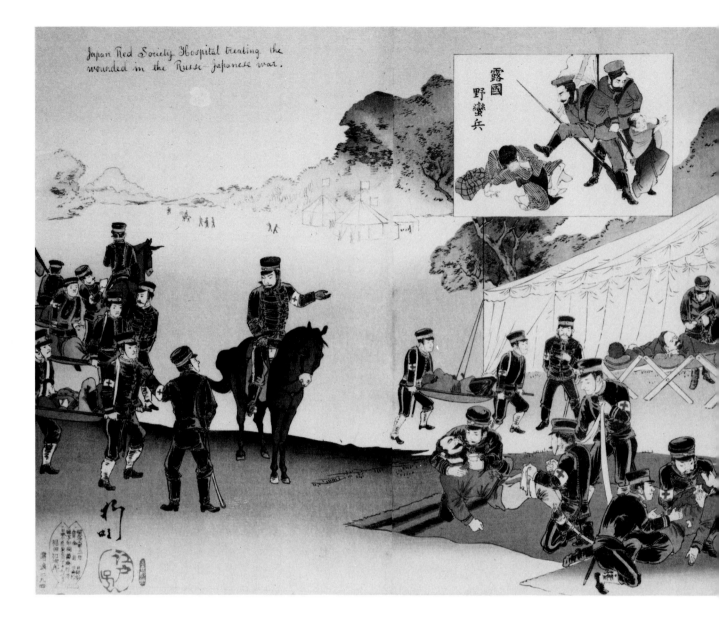

Japan Red Society Hospital treating the
wounded in the Russo-Japanese war.

露國
野蠻兵

110

Nurturing

As the new century began, Japan emerged
to take her place beside the other nations
of the world. In the Russo-Japanese War,
East clashed with West for the first time on
a massive scale. Pitted against giant Russia,
how would Japan fare? As civilization met
civilization, what would this encounter say
about Japan as a nation?

This hospital scene reassured people at
home. Brave in battle, Japan's uniformed
soldiers were compassionate, efficient, and
generous as they moved among their
wounded enemy captives. And in the ab-
sence of women, men found that they
could provide nurturing care.

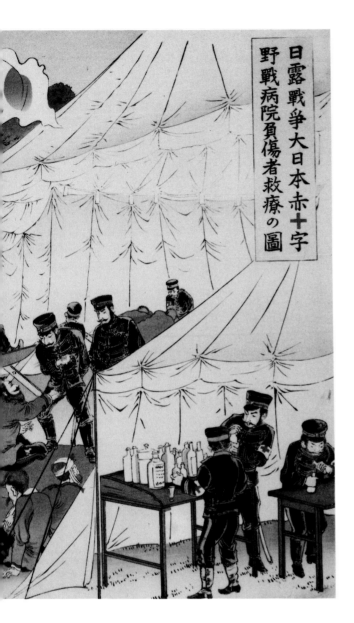

日露戦爭大日本赤十字
野戰病院負傷者救療の圖

III

Fig. 159. A Japan Red So-
ciety Hospital Treating the
Wounded in the Russo-
Japanese War. 1904.
Baidō KOKUNIMASA.
Ōban triptych. A view of
a Red Cross Society field
hospital. In the inset,
"barbaric Russian troops"
are mistreating Japanese
children. Kokunimasa
began to sign his prints
as Edokko RYŪA, as here,
in 1904.

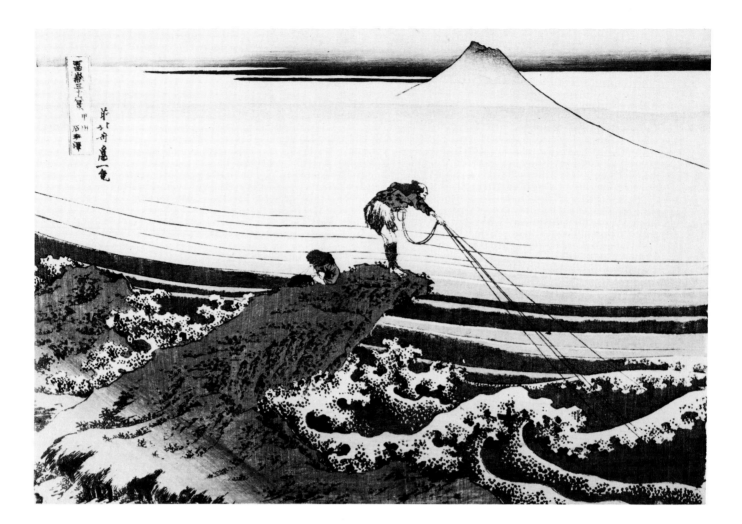

Fishermen

Island dwellers, the Japanese have drawn wealth and sustenance from the surrounding sea since their beginning.

A force with a powerful character all its own, the sea springs to life as oarsmen battle to move their boats through the waves. A fisherman brings his son to the water's edge, passing on ancient traditions that mean sustenance to each generation.

Grasping reality, the Zen monks say, is as hard as catching a catfish with a gourd. Maybe someone has finally done it! The catfish grins, as though he knows better.

Fig. 160 (above). A fisherman and his son on a promontory at Kajikazawa in Kai Province. Early 1930s. From the series *Thirty-six Views of Mount Fuji.* Katsushika HOKUSAI. *Ōban* format.

Fig. 161 (facing page). The actor Ichikawa Kyūzō II as a fisherman trying to catch a catfish with a gourd. Mid-1830s. From a series of eight prints. Trying to catch a catfish with a gourd was a Zen proverb for an impossible task. Utagawa KUNISADA. *Ōban* format. Verse by the actor Ichikawa Danjūrō VII.

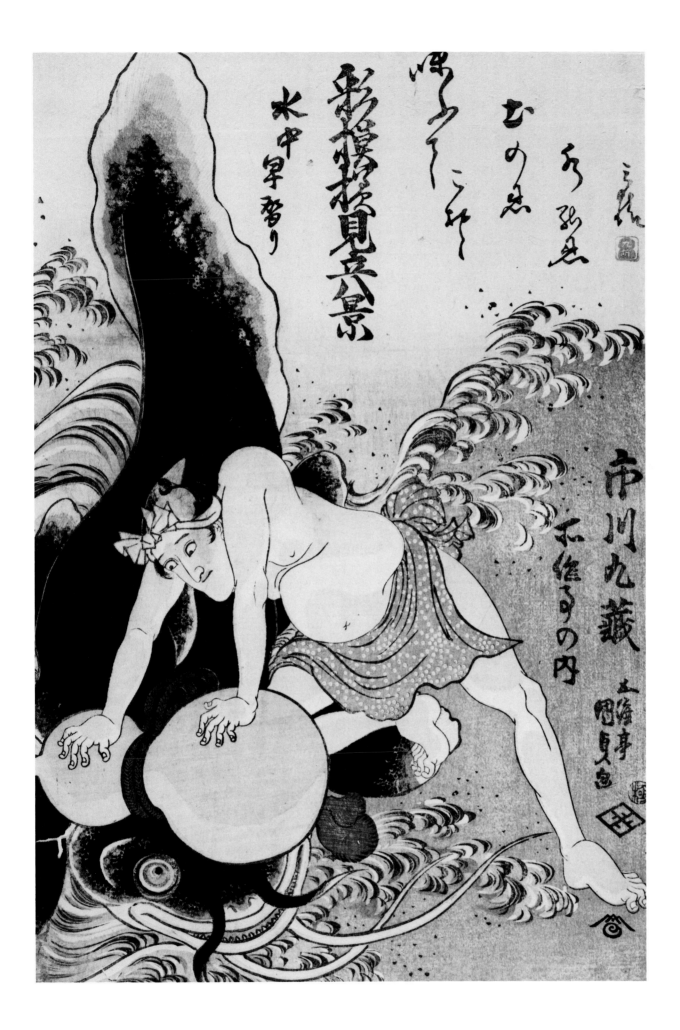

113

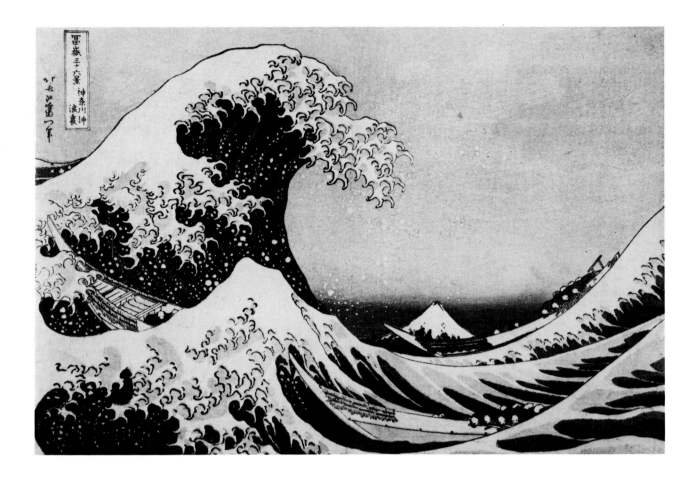

Fig. 162 (above). Ships transporting fish in high seas along the coast of Kanagawa. Early 1830s. From the series *Thirty-six Views of Mount Fuji*. Katsushika HOKUSAI. *Ōban* format.

Fig. 163 (facing page). A peasant family living near the inland town of Miyanokoshi flees from their district secretly at night to escape the famine caused by an extended drought and crop failures. Mid-1830s. Plate 37 from the series *Sixty-nine Stations of the Kiso Road*. Utagawa HIROSHIGE. *Ōban* format.

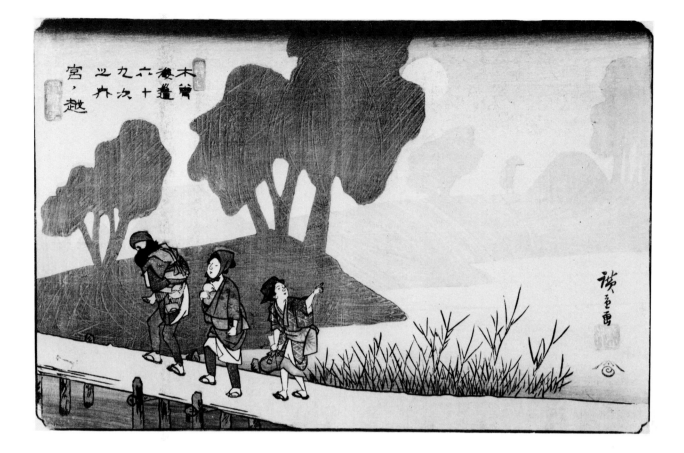

Hardship and Famine

In good times, labor produces food. Farmers work fertile fields and paddies in cooperation with their families and neighbors, each finding satisfaction in his own place (fig. 142).

Misfortunes intrude. Providers and heads of families combat drought, flood, and famine as long as possible, clinging to the land that has always sustained the clan. Finally growing desperate, with no other recourse, they take to the road, sunken in spirit and bereft of hope, their families following behind.

Strange times when men can no longer work in the sun's warm light but must steal away under the cover of fog and darkness.

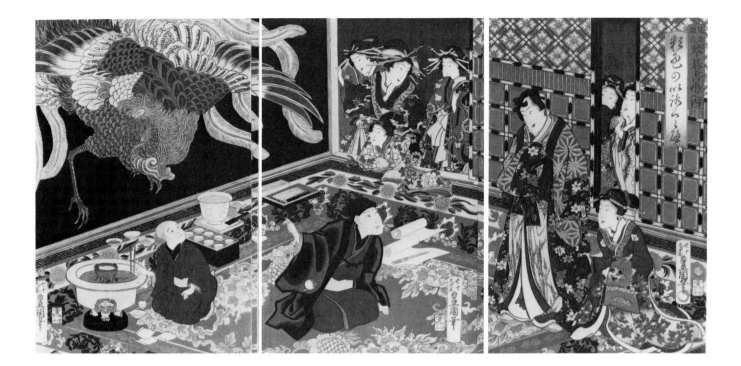

Fig. 164 (above). A self-portrait of the artist Kunisada in a brothel showing a wall painting of a phoenix to Prince Genji. 1865. From a series depicting the four creative arts with Prince Genji.
Utagawa KUNISADA.
Ōban triptych.

Fig. 165 (below). A self-portrait of the artist Kuniyoshi surrounded by figures that have come to life from his sketches. *c.* 1850.
Utagawa KUNIYOSHI.
Ōban triptych. The figures are taken from a style of folk painting produced in the town of Ōtsu; their faces are portraits of Kabuki actors.

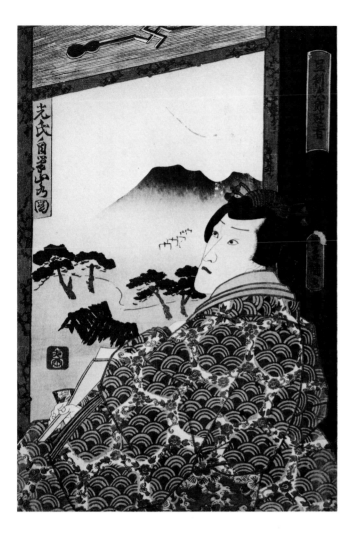

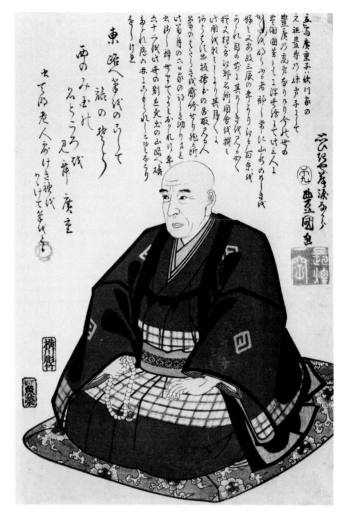

Painters

The artist's work is an alchemical process: from old truths he summons new meanings; from the temporal he fashions the immortal. Embodied by the artist's touch, tangible forms rise from ancient legends. Through the artist's vision, we see ourselves and our world in new and broader ways.

The artist's creations dance and whirl about his head. His own face is strangely obscured as these familiar characters rise from their pages and move about him. In this way, he connects himself with tradition; the larger purpose of his work overshadows his individual identity. This picture is an allegory of the creative process and its transcendent power over both its creator and its viewer.

The objects of much reverence and respect, great artists themselves became the subjects of paintings and prints: their lives celebrated, their deaths commemorated.

In the stark dignity of this portrait of the beloved artist Hiroshige, an artist immortalizes his friend and, in the verse preceding his signature, eloquently articulates a universal grief. The artist, like his creations, exists timelessly in a world apart.

Fig. 166 (*above left*). The actor Ichikawa Danjūrō VIII as Jirō Kanja holding a brush and studying a landscape painting by his father Mitsuuji, the Ashikaga Shogun. *c.* 1850.
Utagawa KUNISADA. *Ōban* format. The painting bears the seal of the actor's father, Ichikawa Ebizō VII.

Fig. 167 (*above right*). Memorial portrait of the artist Utagawa Hiroshige. 1858. Utagawa KUNISADA. *Ōban* format. The artist signed the picture with a haiku, "Remembering and shedding tears, Toyokuni draws." The picture also includes a biography of Hiroshige by Tenmei Rōjin, and the artist's own last verse, "Leaving brush behind on eastern paths, sky of travel, I long to see the famous sites of Western Paradise."

Musicians

In the pictures of the new generation, after the restoration of the emperor and the opening to the West, something has changed. A new element, a compelling presence more nearly evocative of ourselves, has entered the scene.

In the work of the mature artist, the darkness of this legendary night has grown darker and colder. A shadow crosses the moon. The wind lifts the nobleman's cloak mysteriously. As the thief advances, the flute playing continues unbroken; a knowing gleam flashes in the musician's eye.

We recognize the desperation in the thief's hand on the hilt—it is a familiar doom we have seen enacted, even played ourselves as young men. The need even at another man's expense for warmth and shelter—the reluctance to ask, the need to survive.

The musician's hold on the flute—that, too, reminds us of our youth. It recalls the gentleness and quiet of our mother's presence, the tranquillity of closeness and feminine surety. How can this mesmeric melody stave off the murderer's sword? Yet we know it will; it cannot fail.

Surely there are other miracles, then, that a gentle serenity yields. In some part of us, we are disarmed, swayed to another way of being.

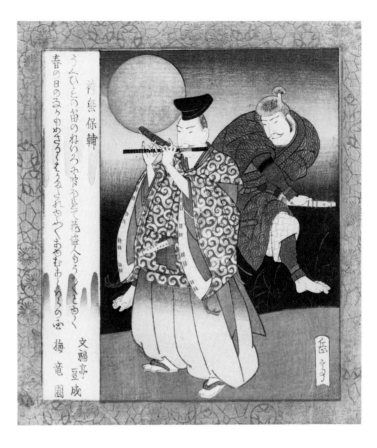

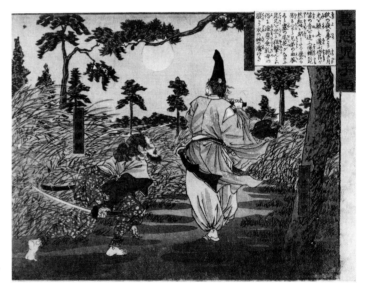

Fig. 168 (above). Hakamadare Yasusuke stealthily approaches the courtier Hirai Yasumasa. Mid-1820s. From an untitled series of scenes from classical literature commissioned by the Katsushika poetry group.
Yashima GAKUTEI. Square *surimono* format. Verse by Bumpukutei Mamenari and Bairyūen.

Fig. 169 (below). The bandit Hakamadare Yasusuke prepares to kill the courtier Hirai Yasumasa and steal his clothing. Mid-1880s. From the series *Good and Evil, Two Sides of the Same Scabbard*. School of Tsukioka YOSHITOSHI. *Chūban* format. With a lyrical text by Ryūsuitei Tanekiyo.

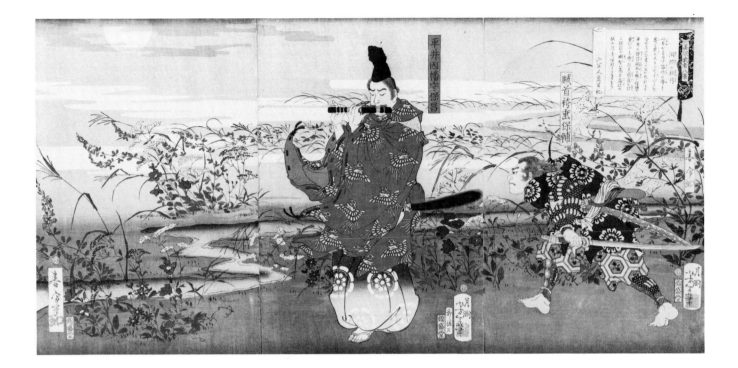

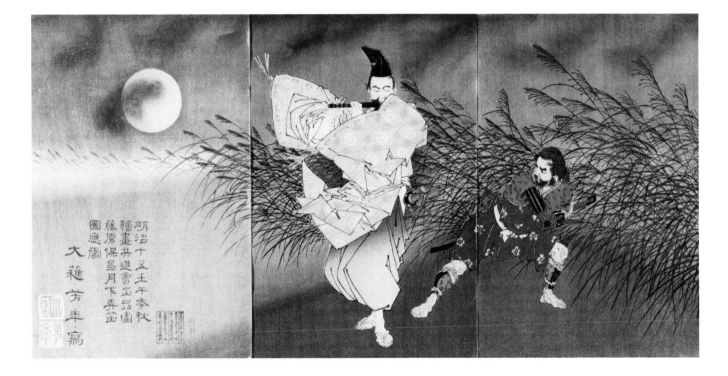

Fig. 170 (above). The bandit Hakamadare Yasusuke stalks Hirai Yasumasa on the autumn moor. 1868. "Autumn Moon," from the series *Eight Views of Warriors from Noble Tales.* Tsukioka YOSHITOSHI (figures) and Wakai SHUNTEI (landscape). *Ōban* triptych. Lyrical text by Sankantei Kōrai.

Fig. 171 (below). "Fujiwara no Yasumasa Playing the Flute by Moonlight." *A Painting in the Exhibition for the Advancement of Pictorial Art in the Autumn of 1882.* 1883. Tsukioka YOSHITOSHI. *Ōban* triptych. This is the second of three states of the print, with the name of the printer, Suri Tsune, added beside the publisher's mark but before the color blocks for the background were replaced.

Writers

Delicate, boisterous, disarmingly simple, some forms of traditional Japanese poetry invited the amateur to enjoy its subtle art. Often, on leisurely afternoons in public gathering places, men engaged in the play of the verse.

Yet the mission of the true poet was very different (fig. 173). We see him walk the river road alone; his form is dwarfed by the landscape. He has, we know by the story, worked magic; in his potent words he wielded an awesome power. Attuned to nature's meanings, the poet—not the warrior or the emperor—is summoned to save the nation from its drought.

By contrast, a journalist, dressed in Western clothing, is distanced from the scene he writes about and, in his largeness, obscures the countryside and dominates the print.

Fig. 172 (facing page). The journalist Fukuchi Gen'ichirō taking notes on the battlefield during the Satsuma Rebellion, a civil war fought on the island of Kyushu in 1877–78. 1885. Plate 45 from the series *Foundations of Morality and Success.* Kobayashi KIYOCHIKA. *Ōban* format.

Fig. 173 (above). The poet Kikaku leaves Mimeguri Shrine after his verse breaks a long drought and causes rain. Early 1830s. Takarai Kikaku (1661–1707) was a pupil of the haiku poet Matsuo Bashō. A monument commemorating this event still stands in the precincts of Mimeguri Shrine, on the east bank of the Sumida River in Tokyo. Utagawa KUNISADA. Fan print.

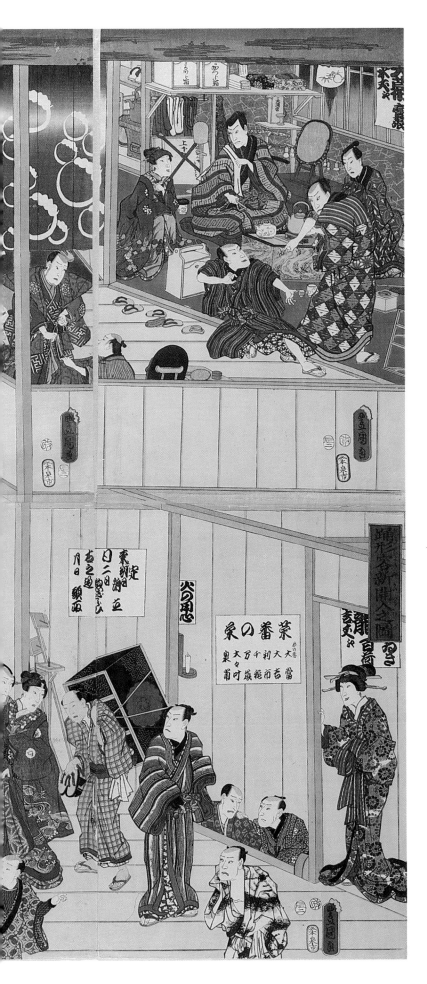

Fig. 174. Backstage view of the actors' dressing rooms at the newly rebuilt Ichimura Theater. 2/1856.
Utagawa KUNISADA.
Double *ōban* triptych. The three Kabuki theaters in Edo burned in the tenth month of 1855. This print was designed in anticipation of the grand reopening of the new Ichimura Theater on the third day of the third month of 1856.

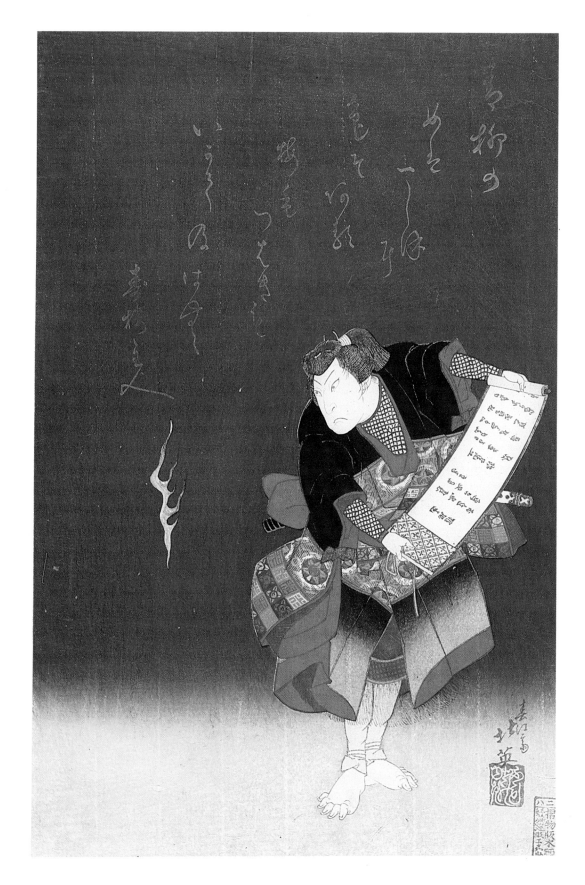

Fig. 175. The Osaka
actor Arashi Rikan II as
Soma Tarō unrolling a
handscroll in the pres-
ence of a spirit fire.
1832. Tarō swore to
avenge the death of his
father, the sorcerer and
general Masakado. As
he opens a scroll of
magical incantations, he
feels the presence of his
father's spirit.
Shunkōsai HOKUEI.
A privately published
surimono with a verse by
Jubai Shujin. *Ōban*
format.

Fig. 176 (facing page).
The actor Arashi Rikan
II as Danshichi Kurōbei
in the night murder
scene from *The Summer
Festival.* 1832.
Shunkōsai HOKUEI. *Ōban*
format. The verse by
Rikan says, "The young
bamboo does not mind
the weight of the rain."
It is intentionally iron-
ical. Danshichi has just
been driven to murder
his father-in-law because
he could not endure the
old man's taunts.

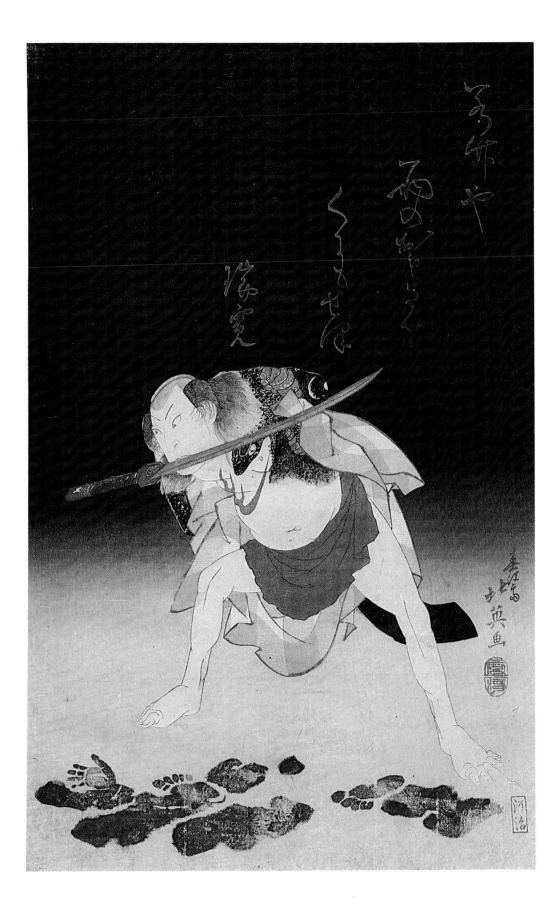

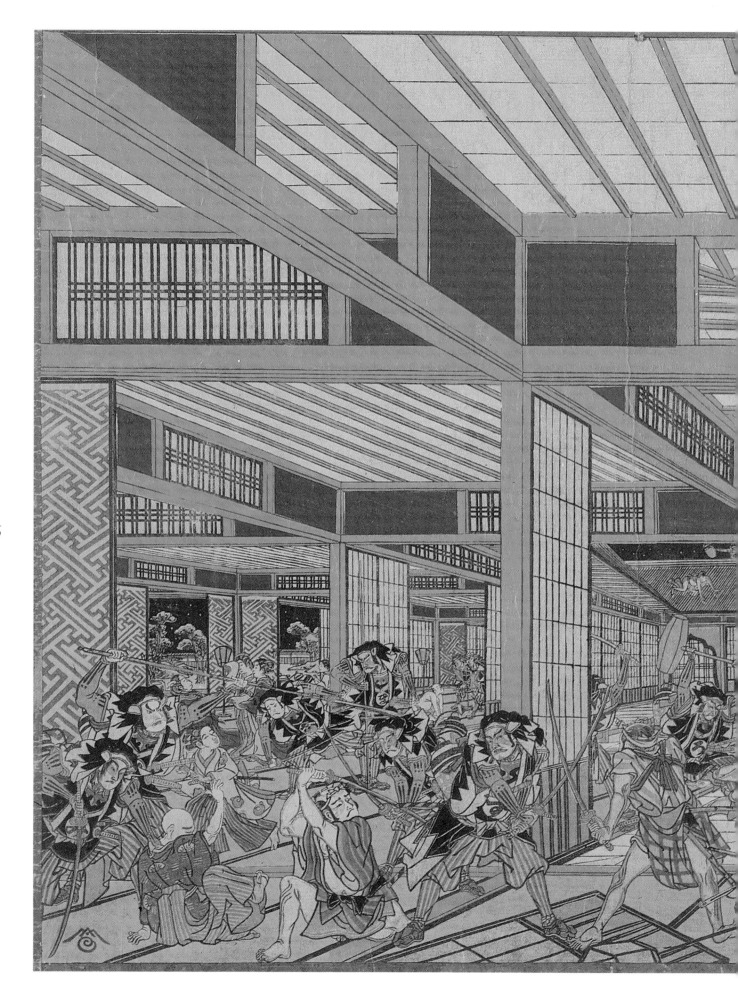

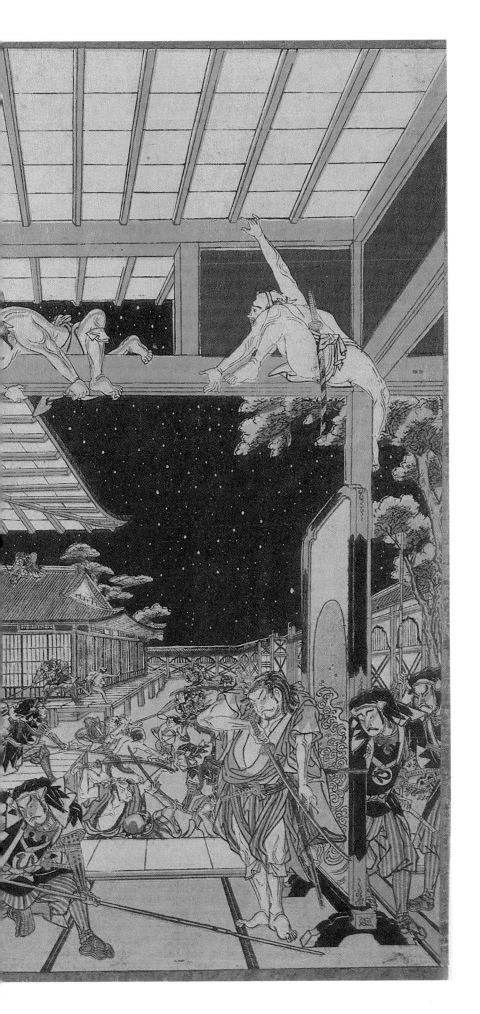

Fig. 177. A perspective rendering of the night attack of the forty-seven loyal samurai in the final act of *The Storehouse of Loyalty.* 1770s. Attributed to Utagawa TOYOHARU. Large double *ōban* format. Many of the warriors' faces are portraits of Kabuki actors.

Fig. 178. Lin Chū Kills Officer Lu by the Temple of the Mountain Spirit. 1887. This is an illustration of an episode in the Chinese novel *All Men Are Brothers* (*Suikoden* in Japanese). Lu and other corrupt government officials tried to assassinate Lin Chū by burning a feed barn where they thought he was sleeping. Tsukioka YOSHITOSHI. Vertical *ōban* diptych.

Fig. 179 (*facing page*). The actor Nakamura Utaemon III as the farmer Gosaku, a disguise of the outlaw Ishikawa Goemon. 1830. Shunkōsai HOKUSHŪ. *Ōban* format. Goemon possessed supernatural powers; he clasps his hands here in a magical gesture summoning up the ghostly warriors in dark clouds (their forms are partly concealed by the painted scrim).

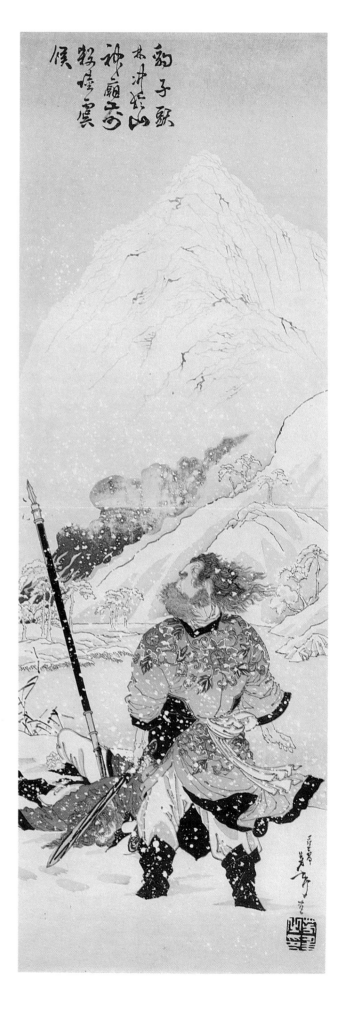

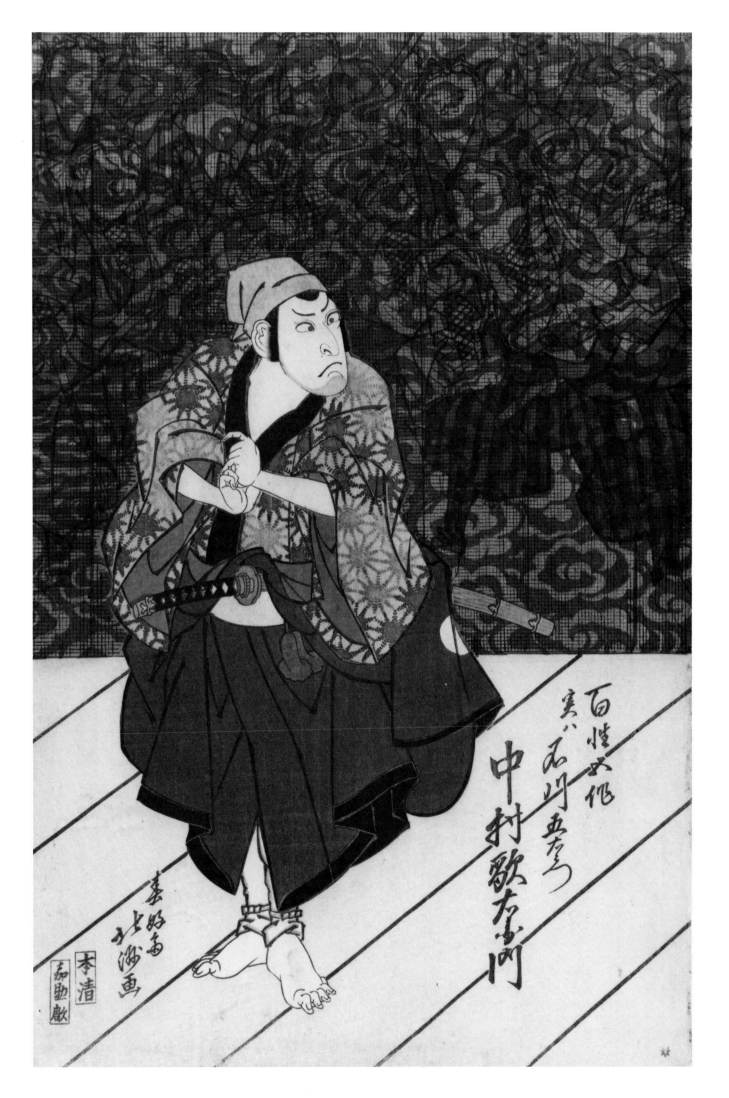

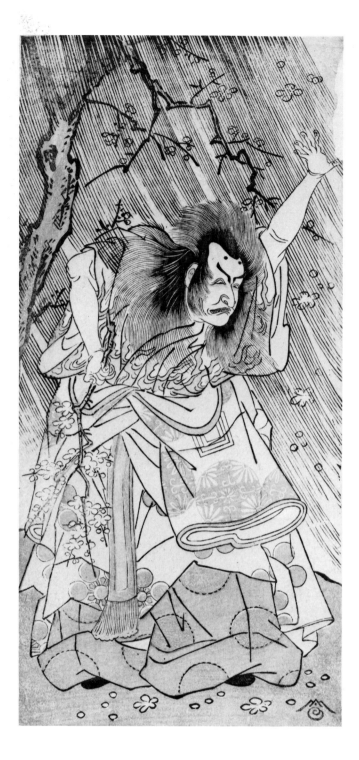

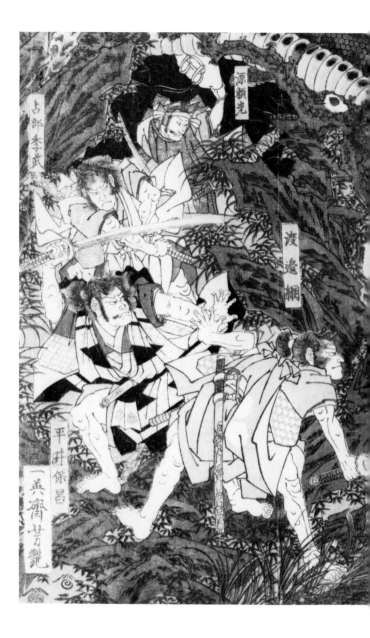

Fig. 180 (*above left*). The actor Ichikawa Danjūrō IV as Sugawara no Michizane (845–903) conjuring up a storm on the summit of Mount Tenpai in the finale of *Sugawara's Secret.* 1775. At the end of his life, Michizane, an exiled courtier, used magical powers to protect the emperor in Kyoto. The storm he created killed a rival who was trying to usurp the throne. Attributed to Katsukawa SHUNSHŌ. *Hosoban* format.

Fig. 181 (*above*). *Yorimitsu Breaks Haka-madare's Magical Spell and Captures Him.* 1858. Utagawa YOSHITSUYA. *Ōban* triptych. The outlaw Hakamadare Yasumasa used his supernatural power to create a giant snake, but the black dog's courage showed Minamoto no Yorimitsu and his four warrior companions that the monster was a phantom. They kept attacking the magician until they captured him.

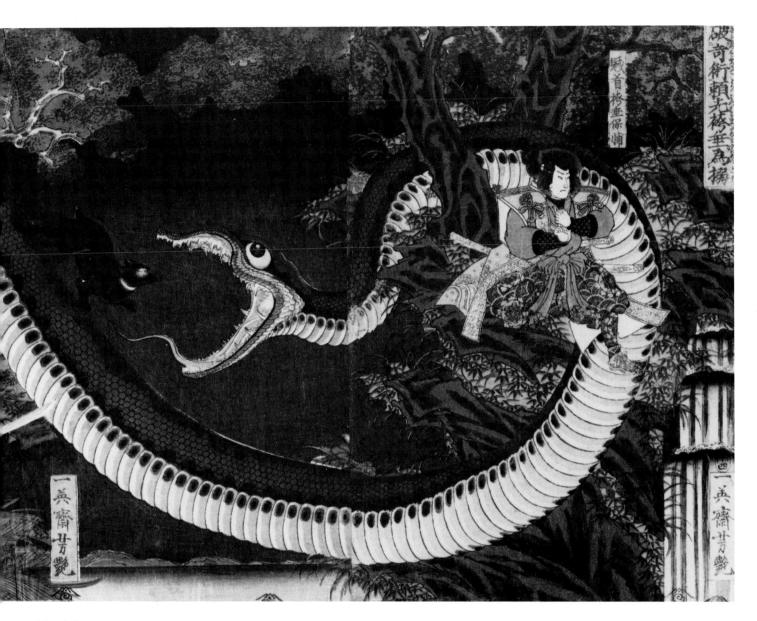

Magicians

Throughout our lives we are aware of an undercurrent lurking just at the edge of our rational mind: something unformed, fantastic, perhaps evil.

As small children, we begin to have nightmares; we shudder when we are left alone in the dark and plead with our mothers to stay a while longer. Even as grown men, at night, on a still city street or country road, we turn often, searching out the shadows for the presences we feel shifting there.

Is this fear without or within? Can we even give a name to it? Is it real or merely child's play?

Sorcerers, magicians, and creatures of supernatural powers inhabit Japanese prints. Like witches and goblins, they belong to the world of make believe.

Yet something else is here: a sense perhaps that these are forms of our own inner experience—that these fantastic scenes offer a key to certain states of mind. If only we could bring them clearly into focus.

What power might we command, were we to try? Desperate, in exile, could we summon forth a storm to defeat the usurper? Were we to descend into ourselves, might we not then have access to this cloudy, mysterious, not-altogether-shaped inner world—and bring forth indomitable power?

Is that not, after all, what these artists did?

132

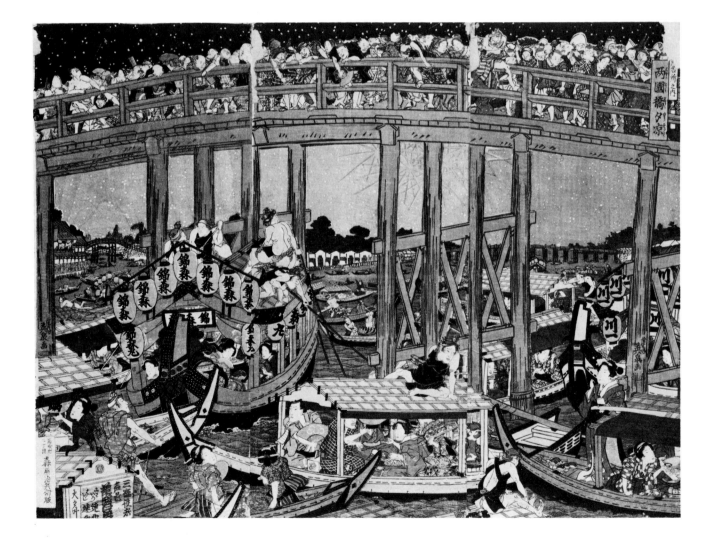

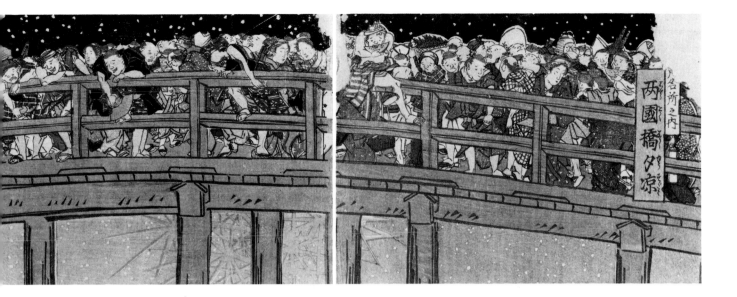

Leisure

At the end of our labor, we return to ourselves and thoughts of our own pleasure, nurture, and relaxation.

The enjoyment of life in simple ways and the contentment derived from the commonplace were very important to the way of life depicted in these prints.

In America, we shun the evening rush hour and holiday crowds; we cringe at the masses hurrying along overcrowded streets.

A different feeling is present in these pictures. Part of the experience of being a man, they say, is entering a crowd and being swept along; there is an indescribable comfort in knowing you are forever part of something human that is larger than yourself. The smiling faces of the onlookers express a joy of crowds, anonymity, community, and bondedness.

Fig. 182. "A Cool Summer Evening at Ryōgoku Bridge." 1830s. From the series *Famous Sites in Edo.* Keisai EISEN. *Nagaban* triptych. Pleasure boats crowd the Sumida River, and townsmen throng Ryōgoku Bridge to watch fireworks and enjoy the cool of a summer evening.

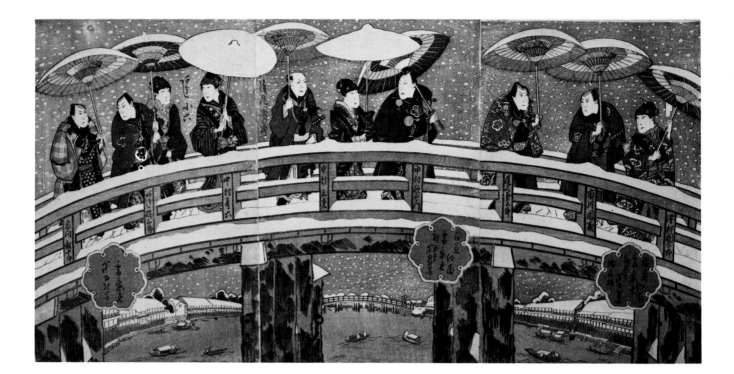

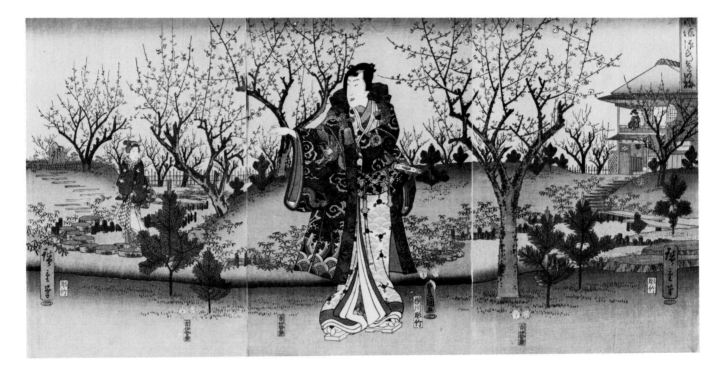

134

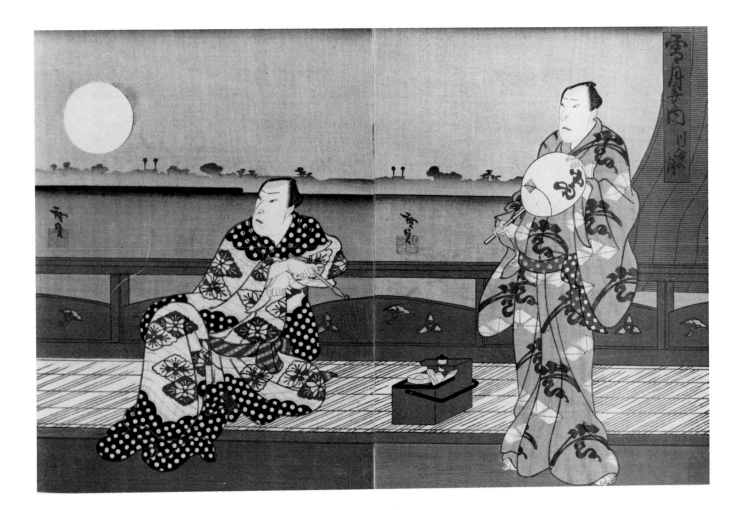

Relaxation

Leisure was enjoyed in a hundred ways and could be joined to traditional themes of art like snow, moon, and flowers. Elegantly and decoratively, actors lounge between performances. Prince Genji lends his regal presence to the plum garden.

All fevered activity is banished from these scenes, creating a sense of satisfaction, abundance, and contentment.

Fig. 183 (above, facing page). Ten actors in a snowfall on Tenjin Bridge across the Yodo River in Osaka. 1825. Gigadō ASHIYUKI. *Ōban* triptych. Nine Osaka actors of male and female roles stroll over the celebrated bridge with Onoe Kikugorō III, an Edo actor who arrived at the end of 1825 for a six-month tour.

Fig. 184 (below, facing page). An elegantly dressed young man beckons to a geisha in the private garden of a restaurant. 1853. "The Plum Orchard," from the series *A Modern Prince Genji.* Utagawa KUNISADA (figures) and Utagawa HIROSHIGE (landscape). *Ōban* triptych.

Fig. 185 (above). The Osaka actors Ichikawa Shikō and Kataoka Gadō II enjoying the summer moon at a riverside tea house. *c.* 1850. "Moon over the River," from the series *Snow, Moon, and Flowers.* Konishi HIROSADA. *Chūban* diptych.

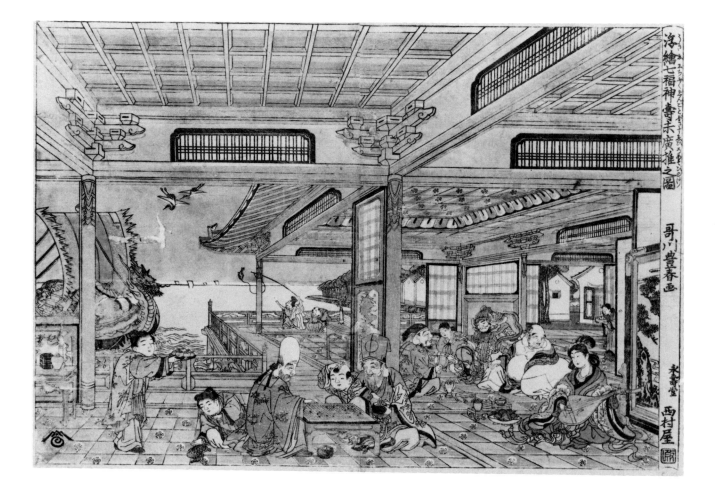

Enjoying Company

In the city, even among others relaxing in the plum garden, each man enjoys his separateness and a sense of self. He writes, reads, drinks tea. In harmony with his activities, he takes pleasure especially in being both a part of the communal scene and perfectly alone.

The seven gods of good fortune waiting to set sail on New Year's Day remind the viewer that relaxation and pleasure are part of life for gods as well as mortals.

Having a name for the things we want—creativity, longevity, wealth, abundance, strength—allows us to direct our energies to bring them to us. The gods of good fortune each embodied one of these desirable qualities. Countless pilgrims visited their shrines and prayed to be imbued with them.

Fig. 186 (above, facing page). A Perspective Picture of the Seven Gods of Good Fortune Relaxing Together. 1770s. The gods enjoy themselves in their seaside palace before boarding their treasure ship and sailing to Japan on New Year's Day. Utagawa TOYOHARU. *Ōban* format.

Fig. 187 (below, facing page). The seven gods of good fortune in a weight-lifting competition. 1810s or 1820s. Keisai EISEN. Long *surimono* format, lacking printed text. Kineya, the name of the musical group that commissioned the print, is inscribed on one of the poem slips in the pine tree and on the wrapping of one of the wine kegs.

Fig. 188 (above). Townsmen enjoying the plum blossoms in the precincts of the Tenjin Shrine. Mid-1830s. "The Plum Grove at Kameido," from *Famous Sites in the Eastern Capital.* Utagawa HIROSHIGE. *Ōban* format.

Enjoying Solitude

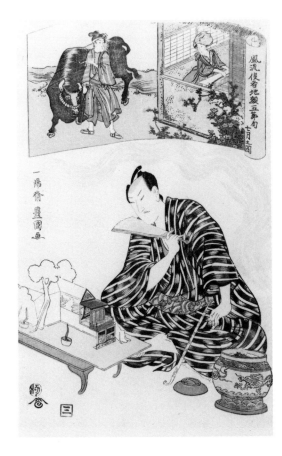

Fig. 189 (above). An entertainer posing with a straw hat and a pillow. 1830s. "Bridge Railing with a Metal Ornament," from the series *Impromptu Shadows.* 1830s. In this parlor game, men would contort their bodies and cast shadows on a sliding paper door panel. Utagawa HIROSHIGE. *Chūban* format.

Fig. 190 (right). The actor Sawamura Gennosuke studying an illuminated paper model of the meeting between the Herdsman and the Weaver. 1810s. "Seventh Month," from the series *Five Seasonal Festivals with Elegant Actors Off Stage.* Utagawa TOYOKUNI. *Ōban* format. The annual meeting of the Herdsman and Weaver stars was celebrated in the seventh month during the Tanabata Festival.

Fig. 191 (facing page). An actor as the greengrocer Hanbei, casually dancing in a city street at night. 1854. "Darkness of the Mind," from the series *Darkness.* Utagawa KUNISADA. *Ōban* format. Hanbei is carefree because his mind is "dark." He is still unaware of the family circumstances that will tragically require him to commit suicide with his pregnant wife.

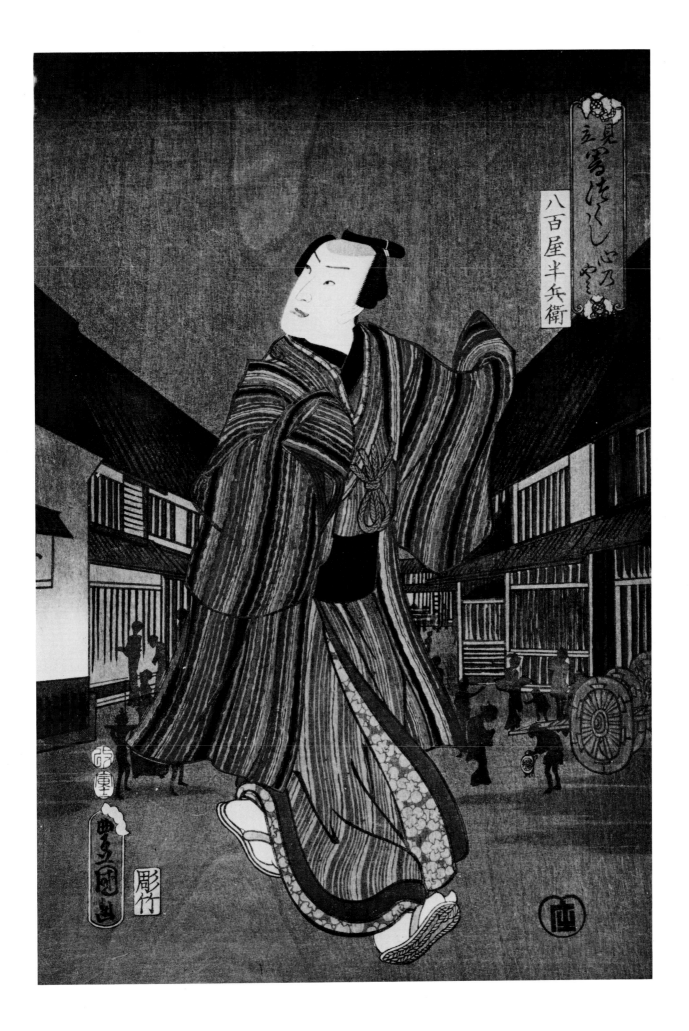

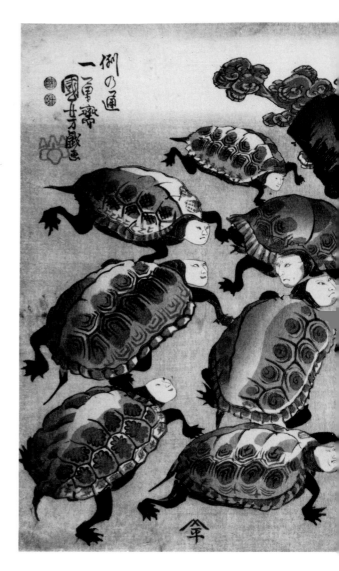

Leisure Pursuits

Leisure is for enjoyment and for many pleasures, for indulging ourselves and our friends in a toast to long life.

It is also for pursuits that fulfill us in unexpected ways. In Japan when these prints were made, it was a time for personal creativity—arranging flowers, composing verse. A renowned actor folds souvenir towels into miniature jackets as a personal gesture of thanks to his patrons and fans.

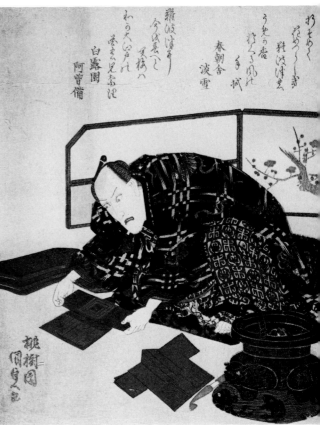

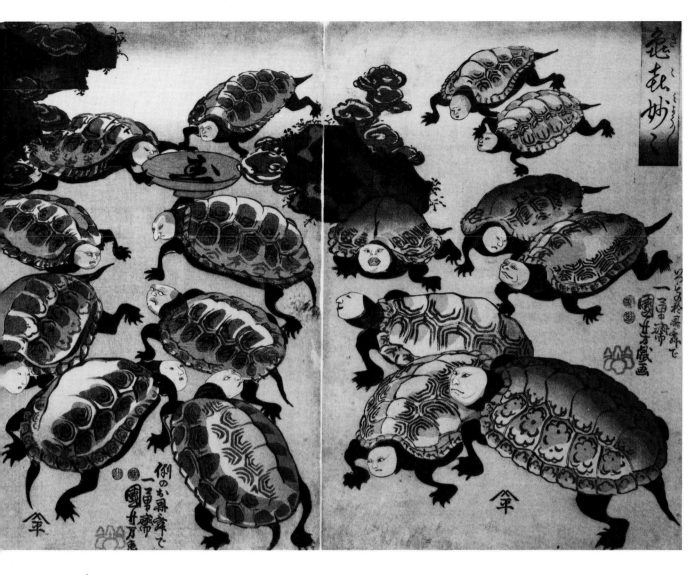

Fig. 192 (above). *Strange and Wondrous Immortal Turtles. c.* 1850. The wine cup is inscribed, "long life"; sea turtles and the mushroomlike growths on the rocks are emblems of immortality. The turtles' faces are portraits of Kabuki actors whose names and emblems are concealed in the patterns on the shells.
Utagawa KUNIYOSHI. *Ōban* triptych. The artist signed the prints, "Drawn for fun by Ichiyūsai Kuniyoshi, singing and dancing as always."

Fig. 193 (below). The actor Ichikawa Danjūrō VII folding hand towels into miniature jackets to present as gifts to patrons. Late 1820s or early 1830s.
Utagawa KUNISADA. Square *surimono* format with verse by Shunchōsha Awayuki and Hakuroen Asobi.

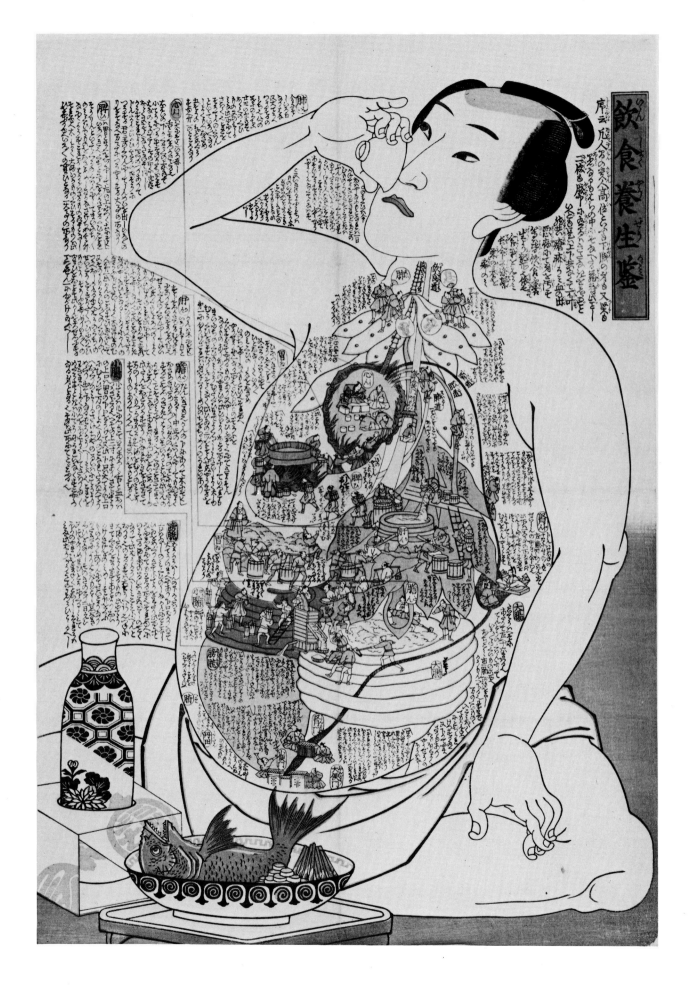

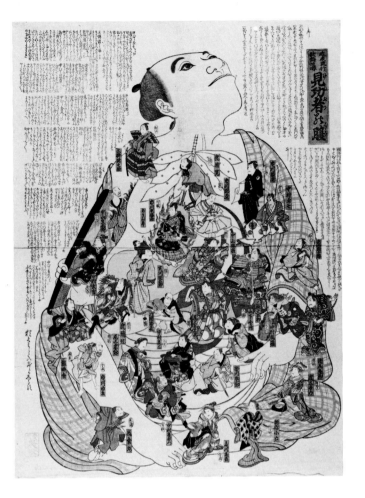

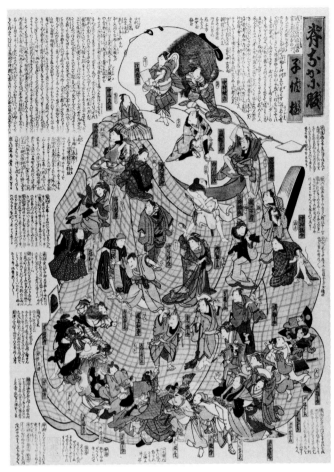

Drinking and Hygiene

143

In a world before X-rays and sonograms, our inner workings must have seemed even more mysterious than they do today.

Prints depicting health issues from anatomy to the symptoms and care of measles were popular, especially in times of epidemics. Anything solemn or serious immediately lent itself to satire. An Edo artist designed a pair of prints showing the inner organs of a courtesan and her client. A wag in Osaka designed a similar pair of prints with groups of Kabuki actors overseeing the body functions of a drunken man.

Fig. 194 (facing page). Nutrition in a Looking Glass. Mid-1850s. The organ systems in the man's body digest his wine; the text explains the process. UNIDENTIFIED EDO ARTIST. Large *ōban* format.

Fig. 195 (above left). Life in a Modern Playgoer's Body. Mid-1850s. The organs in the man's body are presided over by popular Kabuki actors whose humorous comments appear at the left. UNIDENTIFIED OSAKA ARTIST. Large *ōban* format. The red seals on this and the following print bear the name of a vendor, Hyōbei (Tawara Kome).

Fig. 196 (above right). Child's Play on the Body's Back. Mid-1850s. The Kabuki actors carry their comments and performance backstage. UNIDENTIFIED OSAKA ARTIST. Large *ōban* format.

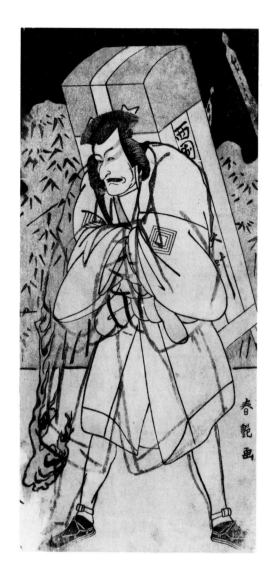

Reverence

As separate individuals, we frequently find conflict and doubt. In worship we seek peace and a sense of connection with the greater whole. We regain our balance.

Best of all is to welcome and acknowledge our spiritual side in company—in calm silence, awe, or boisterous laughter to feel our bond with others and know that we belong.

Fig. 197 (above left). The actor Ichikawa Hakuen as a pilgrim staring at a spirit fire in a graveyard. Mid-1790s.
Katsukawa SHUN'EN. *Hosoban* format. An artist has drawn on the print with a brush, enlarging the figure.

Fig. 198 (above). Pilgrims purifying themselves in Rōben Falls at the foot of Mount Ōyama. *c.* 1850.
Utagawa KUNIYOSHI. *Ōban* triptych. Ōyama, a four-thousand-foot mountain in Kanagawa Prefecture sacred to a rain-making deity, was a popular summer pilgrimage site.

Fig. 199 (right). Pilgrims at a stream near Odai, in central Honshu. Mid-1830s. Plate 22 from the series *Sixty-nine Stations of the Kiso Road.* Mid-1830s. The priest at the right is traveling through the countryside to raise money for rebuilding the main hall of his temple. The group at the left is a family making a pilgrimage together. The mother is carrying a baby.
Utagawa HIROSHIGE. *Ōban* format.

145

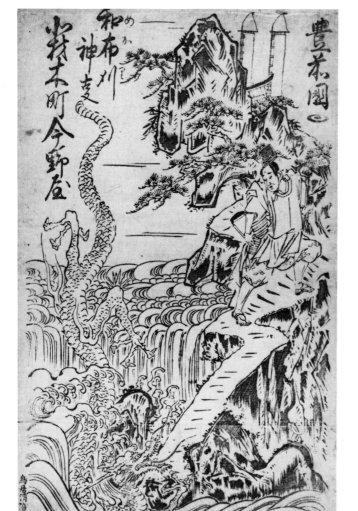

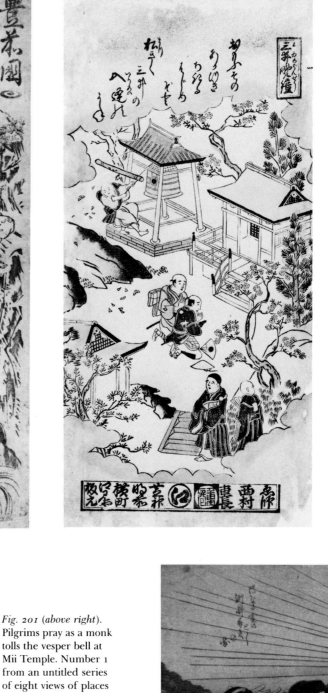

Devotion

Wealthy and poor, laymen and priests, all
make the same journey, descending to the
water, ascending to hilltop shrines. Lengthy
and even arduous, the pilgrimage is an out-
ward expression of inner purpose.

Afterward, his journey complete, the pil-
grim throws his unused name strips into
the river's flow and stands for a moment,
feeling renewed, before starting home.

Fig. 200 (above left). The
Kelp Harvesting Cere-
mony in Hizen Prov-
ince; a float sponsored
by Imanoya, a shop in
Kitazaimoku-chō,
Sendai, in an annual
parade. *c.* 1800. The
Shinto priest has har-
vested a handful of kelp
and safely escaped the
sea dragon and the tur-
bulent waves.

UNIDENTIFIED SENDAI
ARTIST. Hanging scroll
format. Published to
commemorate a float in
an annual festival pa-
rade. False signature of
the Edo artist Torii
Kiyomasu.

Fig. 201 (above right).
Pilgrims pray as a monk
tolls the vesper bell at
Mii Temple. Number 1
from an untitled series
of eight views of places
near Lake Biwa. 1720s.
Nishimura SHIGENAGA.
Hand-colored print in
hosoban format.

*Fig. 202 (above left, fac-
ing page).* Self-portrait
of the artist as a servant
of Bishamon, one of the
seven gods of good for-
tune, during a New
Year's shrine festival at
Atago Hill. 1857. From
the series *One Hundred
Famous Views of Edo.*
Utagawa HIROSHIGE.
Ōban format.

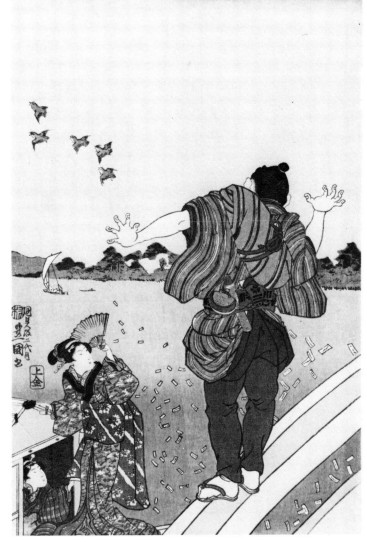

Fig. 203 (above right).
A pilgrim
his unused name
slips from the railing of
Eitai Bridge. Mid-1840s.
Pilgrims pasted paper
slips with their names on
temple structures as
records of their visit.
Utagawa KUNISADA.
Panel from an *ōban*
triptych.

Fig. 204 (below).
Sunrise at Susaki
Benten Shrine on the
first Snake Day of the
New Year. Late 1810s or
early 1820s.
Utagawa TOYOKUNI.
Ōban triptych. A white
snake was the animal
companion of Benten, a
goddess of creative
expression.

Conflict

At our beginning, we are the center of all things. Nothing is denied us; no need unmet, we are complete.

As our horizons expand, we learn of boundaries; once all-giving, all-permitting, all-providing, our parents and the larger world begin to direct, demand, and withhold. We learn rage after we learn fulfillment. We learn to fight for what we hate to ask. We learn to struggle to satisfy our needs.

As we grow, we start to hear an inner voice, but sometimes we are forced to betray ourselves by denying our truest self and innermost experiences. Carefully we fold them, layers deep, under careful ceremony and silence. They peer out at us occasionally through strange mirrors.

What do we see in the explosion of wartime cannons? Or the heroic warrior, under siege and certainly dying? The battle becomes an allegory of our divided selves, a vision of our own inner struggle, and the truth of our secret conflicts. The pictures acknowledge what we have learned to deny, and they release us from shame by telling our secrets.

Fig. 205 A cannonball explodes on the battlefield during a campaign by the fictitious general Satō Masakiyo. 1886. *Masakiyo's Difficult Battle, a Scene from the Taikeiki.* The figure on horseback represents the general Katō Kiyomasa (1562–1611). His name was changed to comply with a Tokugawa ban on the direct representation of politically charged historical events. Tsukioka YOSHITOSHI. *Ōban* triptych.

150

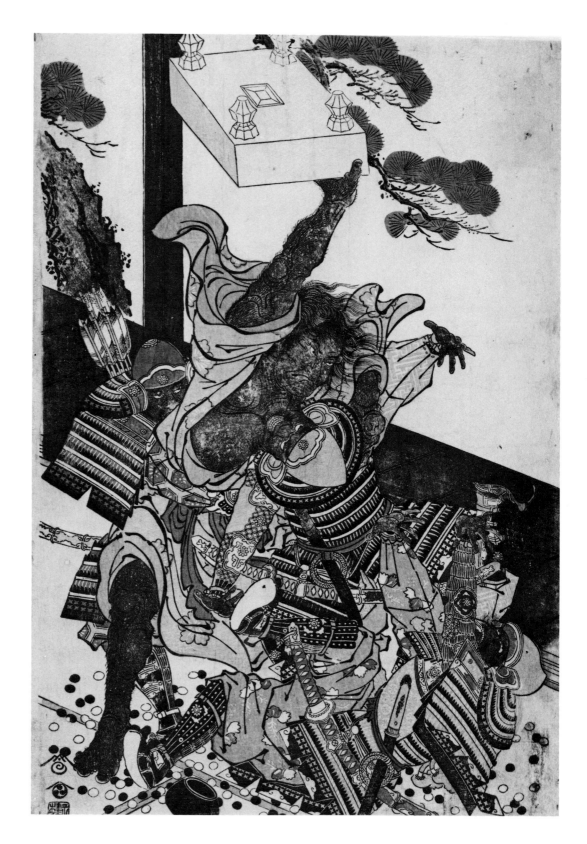

Fig. 206. Satō Tadanobu uses his *go* board to defend himself successfully against three armed attackers. Late 1780s. Tadanobu (1161–86) was a favorite retainer of the general Minamoto no Yoshitsune. He was killed in Kyoto by order of Yoshitsune's brother.

UNIDENTIFIED EDO ARTIST. *Ōban* format.

Fig. 207 (above). The actor Ichikawa Danjūrō IX as the wrathful spirit of Akugenta Yoshihira hurling lightning bolts at his executioner from the sky above Nunobiki Waterfall. 1896. Minamoto no Yoshihira (1141–60) was executed by order of the Taira general Kiyomori. Toyohara KUNICHIKA. *Ōban* triptych.

Fig. 208 (below). Rage and resentment begin to turn the priest Raigō into a rat as he destroys his temple's sutras. 1830s. "Rat," from the series *Twelve Powerful Men Matched with Animals of the Zodiac.* Raigō was enraged because the emperor failed to honor a promise made when the priest saved his child's life. Utagawa KUNIYOSHI. Panel format.

Rage and Resentment

When unjustly attacked, we can draw on righteous anger for refuge and strength. Rage can make us fearless and invincible—we awe our attackers and vanquish them with sudden strength. Our anger thus becomes a force for good: righteous rage rings true, restores order, hastens justice.

Surprised in the midst of his leisure, the man fends off his armed attackers with the only weapons he can call upon—his *go* board and his anger. Rage transfigures him. He becomes ugly, possessed, and empowered; he is not a victim.

The medieval priest, instead of cursing the emperor who refused to honor his promise after the priest saved his child, turns his anger inward. As he nurtures his resentment, it turns on him; his misdirected rage changes him to a rat.

151

Anger

Anger can be treacherous. Danshichi is imprisoned for his brawling and quarrelsomeness but is then paroled on condition that he forswears violence. He contains his rage until one night his wicked, abusive father-in-law taunts him mercilessly. Danshichi loses control; his rage overpowers him. Even though he knows he will go back to prison, he vows to rid the world of this one evil man (fig. 176). Afterward, as he washes the mud from his body, he feels calm, just, and cleansed.

Fig. 209 (above). Nakamura Utaemon IV and Nakamura Tomozō as Danshichi Kurōbei and his father-in-law, Giheiji, in the night murder scene from the play *Summer Festival*. 1850. Danshichi murdered Giheiji because he could no longer endure his taunts and wickedness. Konishi HIROSADA. *Chūban* diptych.

Fig. 210 (facing page). Nakamura Utaemon IV as Danshichi Kurōbei in the night murder scene from the play *Summer Festival*. 1855. "Night Darkness," from the series *Darkness*. Utagawa KUNISADA. *Ōban* format.

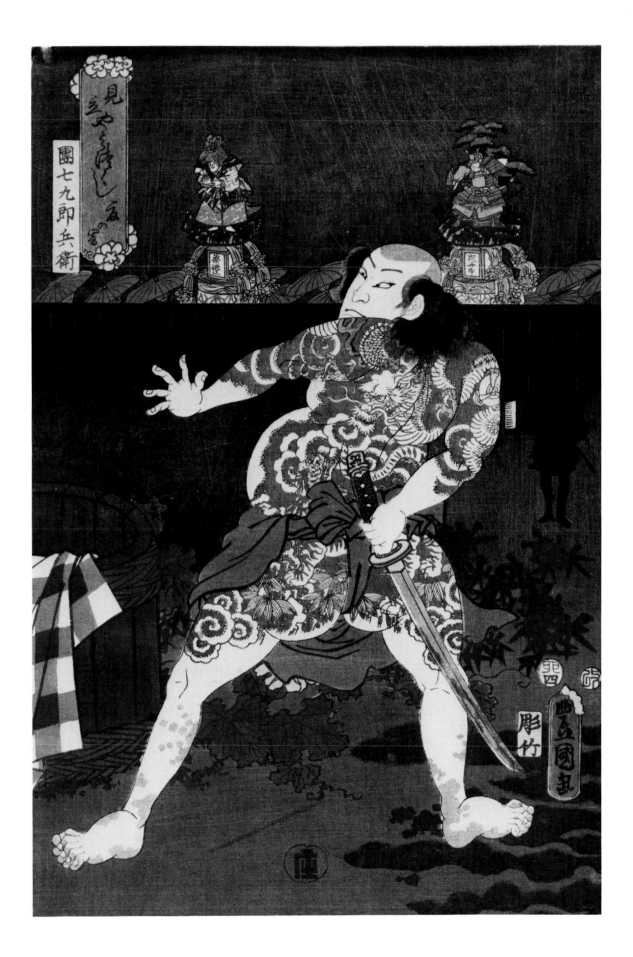

153

Combat

As young men, we are impetuous and strong. Our growing ego expands beyond our capacity to contain it. We seek out proving grounds to display our heroism. Like charging bulls, our strength is exuberant.

We do not play for keeps—we enter the warrior's dance. Our violent strides release our unspent energy and carry us home again, gentled and eager to a lover's arms.

Fig. 211 (above left).
Sagara Tōtomi no Kami using a stack of tatami mats as a shield and barricade. 1868. From the series *One Hundred Aspects of Battle.* Tsukioka YOSHITOSHI. *Ōban* format. The biography by Unpō Sanjin identifies Sagara as a vassal of the sixteenth-century general Ōuchi Yoshitaka. However, the series was based on Yoshitoshi's impressions of the Battle of Ueno in 1868.

Fig. 212 (above right).
An actor as the samurai Yamanaka Fujitarō dodging gunshots and brandishing a club. 1868. From the series *Good and Evil Demon Men.* Toyohara KUNICHIKA. *Ōban* format.

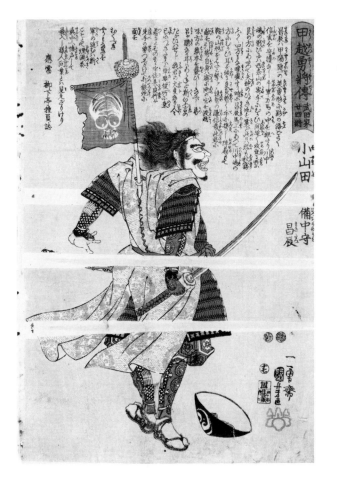

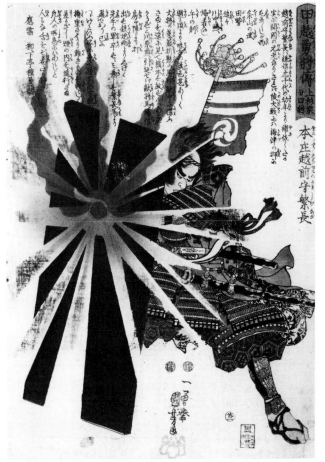

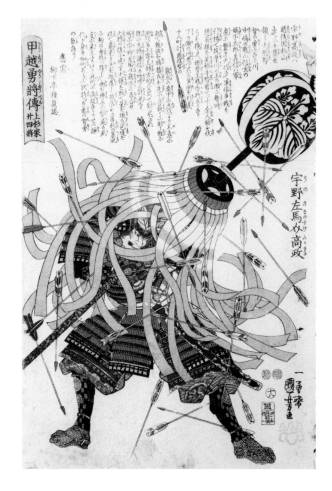

Fig. 213 (below, facing page). The actor Nakamura Fukusuke II as Sugino Jūheiji Harufusa. 1864. Number 7 from a series of portraits of the forty-seven loyal samurai sworn to avenge their master's death. Utagawa KUNISADA. *Ōban* format.

Fig. 214 (above left). Oyamada Masatatsu, a general of the Takeda clan, exposing himself to rifle fire. *c.* 1850. Number 17 from the series *Biographies of Generals in Kai and Echigo Provinces*, which contains imaginative portraits of warriors in the campaigns between Takeda Shingen and Uesugi Kenshin, lords of Kai and Echigo provinces during the sixteenth century. Each picture contains a short biography written by Ryūkatei Tanekazu (an author who used the studio name Ippitsuan on some sheets). Utagawa KUNIYOSHI. *Ōban* format.

Fig. 215 (above right). Honjō Shigenaga, a general of the Uesugi clan, deflecting a cannon shot with a wooden shield. *c.* 1850. Number 22 from the series *Biographies of Generals in Kai and Echigo Provinces*. Utagawa KUNIYOSHI. *Ōban* format.

Fig. 216 (right). Uno Samanosuke Takamasa, a general of the Uesugi clan using a tasseled standard to shield himself from a shower of arrows. *c.* 1850. Number 18 from the series *Biographies of Generals in Kai and Echigo Provinces*. Utagawa KUNIYOSHI. *Ōban* format.

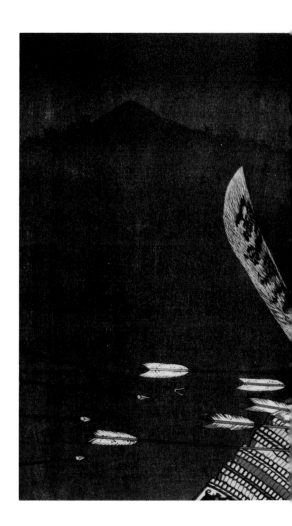

Hearing the unvoiced, listening to the unspoken, the artist bends to his work. The artist serves an art, which serves many purposes. Many voices clamor for expression—violence, compassion, humor, and tragedy. What is it that causes us to pause before a particular print? Why has the artist chosen this story, this moment, this shading or color, this hand on the hilt of a dagger, the exact fall of this robe? Perhaps the artist himself could not say.

When he depicts conflict, the artist brings forth his own memories and ranges them against our own. To those of us who remember, he serves as a witness. To those of us who prefer not to remember, he offers an open invitation to respond as we are willing. By shaping the beast and making it visible, the artist exorcises the raging within us. His images reflect our own inner states and release them. He lends us power over the unseen.

Whatever our pain, he says, we may stand sure amid destruction. We create order by our willingness to yield to chaos. By our willingness to die, we affirm life.

Art serves many masters, and serves them well. At other times, when the nation is at war, the artist tells us other tales—of the glory of killing and the need for force. Summoning all our strength, we jubilantly dispatch the foreigner. But even in blatant propaganda, we can feel the need to keep our integrity when under attack.

Fig. 217 (above). The actor Ichikawa Danjūrō IX as Oyamada Kenmotsu Takaharu in the fourteenth-century battle of Motomezuka, near Kobe. 1892. In this scene Takaharu sees his son sacrifice himself to save their lord, Nitta Yoshisada.
Toyohara KUNICHIKA. *Ōban* triptych.

Fig. 218 (below). During the Battle of Port Arthur, a Japanese sailor leaps on board a Russian warship and kicks its captain overboard. 1904.
Uda TOSHIHIDE. *Ōban* triptych.

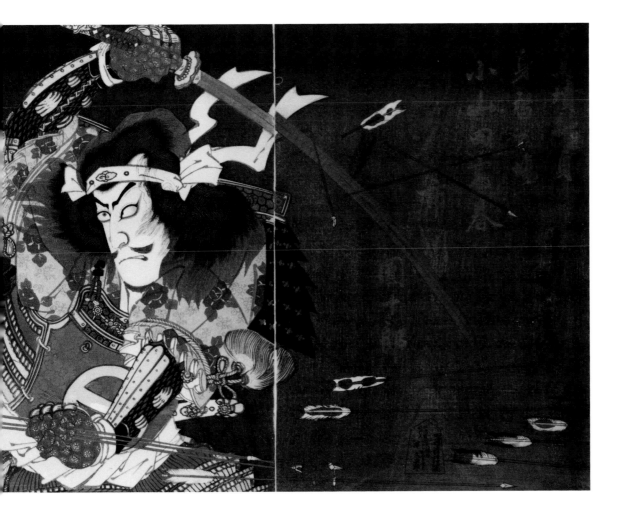

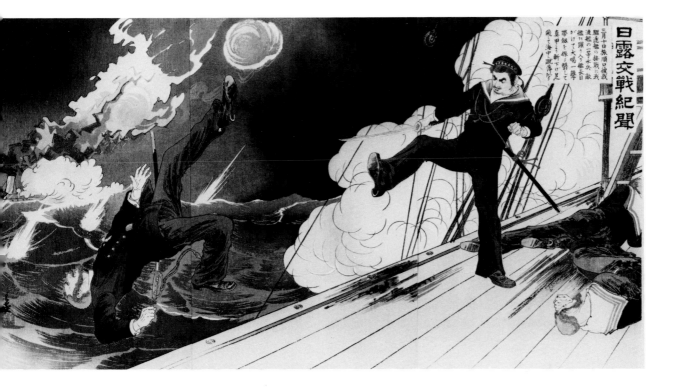

Rivalry

Conflict can even seem slightly ridiculous.
Friends square off and have at each other.
Old companions wonder how to call off this
foolishness.

Fig. 219 (above). The
actors Nakamura Utae-
mon III and Bandō Mit-
sugorō III as Gokumon
no Shōbei and Sengoku
Chūemon sparring at
the foot of a temple
staircase in a rainstorm.
1808–10. The two men
later became close
friends.
Utagawa TOYOKUNI.
Ōban diptych.

Fig. 220 (left). Daikoku
and Fukurokuju, two of
the gods of good for-
tune, facing one another
in a wrestling ring. 1894.
Number 2 from a series
of humorous subjects re-
lated to Ōtsu-style folk
painting.
UNIDENTIFIED ŌTSU ART-
IST. *Chūban* format.

Fig. 221 (facing page).
The comic actors
Kirishima Giemon and
Nakamura Nakasuke
presenting a quarrel be-
tween Sajibei, a land-
lord, and Jirōkichi, his
servant. 1800–1805.
Utagawa TOYOKUNI.
Ōban format.

159

Fig. 222 (above). Man raping a housemaid beside his bath tub. 1770s. From an untitled set of erotic prints. The woman says, "If our lord hears us, we'll be in trouble." The man replies, "Don't worry, I'll make you my mistress." Isoda KORYŪSAI. *Ōban* format.

Fig. 223 (right). The actors Ichikawa Danjūrō II and Somekawa Kozō-shi as a merchant trying to seduce a young girl behind a display of dolls for the Girl's Day Festival. 1720s. Torii KIYOSHIGE. Hand-colored print in *hosoban* format.

Fig. 224 (facing page). The actor Sakata Hangorō II as Fujikawa Mizuemon, the villain of the play *Hanaayame bunroku soga.* 1794. From an untitled series of twenty-eight half-length portraits of actors with dark mica backgrounds. Tōshūsai SHARAKU. *Ōban* format.

Fig. 225. The actor
Ōgawa Hashizō (Onoe
Kikugorō III) as the
outlaw Shirai Gonpachi
in the suicide scene
from the play *Fifty-three
Stages of the Plum Tree's
Journey.* 1848. Gonpachi
was a samurai from
Tottori Province who
turned to crime after
falling in love with a
courtesan. He was cap-
tured and executed in
the 1670s. In this play,
he avoids the shame of a
public execution by
taking his own life be-
fore being captured.
Konishi HIROSADA. *Ōban*
format. The verse says,
"Mountain cherry: we
love its flowers because
they fall."

Fig. 226 (facing page).
The suicide of Moro-
zumi Masakiyo, a gen-
eral of the Takeda Clan.
c. 1850. One of three
celebrated deaths in
battle, plate 23 from the
series *Biographies of Gen-
erals in Kai and Echigo
Provinces.*
Utagawa KUNIYOSHI.
Ōban format. Biography
of Masakiyo by Ryūkatei
Tanekazu.

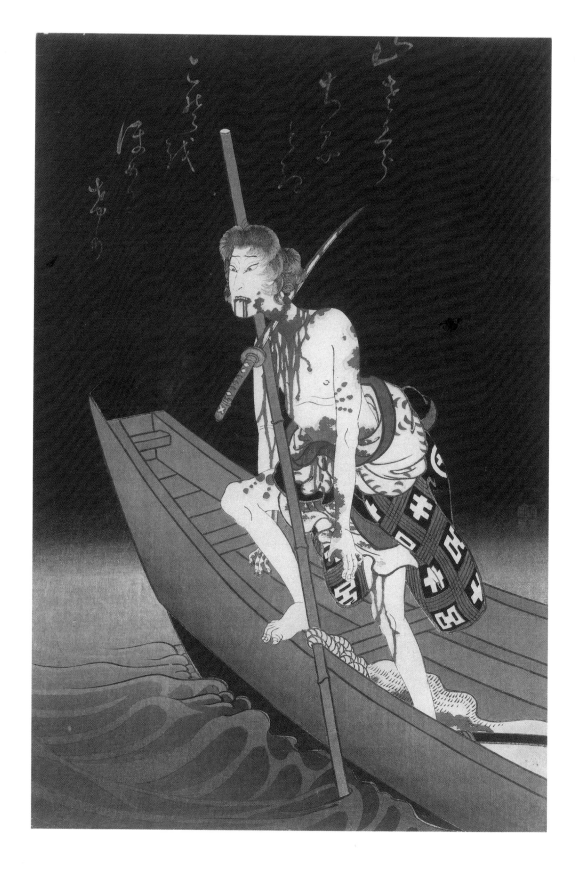

Fig. 227. The actor Onoe Kikugorō III as the sword master Kasahara. 1852. "Nihonbashi," from a series of actors matched with thirty-six popular restaurants in Edo. Kasahara was the teacher of the great swordsman Miyamoto Musashi (1584?–1645). He is matched with a restaurant because he fought Musashi using only the cover of a rice pot to ward off the youth's two swords.
Utagawa KUNIYOSHI.
Ōban format.

Fig. 228 (*facing page*). The actor Kataoka Nizaemon VII as Shiradayū in the "Birthday Celebration" scene from the play *Suguwara's Secret.* 1796. Shiradayū looks on with helpless anger as his sons quarrel and spoil his seventieth birthday celebration.
Katsukawa SHUN'EI.
Ōban format.

165

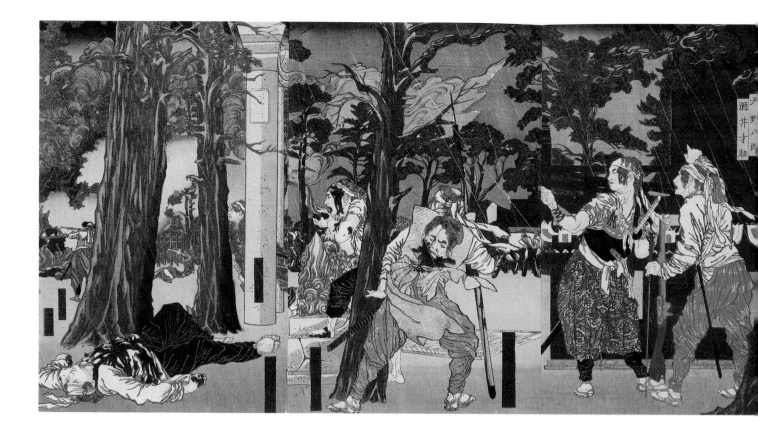

Cruelty

Fig. 229 (above). The Battle of Sannōzan at Tōeisan Temple in Ueno. 1874. This picture of samurai who remained loyal to the shogun as the imperial army entered Edo was one of the first prints to challenge the government's ban on the representation of current political events. Tsukioka YOSHITOSHI. *Ōban* triptych.

Fig. 230 (facing page). Saisaburō cruelly murders Ohagi, a woman who refused his sexual advances. 1867. From *Twenty-eight Verses for Famous Murders.* Tsukioka YOSHITOSHI. *Ōban* format. With a floridly poetic text by Kashi Sanjin Kōi.

Is it a sign of increasing madness that images of cruelty and violence take their place beside the traditional pictures of contentment and serenity? Or is it the breaking through to conscious awareness of a dark side of ourselves that we can no longer deny? In the nineteenth century, as war neared and the social order collapsed, artists became risk takers, revealing sides of human life that had long been unacceptable. Their subjects connected more and more with the whole of human feeling and terrifying elements began to appear in the printmaker's art.

These nineteenth-century prints disturb us more than a century after they were made. They break through patterns of denial that have prevented us from feeling our pain and the pain of others.

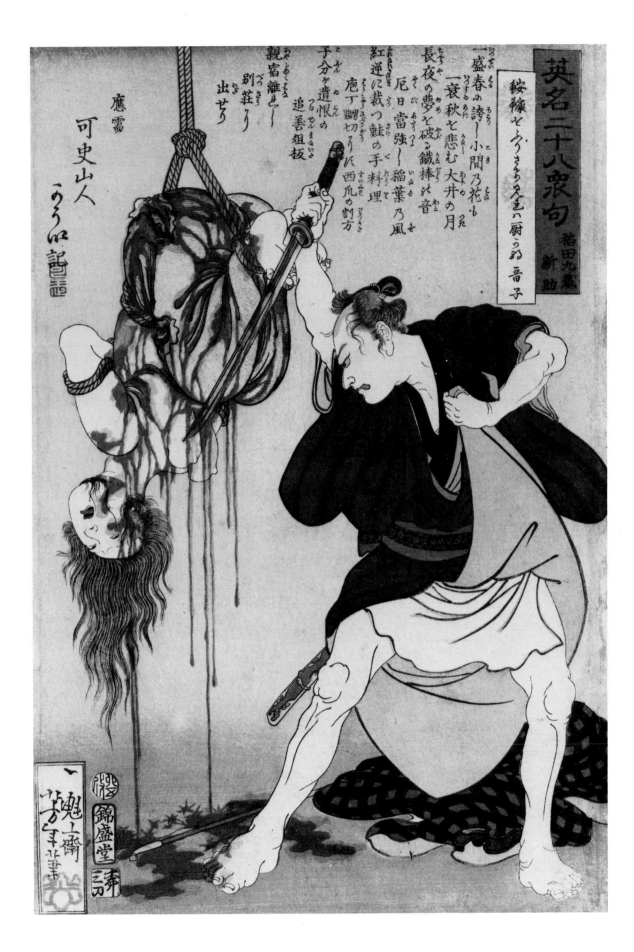

167

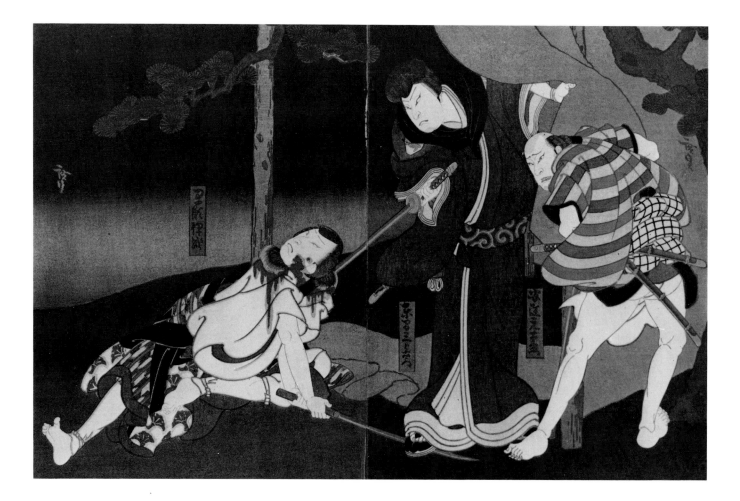

168

Murder

The thief's imagination fails. He decides, without asking, that his need is greater than his victim's.

The murderer acts from a terrible distance. He reaches out for the human contact he needs but then cruelly repudiates that need. To maintain his illusion of power and freedom from need, he has to cut his bond to other human beings over and over again.

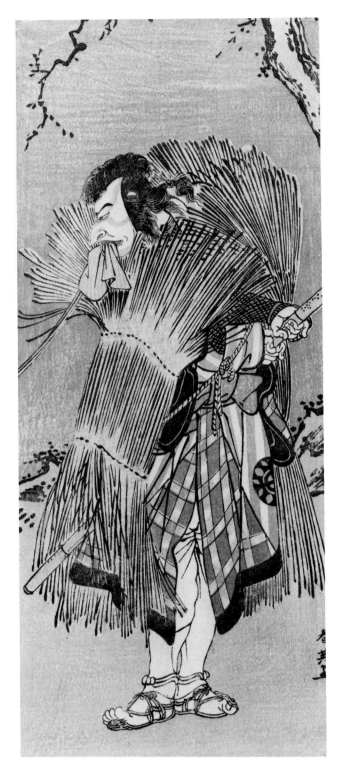

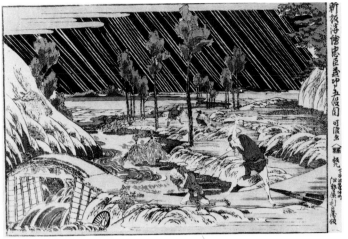

Fig. 231 (facing page).
The actors Kataoka
Gadō II, Onoe Tamizō
II, and Kataoka Ichizō
as Hayase Iori, Honma
Saburōemon, and
Adachi Gen'emon in the
murder scene from *The
Tenka Teahouse*. 1850.
Konishi HIROSADA.
Chūban diptych. Hayase
tried to avenge his fa-
ther's death, but he was
weak and sick when he
finally located his enemy
and the older man
pitilessly killed him.

Fig. 232 (*left*). The actor
Nakamura Nakazō I as
an outlaw, possibly
Kumasaka, from the
town of Nissaka on the
Tōkaidō Road. 1789.
Katsukawa SHUN'EI.
Right panel of a *hosoban*
diptych. This scene is
based on the murder of
an old man by the rene-
gade samurai Sadakurō
in Act 5 of *The Storehouse
of Loyalty*.

Fig. 233 (*above*). Sada-
kurō murders Yoichibei
as Kanpei receives his
ultimatum from the con-
spirators. 1800–1805.
"Act 5," from the series
*Newly Published Perspec-
tive Pictures for The Store-
house of Loyalty*. Kanpei
needed money to secure
a place among the con-
spirators avenging his
master's death. His
fiancée indentured her-
self to a brothel to ob-
tain the money, but her
father was murdered
and robbed by Sadakurō
on his way home with it.
Katsushika HOKUSAI.
Aiban format.

169

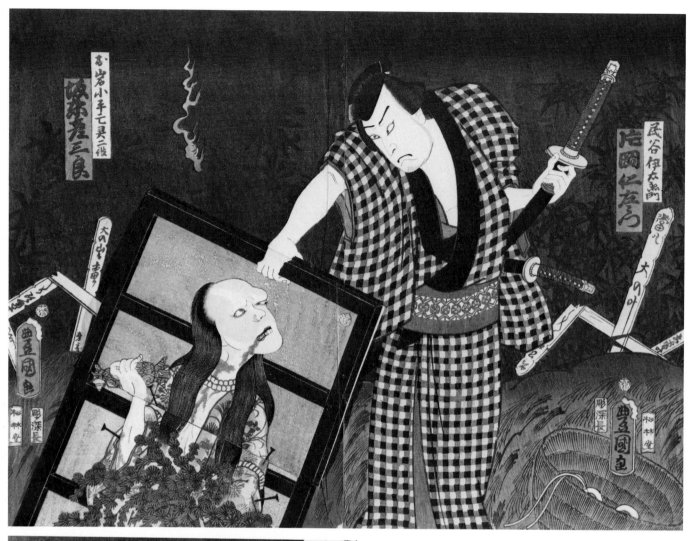

170

Retribution

We learn early that all cannot be right in the world. Evil despoils virtue; strong men overpower the weak. Yet our faith stays strong, because our need for order and justice is very great.

In our legends, we admit that wicked events befall the innocent, but balance must be restored and evil avenged. Retribution pursues the wrongdoer; the murderer goes mad. We are pacified by seeing his soul become a feast for demons.

But the avenger does not enjoy his victory (fig. 178). His visage is stern and sorrowful. About him, pure snow falls.

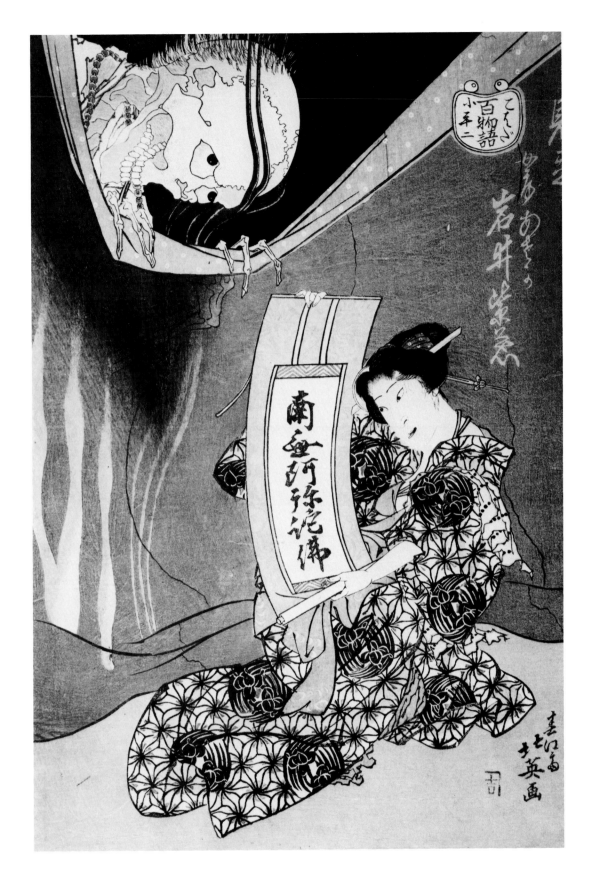

Fig. 234 (above, facing page). The actors Kataoka Gadō II and Bandō Hikosaburō V as Tamiya Iemon and the ghost of Oiwa. 1861. Utagawa KUNISADA. *Ōban* diptych. Tamiya Iemon poisoned his wife Oiwa and then killed Kobotoke Kohei, the man who stole the poison for him. He nailed them to either side of a wooden door and set them afloat. Their restless spirits seemed to animate the corpses.

Fig. 235 (below, facing page). The actor Bandō Hikosaburō V as the ghost of the thief Kobotoke Kohei. 1861. Utagawa KUNISADA. The reverse of the door panel in figure 234. Hikosaburō performed the roles of both ghosts, using a revolving door and a quick costume change.

Fig. 236 (this page). The actor Iwai Shijaku I as Asaka, holding up a calligraphic *mantram* of Amida Buddha to protect herself as her husband's ghost appears above her mosquito net. Early 1830s. After Kohada Koheiji, Asaka's husband, was murdered by her lover, he came back to describe his painful death. Shunkōsai HOKUEI. *Ōban* format. From a pair of portraits of actors matched with ghosts taken from prints designed by Katsushika HOKUSAI and published in 1830.

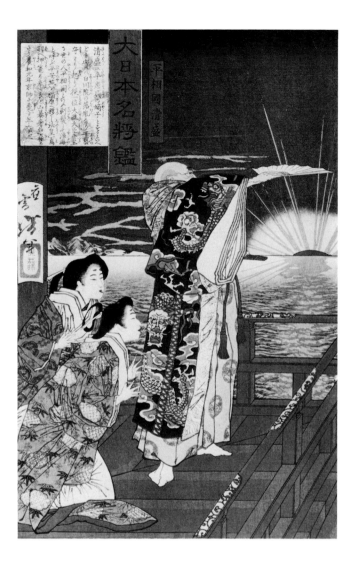

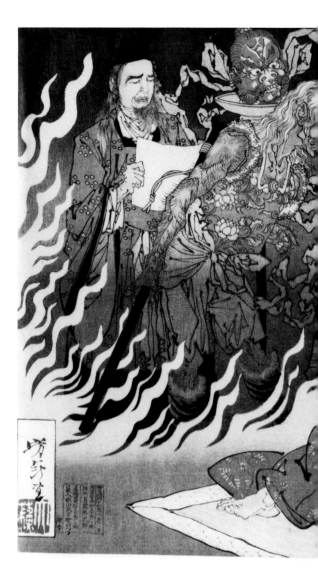

Madness

The abuse of power separates us from the world. Isolation leads to inconsolable pain. Remorse is a return to feeling. An inability to feel produces madness. Inability to feel is fear of feeling.

Fig. 237 (above left). Taira no Kiyomori using his power to delay the sunset. 1876. From the series *A Mirror of Famous Generals of Japan.* Tsukioka YOSHITOSHI. *Ōban* format. Kiyomori (1118–81) was a capable but ruthless general who unified Japan by force and abused his power.

Fig. 238 (above). The Fever of Taira no Kiyomori. 1883. Before his death, Kiyomori was haunted by visions of hell and the spirits of people he had killed. Tsukioka YOSHITOSHI. *Ōban* triptych.

Fig. 239 (below, facing page). The Heart and Navel Technique for Creating Balance in the Body. 1862. The man burns moxa on one leg to relieve the pain caused by the spirits at his head and shoulders. Utagawa YOSHIKATSU. *Ōban* diptych.

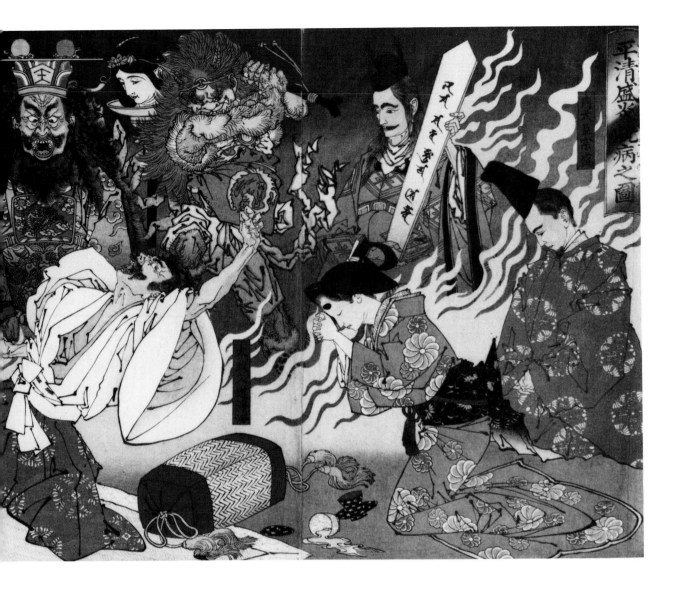

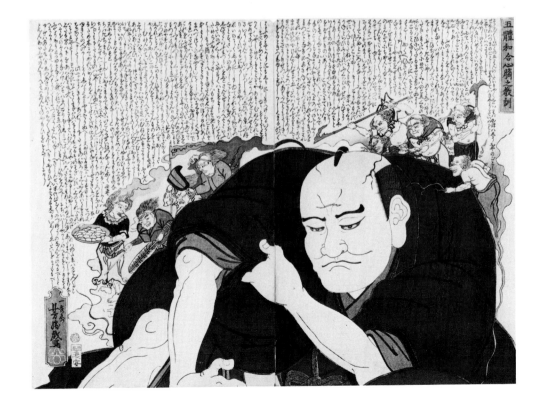

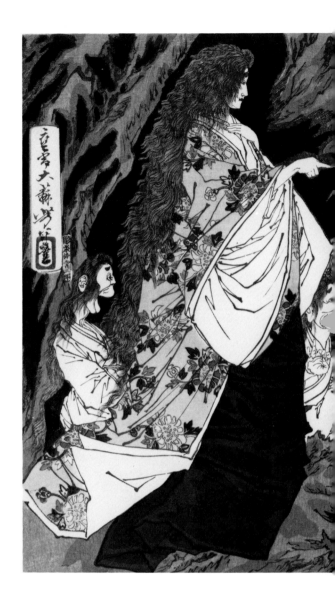

*Fig. 240. Mito Kōmon
Mitsukuni Meets a Group
of Evil Spirits at Shira-
zunoyabu.* 1881. Mito
Kōmon (1628–1700)
was a famous magistrate
who traveled widely to
study social conditions
throughout the country
firsthand.
Tsukioka YOSHITOSHI.
Ōban triptych.

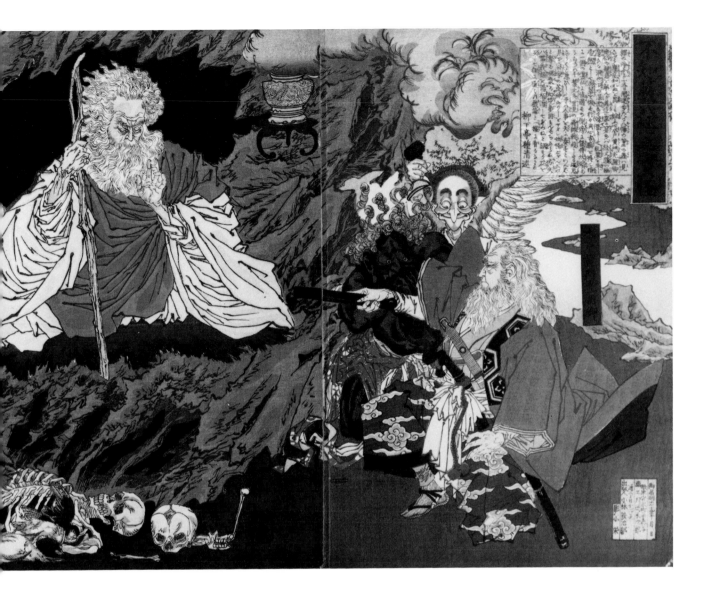

175

Serenity

In life we are many people; we perform
many functions—child, lover, protector,
head of family, wage earner, soldier. We
move through our time, taking on each
role in turn. In later years, we perform the
journey in reverse; slowly divesting our-
selves of obligations, we grow old.

As survivors, we are left to ourselves to
be ourselves: the old men in Japanese prints
have individuated features.

At the end, we possess our memories,
our poetry, our hard-won skills. We are re-
moved from center stage; no longer the
principal actor, we look on as new players
replace us.

Old age, if we are blessed, is a time of
sunrise, harmony, contemplation, and
peace. Perhaps it is also a time to grieve our
lessening strength and to acknowledge the
wisdom we have gained.

Fig. 241 (above). The old couple Jō and Uba stand beneath the Takasago Pine and pray to the rising sun on New Year's Day. *c.* 1790s. Jō and Uba, spirits of the ancient pine tree at Takasago, were symbols of married happiness. UNIDENTIFIED EDO ARTIST. Long *surimono* format, lacking text.

Fig. 242 (below). The aged warrior Sakata Kintoki leans against a wine keg and dreams of his youth. 1789. Kintoki was the adult name of Kintarō. Torii KIYONAGA. *Ōban* format. The picture beside Kintoki's knee is a treasure-ship print; people slept with these prints under their pillows to foster lucky dreams on New Year's Eve.

Mastery

The old become invisible. What can an old man teach? Kept to himself, what use is his experience? Among the invisible, how can a young man recognize a teacher?

Musashi wishes to master the art of swordsmanship and learns of a teacher. He journeys far into the mountains, where he finds a frail old man living in poverty. This helpless fellow could not be the great swordmaster, he thinks, and as he introduces himself and describes his own accomplishments, the old man looks smaller and weaker. Why even bother, he thinks, I've just made a mistake. But the old fellow has challenged him. Attack! he says. Attack? A weak and unarmed man? Musashi swings halfheartedly. Attack! the man commands. Drawing two wooden practice swords, Musashi decides to teach this ridiculous old fool a lesson. As the youth composes himself, the old man calmly leans to the side and picks up the wooden cover of his rice pot (see fig. 227). They duel. Much later, thoroughly exhausted, Musashi knows he has found a master.

Fig. 243 The actors Ka-
taoka Nizaemon VII
and Ichikawa Danjūrō
VII as the sword master
Kasahara Shinzaburō
and Miyamoto Musashi.
1817.
Utagawa TOYOKUNI.
Ōban diptych.

179

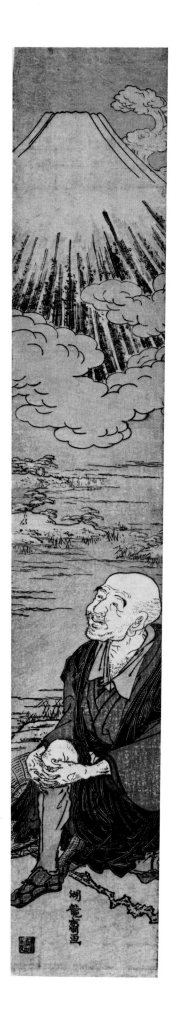

180

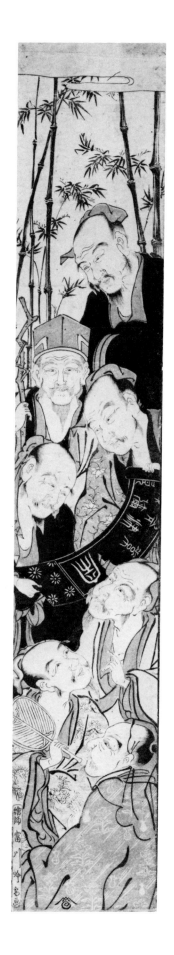

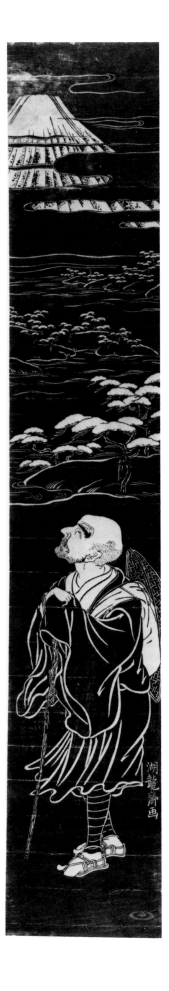

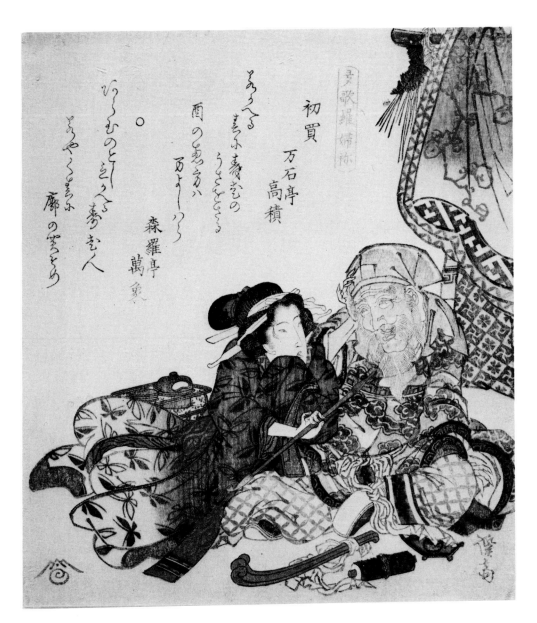

Detachment

What are they asking us? Young voices speak of distant matters. Their cares are no longer important; their appetites no longer gnaw at our hearts. Or do they?

We are contented now—leave us to our bamboo grove, we and our friends have much to share.

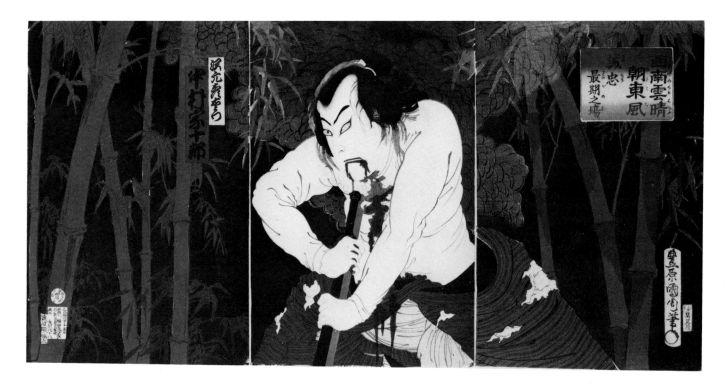

Death *Suicide*

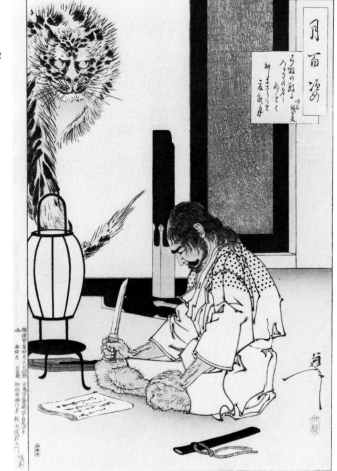

The unspeakable brink—the darkness beyond the only truths we know. It seems impossible to bring ourselves to die.

And yet a man might find a virtue strong enough, a defiance desperate enough, a sense of honor great enough to attempt the impossible and even succeed (fig. 250).

We may see death as a disengagement from life and a renouncing of light. But is suicide not an acceptance of the dark and an engagement with death? It has its focus beyond the sight of the living (figs. 225, 226).

In his ritual, the suicide fashions a door; he opens it and steps through.

Fig. 248 (above). The actor Nakamura Sōjūrō as Sawamoto Hikoemon, a samurai who had rebelled against the central government, in "The Last Moment of a Loyal Life," the suicide scene from a play based on the Satsuma Rebellion. 1878.
Toyohara KUNICHIKA. *Ōban* triptych. The print was published with a small sheet bearing the actor's soliloquy.

Fig. 249 (left). Akechi Gidayū reading over his farewell note as he prepares himself for suicide. 1890. From *One Hundred Aspects of the Moon.*
Tsukioka YOSHITOSHI. *Ōban* format.

Fig. 250 (facing page). The aged warrior Matsunaga Hisahide shouts his defiance before committing suicide. 1883. From the series *Yoshitoshi's Warriors Trembling with Courage.* Hisahide (1507–77) was forced to commit suicide after he was defeated in battle by Oda Nobutada.
Tsukioka YOSHITOSHI. *Ōban* format.

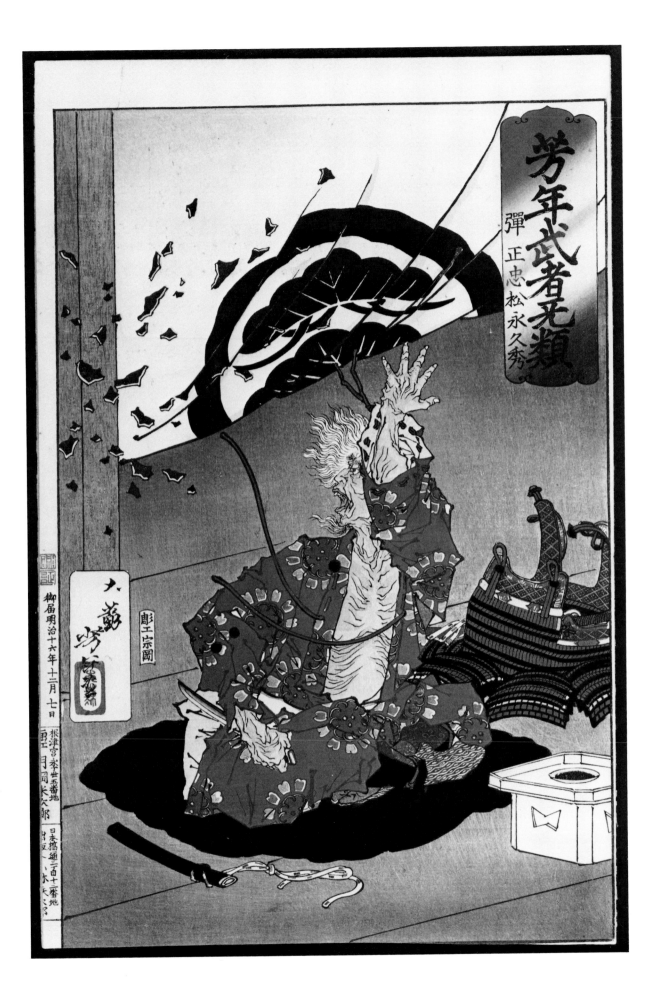

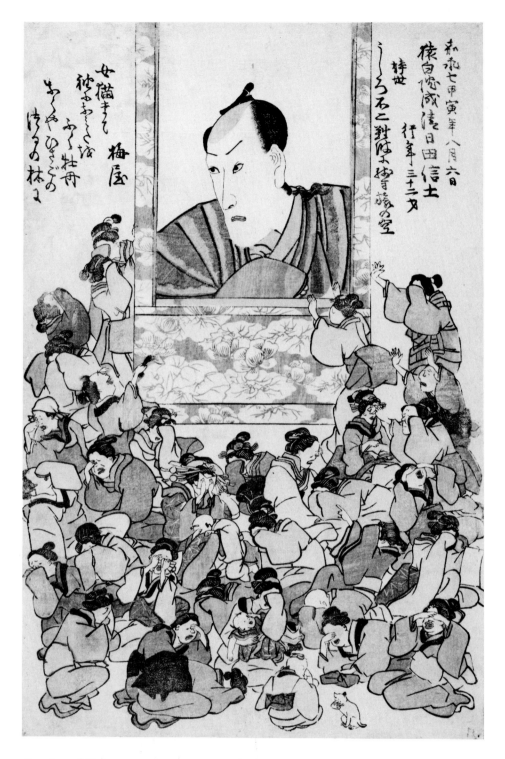

Death and Dying

Because prints were an art of the living, death had little place in them. Dying, however, was part of living; heroes and heroines in the theater often chose death.

The pain of death can be terrible, rekindling ancient memories in the people who see it. But the dead body is inert. It has nothing to say. It is the departure of the beloved's soul—teacher, hero, spouse, child, lover, friend—that causes us grief, not the body's collapse and decay.

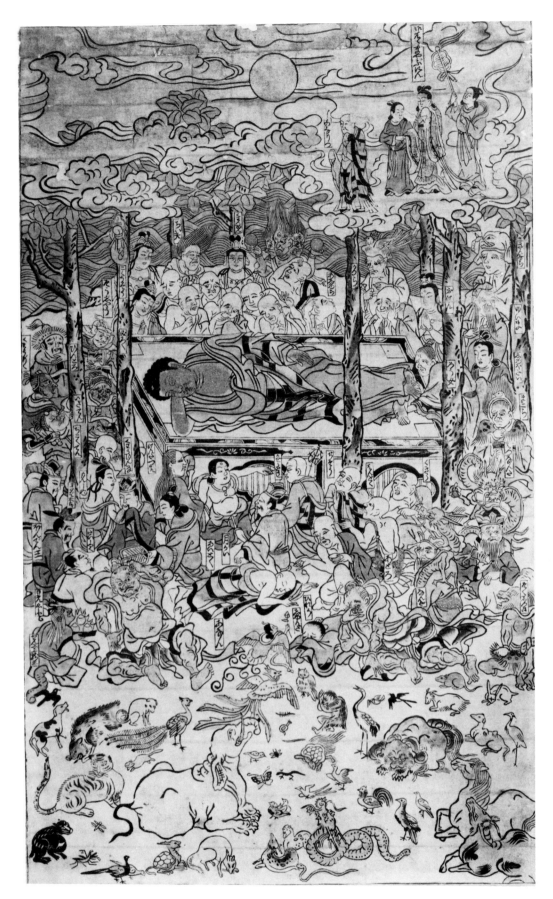

Fig. 251 (facing page).
Female admirers
weeping before a large
painting of the actor
Ichikawa Danjūrō VIII.
1856.
UNIDENTIFIED EDO ART-
IST. *Ōban* format. A me-
morial portrait based on
an image of the death of
Buddha.

Fig. 252. The death of
Gautama Buddha.
1720s. Buddha is sur-
rounded by mourning
animals, disciples, and
deities. His mother de-
scends on a cloud.
Nishimura SHIGENAGA.
Large *ōban* format.

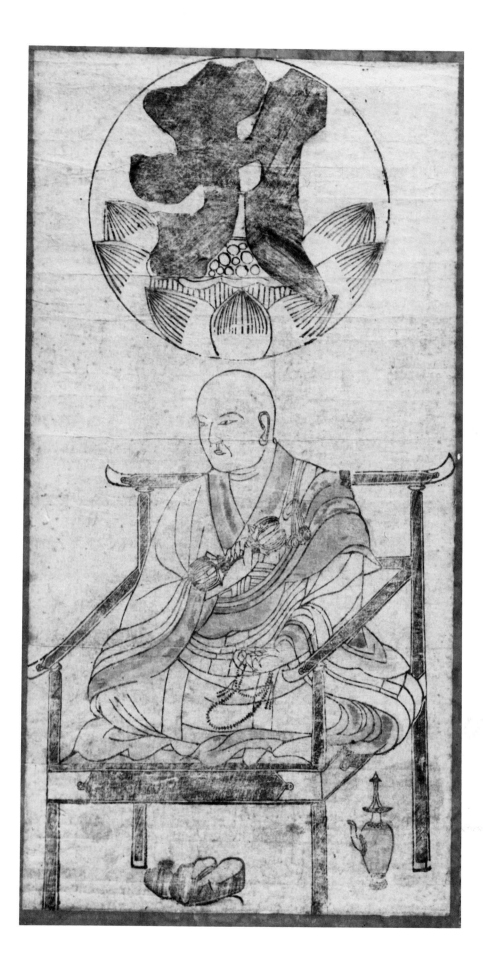

Unlike a photograph taken in life, the posthumous portrait takes its image from the sum of the man.

The artist pours into the work the memories of deeds and lifetime accomplishments, the essence of the man and all his moods. He conveys the love and loss of those left mourning.

Before us, the faces of the dead speak of a caring and a presence that continue beyond the grave. As we look at their pictures, the deceased are reborn in our emotions and thoughts.

We sense their immortal presence and reaffirm our link with them. Even future ages will not lose them. As long as we are remembered, we remain.

Fig. 253 (facing page). Posthumous portrait of the priest Kōbō Daishi (774–835). Eighteenth century. The symbol at the top is a Sanskrit letter with a mystical meaning in esoteric Buddhism. UNIDENTIFIED ARTIST. Large hand-colored print in its original paper scroll mount.

Fig. 254 (above). Memorial portrait of the Osaka actor Nakamura Utaemon IV as Taira no Kiyomori. 1852. Attributed to Utagawa KUNIYOSHI. Utaemon died in Osaka in early 1852; Kiyomori, the tonsured leader of the Taira clan, was one of his last roles. Verse by Umemoya.

Fig. 255 (below). Memorial portrait of the wrestler Hiodoshi Rikiya vanquishing two demons and the god of hell. 1839. Utagawa KUNISADA. *Ōban* format. The verse at the left is an elegy by Hayashiya Shōzō.

187

I would like to acknowledge the men who have shared their lives with me and who have helped me form my notion of what men are and what as a man I could, ought, or had, to be.

My grandfathers, William Start and Raymond Keyes; my father, Lynford, and my stepfather, John Reynolds; my uncles, Bill and Lester Start; my father-in-law, Usaburo Mizushima, and his sons, Nobuyuki and Yasuhiko; my father's friends Freddy Lanoue and C. Y. Hsu. My teachers Mark Nestle, Fernando Zobel, and Ray Lewis. My colleagues Jack Hillier, Matthi Forrer, Juzo Suzuki, Tadashi Kobayashi, and Susumu Matsudaira. My childhood friends Bernie Bush, Mike Dobry, and Boris Benado; and my present male friends, especially Sam Adams, Jim Brady, Mel Bucholtz, Nic Caldarero, Jim Collins, Don Dame, Gene Fowler, Israel Goldman, Don Ed Hardy, Laury, Micah Schwaberow, Larry Schwarm, and Michael Whitson. The members of the Men's Group: Bob Futernick, Dave Hubbell, Robert Flynn Johnson, Dick Katsoff, Pat Maloney, Barclay Ogden, and Jeff Pflugrath, who shared their dreams and anger, their lives, their souls, their fears and doubts. And the courageous men I have met in ACA and Al-Anon who have been willing to share the hidden truths of their own childhoods as a step in healing our wounds.

I would also like to thank a few of the women who showed me how men looked from the other side: my mother, Lorena; my sister, Janet; my wife, Keiko; our daughter, Aenea; and my friends Belinda Sweet, Shirley Triest, Helen Palmer, and Jackie Kirk.

Finally, I would like to thank Bill McClung, Lisa Banner, Betsey Scheiner, and Steve Renick of the University of California Press for their unfailing courtesy and generous help; Karin Breuer, Judith Eurlich, and Maxine Rosston of the Achenbach Foundation for Graphic Arts, Debra Evans, Ann Karlstrom, Harry Parker, Tom Seligmann, Ian White, and other staff of The Fine Arts Museums of San Francisco, past and present, for their cooperation and kind support. My extraordinary personal editor, Barbara Brauer, worked with me on this book very much the way the Japanese carvers and printers collaborated with the artist-designers to make color prints, to my great pleasure and our reciprocal satisfaction.

Designer: Steve Renick
Compositor: G&S Typesetters, Inc.
Text: Baskerville 10/12
Display: Baskerville